1000 YARD STARE

1000 YARD STARE

MARC C. WASZKIEWICZ

WITH LEA JONES AND
CRISTA DOUGHERTY

A MARINE'S
EYE VIEW OF THE
VIETNAM WAR

STACKPOLE
BOOKS

Guilford, Connecticut

Published by Stackpole Books
An imprint of Globe Pequot

Distributed by
NATIONAL BOOK NETWORK
800-462-6420

British Library Cataloguing in Publication Information Available

Library of Congress Cataloging-in-Publication Data
Names: Waszkiewicz, Marc C., author. | Jones, Lea, editor. | Dougherty, Crista, editor.
Title: 1,000-yard stare : a Marine grunt's-eye view of the Vietnam War / Marc C. Waszkiewicz ; with Lea Jones and Crista Dougherty.
Other titles: One thousand yard stare | Thousand yard stare | Marine grunt's-eye view of the Vietnam War
Description: Guilford, Connecticut : Stackpole Books, [2017]
Identifiers: LCCN 2016047391 (print) | LCCN 2016048547 (ebook) | ISBN 9780811717922 (hardcover : alk. paper) | ISBN 9780811765664 (e-book)
Subjects: LCSH: Vietnam War, 1961-1975–Pictorial works. | Vietnam War, 1961-1975–Artillery operations, American–Pictorial works. | Waszkiewicz, Marc C. | United States. Marine Corps. Marine Regiment, 5th. Battalion, 2nd–Biography. | United States. Marine Corps. Officers–Biography. | Vietnam War, 1961-1975–Personal narratives, American
Classification: LCC DS557.72 .W37 2017 (print) | LCC DS557.72 (ebook) | DDC 959.704/345 [B] –dc23
LC record available at https://lccn.loc.gov/2016047391

Printed in the United States of America

♾™ The paper used in this publication meets the minimum requirements of American National Standard for Information Sciences–Permanence of Paper for Printed Library Materials, ANSI/NISO Z39.48-1992.

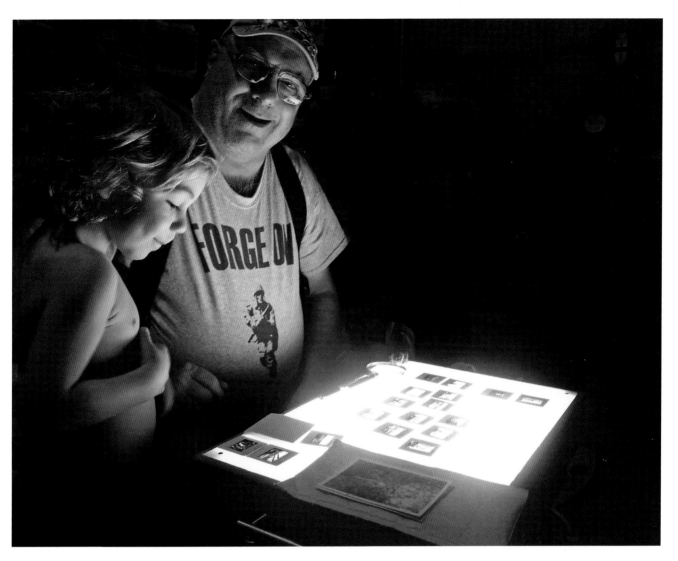

My grandson Attis and I enjoying the process of screening slides. PHOTO COURTESY OF CRISTA DOUGHERTY

They say every picture tells a story, and people love stories. I pray veterans will find voice for their own experiences in the pages that follow. May they also find the acceptance and peace in their sharing these photos with loved ones that I found in making this book.

Marc C. Waszkiewicz

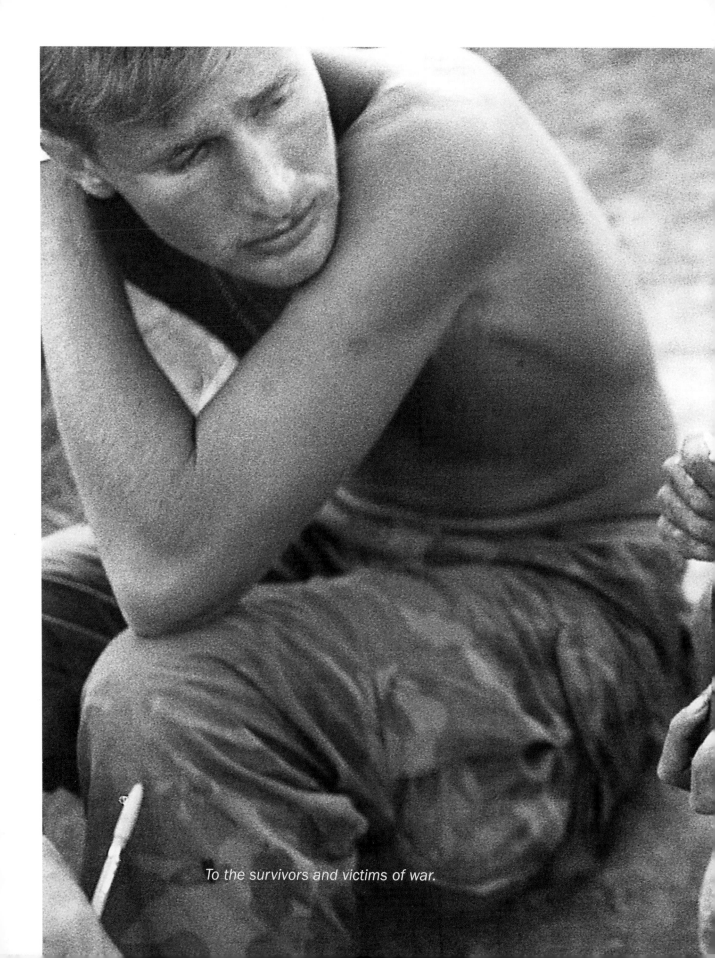

To the survivors and victims of war.

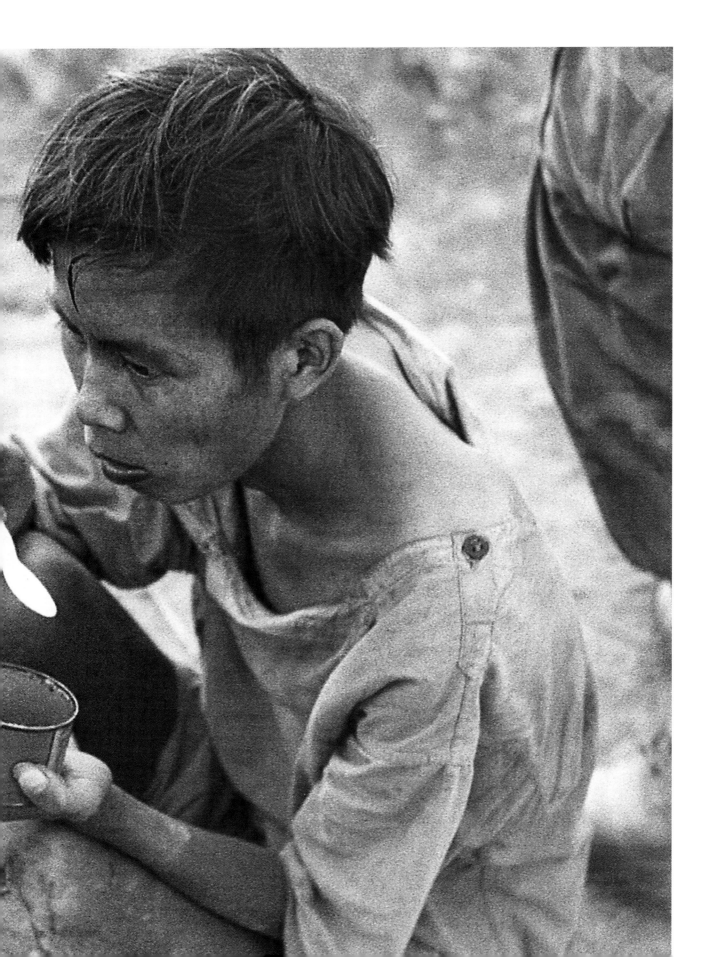

CHANGING OF THE GUARD

I remember photographs
My father's war and his victories
Red white and blue of thee I sing

In my heart there was no doubt
When my time came I'd fall in line
I'd give it all to hear those bells of freedom ring

Nineteen years old when I got the call
Semper Fi! And here I go
And for two long years I felt that jungle's heat

But the times and me we were changing fast
I saw babies and my partners die
While flags back home were burning in the street

I marched young and strong into the fire
Moved by faith courage fear and desire
Never guessed that my dreams would go down so hard
It's the changing of the guard
The changing of the guard

Been years now since I came back home
And time will heal all wounds they say
But despite all this I'll not let it go

I see my son looking up to me
See him working towards his own victories
He reminds me of a child I used to know

I marched young and strong into the fire
Moved by faith courage fear and desire
Never guessed that my dreams would go down so hard
It's the changing of the guard
The changing of the guard

–Marc Waszkiewicz and Lea Jones

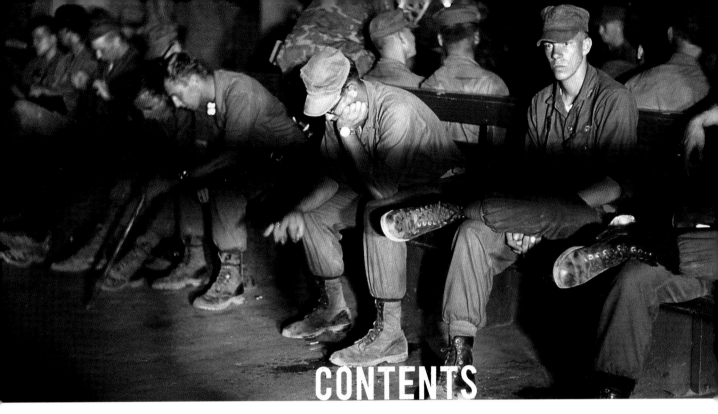

CONTENTS

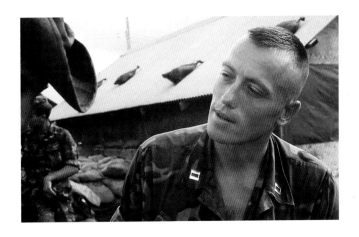

FOREWORD

Sometime in the fall of 1968, after getting to know one another through the shared camaraderie forged by frontline fighting, Corporal Marc Waszkiewicz confided in me that he had always wanted to escape from the rear-area artillery fire support bases where he had been assigned to his artillery regimental headquarters for most of the previous year. He envisioned moving out to the field as a forward observer to "get into some real action." From the information he had, Marc said, "The 5th Marines were in the busiest combat area, called the An Hoa Valley." In boot camp he had learned that its 2nd Battalion, 5th Marines was the most highly decorated battalion in the Marine Corps, with its roots planted before and during World Wars I and II. According to all the combat reports he had read, the most "butt-kicking company" in that battalion was my Fox Company. Thus, in early September Marc initiated a transfer from the rear to join Fox Company as the company's assistant artillery forward observer. The price to Marc was a six-month extension of his nearly completed tour of duty plus what would come to be a lifelong struggle with PTSD, although in those days we had neither a name for that phenomenon nor any thoughts of such outcomes.

I had been the commanding officer of Fox Company since the end of July 1968, having extended an extra six months to be given command of an infantry company. In August, Fox had defeated an NVA/VC company, capturing its 75mm recoilless rifle, only to have an F-4 Phantom jet mistakenly drop napalm on my 2nd Platoon, essentially wiping us out. We recovered on a hilltop fire support base, building back up to battlefield strength while defending an entrance to the An Hoa Valley at a place called Liberty Bridge. The night before we were to be relieved from these defensive duties, our ambush platoon was itself ambushed.

We lost eight killed and seven wounded. The next morning, September 12, 1968, Fox Company assaulted Phu Lac (3), the hamlet where the enemy had gathered after their ambush.

At this precise moment, Marc arrived to join the company's command group. No one welcomed him or even cared if he was there. I was pissed about the previous night's dead and wounded—really pissed. I led the company down the hill and into the village and had the local adults rounded up. In Vietnamese, I gruffly asked the few old, toothless ladies we found in the hamlet if they knew where the VC who had ambushed us the night before were located. Each claimed she hadn't heard or seen a thing. I cursed them vehemently, the same as my Vietnamese counterparts had done the year before, when I was an advisor to a South Vietnamese unit. I barked at the tank commander assisting our assault, "Run over every hooch in this hamlet." It would never again be a safe place for the enemy. The rest of the morning and that afternoon, before our next company movement, the men fumed that they wanted blood.

"Oh yeah, kid, what's your name? Waszkiewicz? That's a mouthful. We'll call you 'Ski.' Oh, and get ready for a good ride!" Marc's PTSD would start to develop from then on.

Marc was always on my mental wavelength. He had a soft voice and a sharp eye. His sense of humor mirrored mine. His map-reading skills were impeccable, and I came to trust him to keep track of exactly where we were at all times. I soon had the lieutenant forward observer transferred back to his artillery base, since he really didn't enjoy combat, and elevated Marc to be Fox's only artillery forward observer, a first lieutenant's job. We would fight the VC and NVA/VC mixed units together for the next four months. In combat, when the bullets are flying and grenades are being thrown at you, there is little opportunity to verbally communicate. I could look at Marc, both of us lying flat on our stomachs, nod at him, and move my head toward where I wanted the artillery. Soon the rounds would be falling on the targeted enemy with dependable speed and accuracy.

After Vietnam, I reconnected with Marc in the early 1980s, learning he had not only continued on in his duty as forward observer but had actually extended an almost unprecedented second time to continue battling the enemy out in the jungles and rice paddies, earning a field combat promotion to sergeant, a Bronze Star, and a Navy Achievement Medal, both with "V" for valor in the face of the enemy. I have been with him through many of his turbulent years. He has been engaged in the development of this project since as early as I can recall. This has been his life's work. He was particularly active at a Fox Company reunion in 1994. I used many of the tapes of interviews with Fox Company vets he recorded at the time in writing *Battlelines*, my book about the history of Fox in Vietnam.

The book that you are about to look at captures the remarkable joys of brothers who have bonded together and who know each other without the distractions normally found "back in the world," as we called the States. The men shared their souls and became brothers in battle, by campfires, on patrols, or in the dark silence of ambush positions. They grieved when their brother received a "Dear John" letter, was wounded and whisked away on a medevac chopper, was zipped up in a body bag, or was rotated back home. They were under torturous psychological stress day after day, knowing harm could be seconds away, yet they never lost their love for their country, their Marine Corps, their families, their fellow Marines, or docs. Nor did they lose their sense of humor. Marc is my true friend, a man I will forever deeply admire.

There was one thing that separated me from Marc back then. I had one focus: to make sure men like Marc made it back home safe and that we destroyed the enemy in the meantime. That was my only focus. Marc, on the other hand, was fascinated by all the things around him, often taking pictures of daily life and even volunteering for special assignments in order to get some "good shots." Today, I finally see why.

I want to thank my brother Marc Waszkiewicz for having the courage to complete this magnificent book. Crista Dougherty, you are a gifted artist—thank you for helping Marc complete this treasure.

Lieutenant Colonel David B. Brown
USMC (Ret.)

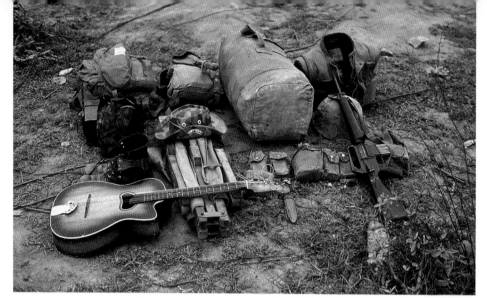

As an REMF, this was my entire world of possessions. How quickly, as an infantryman, this pile of gear would consolidate to only what I could carry on my back.

WARSPEAK

Bloused trousers, bush hat, cammies neatly pressed,
Polished boots, rifle clean, lifers ain't impressed.
Poker game, stand my watch, c'mon cut me slack,
Mail call, chow call, time to hit the sack.
Roadside coke stand, barber shop, haircut, shave, black market pot.
See a flick, chug a beer, freedom bird, check out of here.

Saddle up, lock and load,
Selector switch on rock and roll.
Advance on line, recon by fire,
Grenades in cans with fishing wire.
Blooper, frag, M-16, Spookey, Huey, and fixed wing,
05, 55, zone and shift, shell mix, fuse mix, make it quick.

Buku, titi, lai dai, duma mi,
Cao ong, cao ba, cao co, come with me.
Long time, short time, souvenir me cigarette,
Boom boom mama-san, cockadau Nam Viet.
Hue, Da Nang, DMZ, Central Highlands to the sea.
Chieu hoi, didi mau, man I think we're dinky dau.

CIA, and MAC-V,
XO, CO, MPC,
FPO, ASAP, FNG,
Deros, Conus, PRC.
ARVN, VC, NVA, LBJ and JFK.
Victor Charlie, SOP, GI, DI, USMC.

—Marc Waszkiewicz and Lea Jones

IMAGES
OF
WAR

EVERYWHERE I TURNED
THERE WERE PHOTOGRAPHS
WAITING TO BE MADE . . .

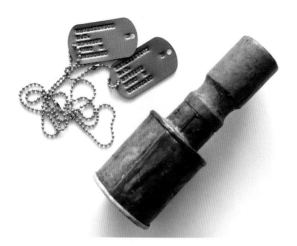

I was wearing these dog tags when this handmade enemy grenade landed between my feet during combat.

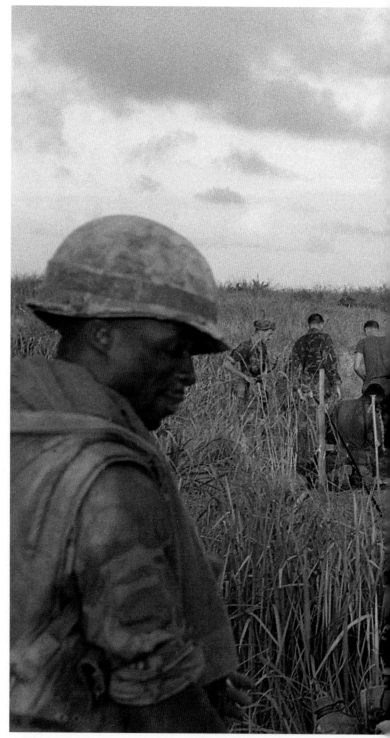

For me the strongest element of all images of war is the affection soldiers show for one another.

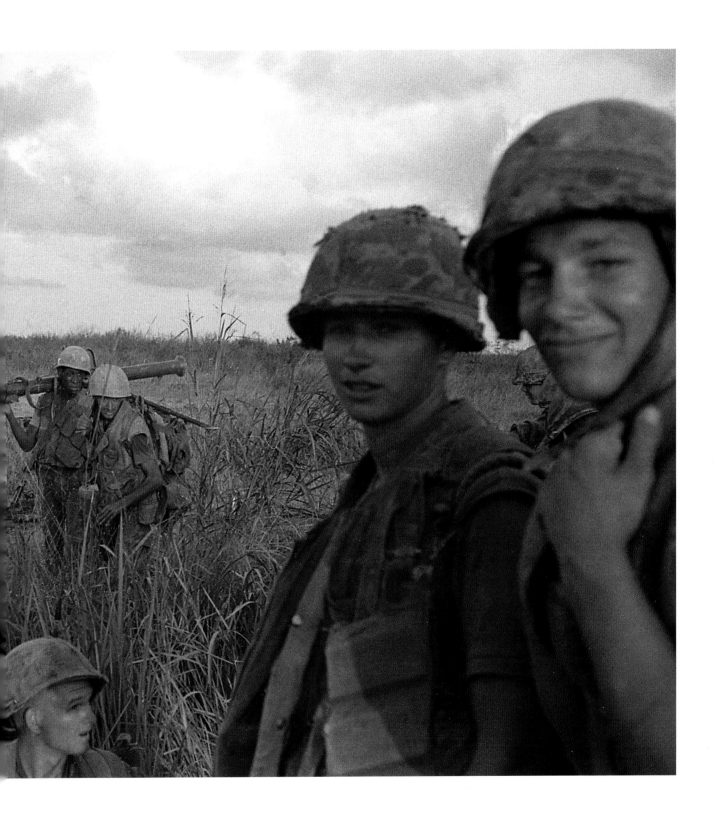

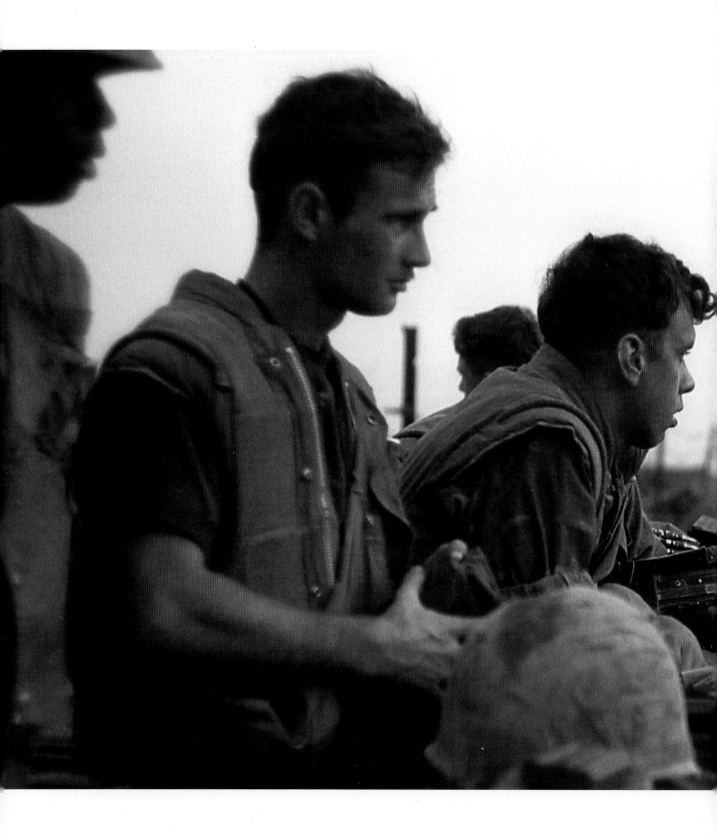

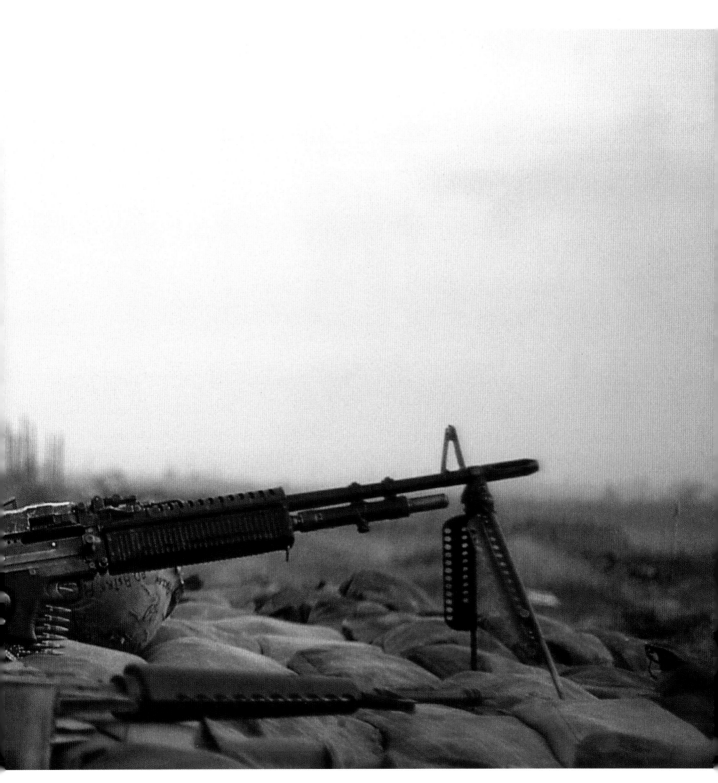

At a field outpost, sometimes called a fire support base, daylight brings a welcome reprieve from last night's attack. The troops remain on 100 percent alert.

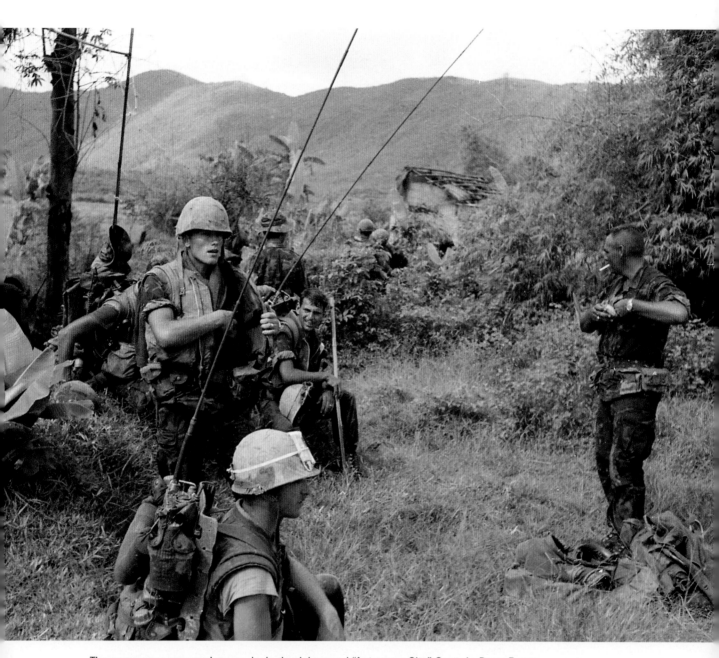

The company command group, lovingly nicknamed "Antennae City." Captain Dave Brown leads the way while the company gunny eyeballs the troops.

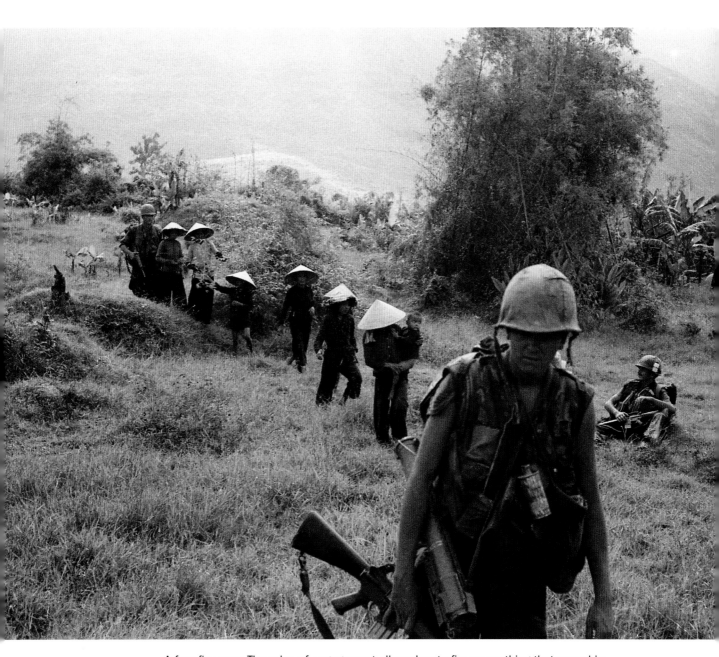

A free-fire zone. The rules of engagement allowed us to fire on anything that moved in these areas. Here we are leading an evacuation of civilians to a nearby refugee camp.

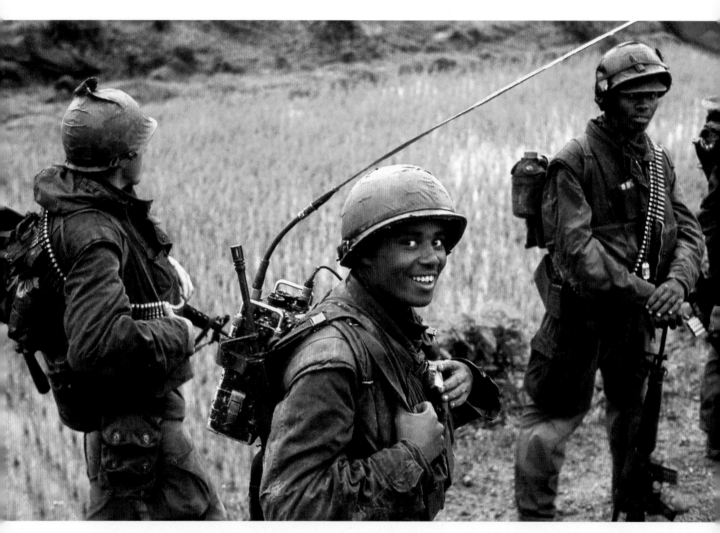

Smiles were rare when humping in the rain. During the monsoon season, we would get chilled to the bone, wearing the same wet clothing and socks for days or weeks on end.

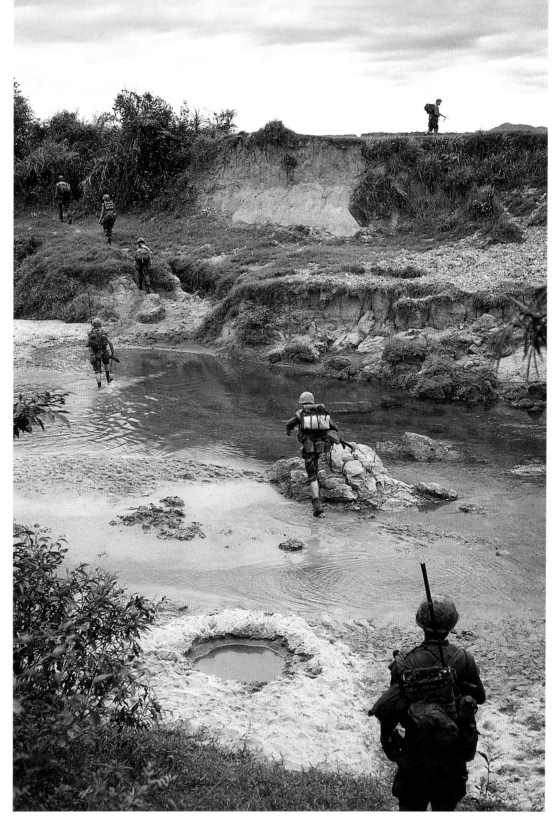

Humping the boonies. Thank God this river was low. The point man stands guard atop the opposite bank while we catch up to him.

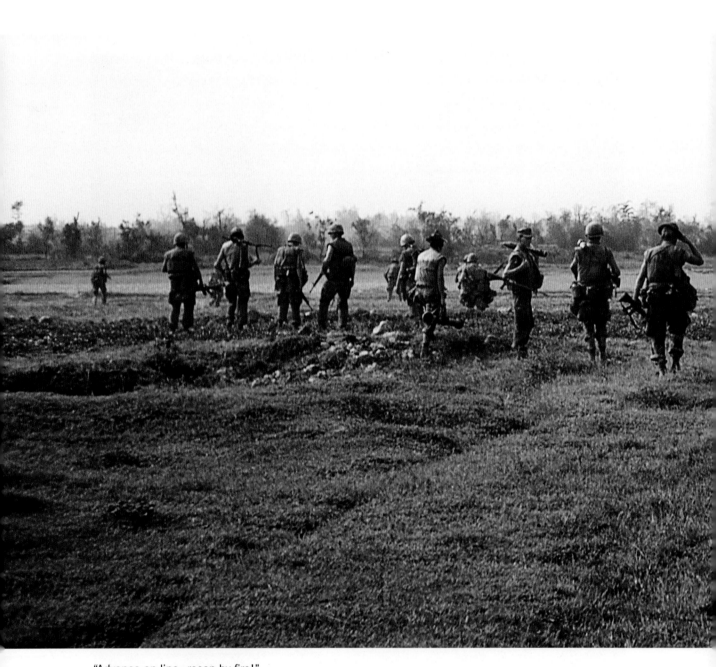

"Advance on line—recon by fire!"

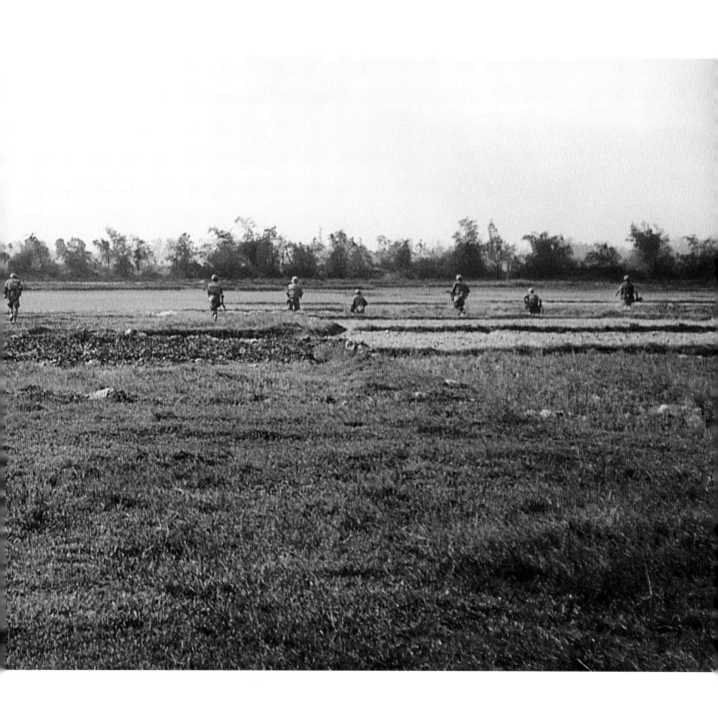

A helicopter support team (HST) Marine directs an incoming helicopter.

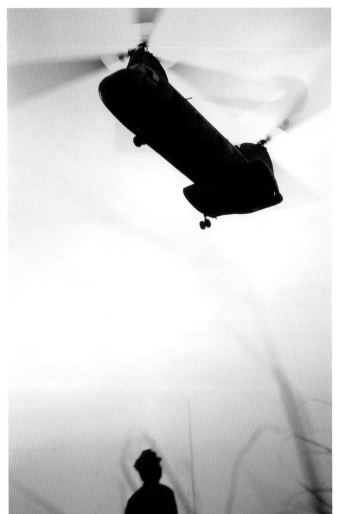

The boredom of waiting is over once the order to board the choppers is given.

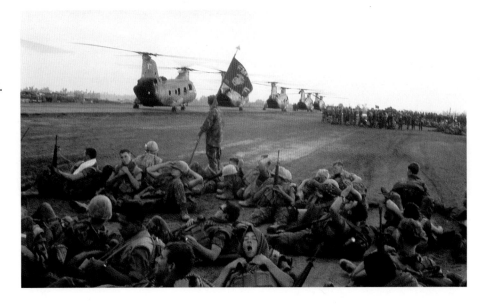

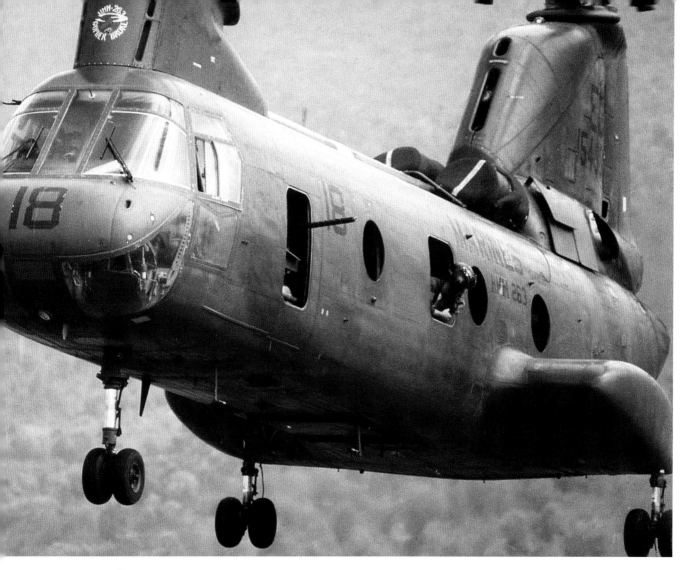

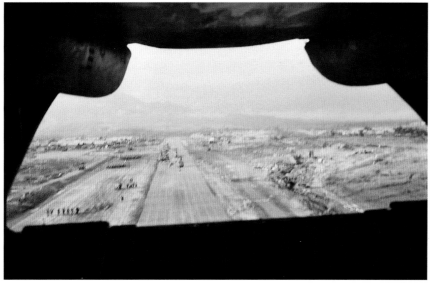

A CH-46 Chinook helicopter landing with fresh troops and—we hoped—mail. The Plexiglas windows have been removed for less debris upon crashing and for handy gun ports in hot LZs.

And in the blink of an eye, we're airborne, heading into battle.

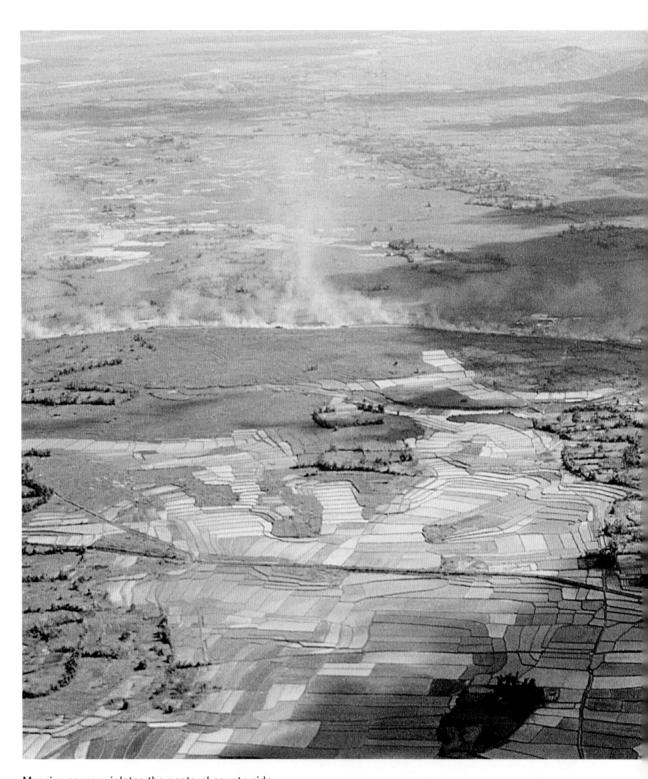

Massive convoy violates the pastoral countryside.

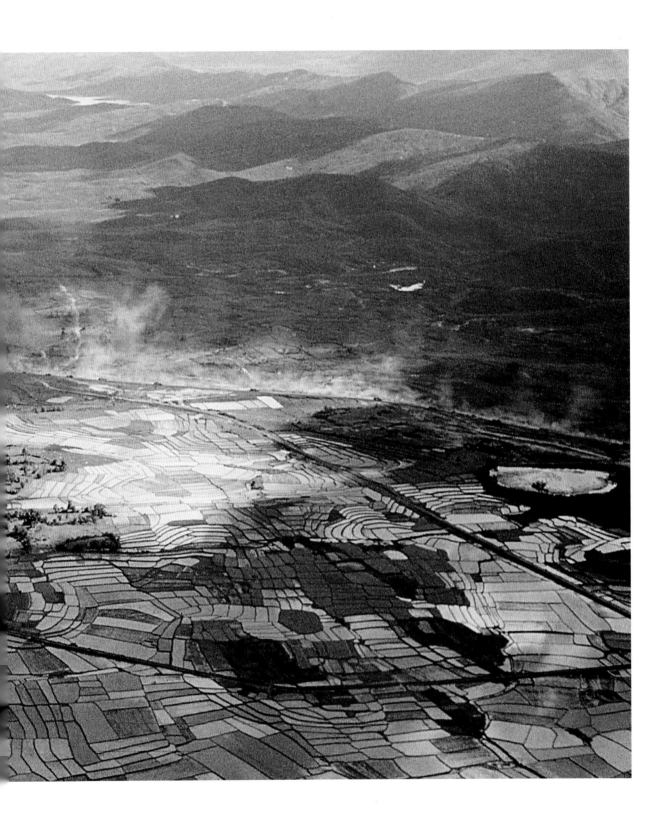

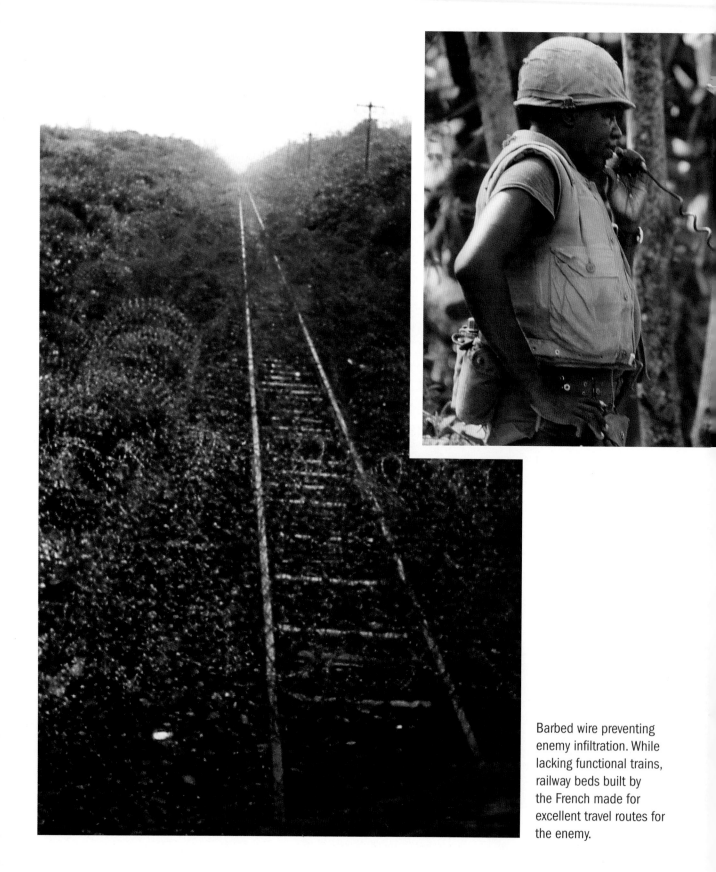

Barbed wire preventing enemy infiltration. While lacking functional trains, railway beds built by the French made for excellent travel routes for the enemy.

Communication in the jungle is essential. Here a platoon sergeant rallies his troops.

Performing my duties as both scout sergeant and artillery forward observer.

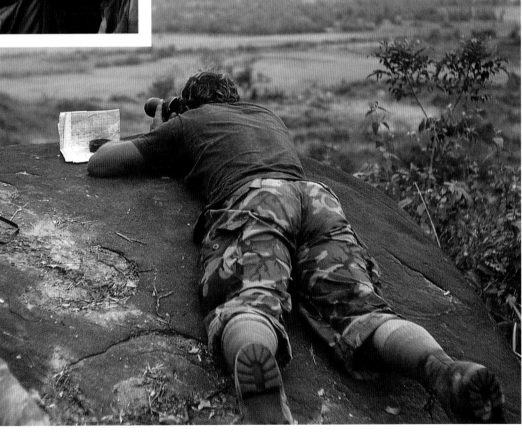

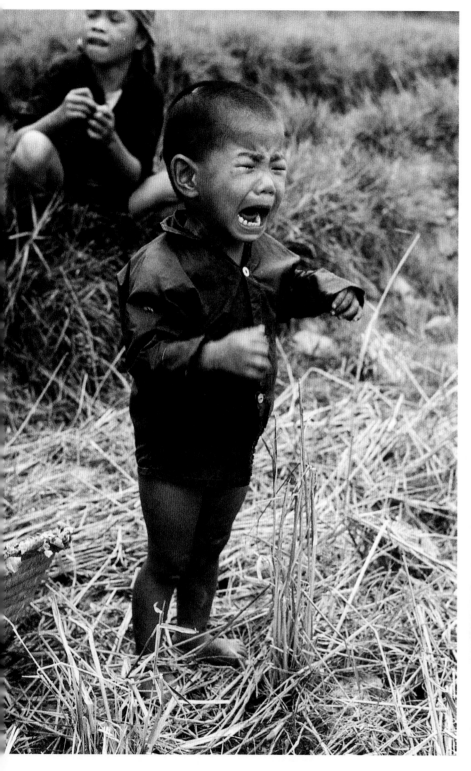

The bane of every war: Children get caught in the middle.

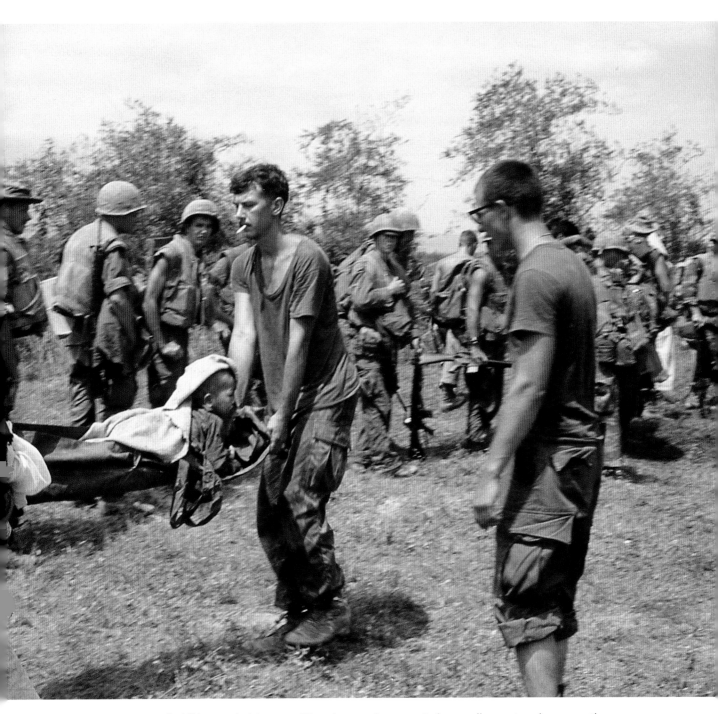

A child wounded by my artillery barrage is evacuated as we line up to advance on the enemy positions.

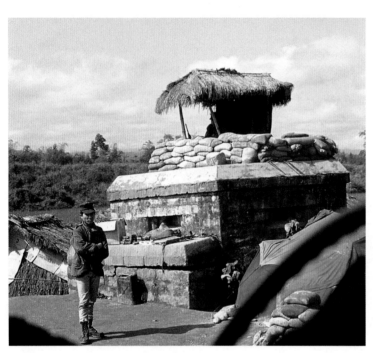

A French pillbox bunker guarded by Army of the Republic of Vietnam (ARVN) troops is a grim reminder of the French war decades earlier. Photographed from the cab of my truck as I drove past.

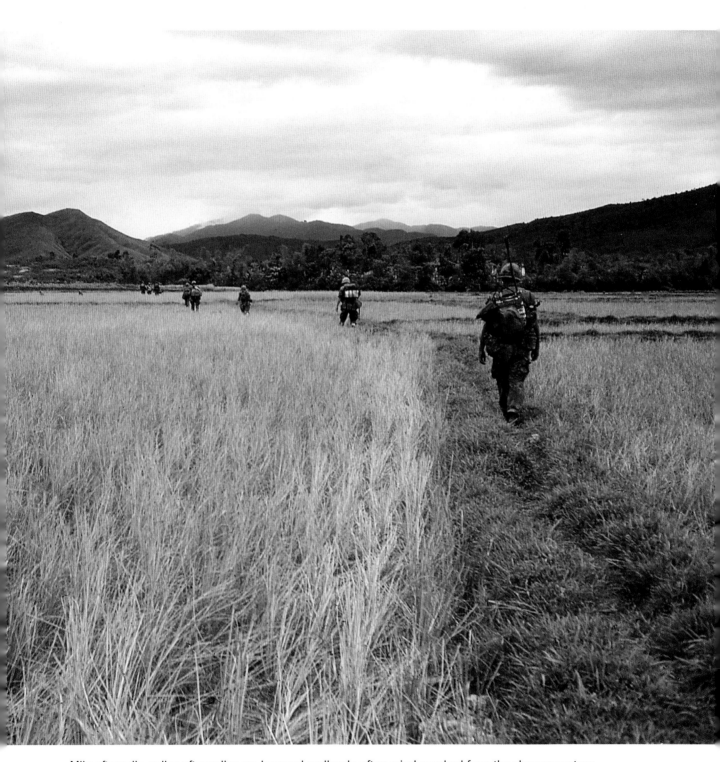

Mile after mile, valley after valley, we humped endlessly, often mind-numbed from the sheer monotony.

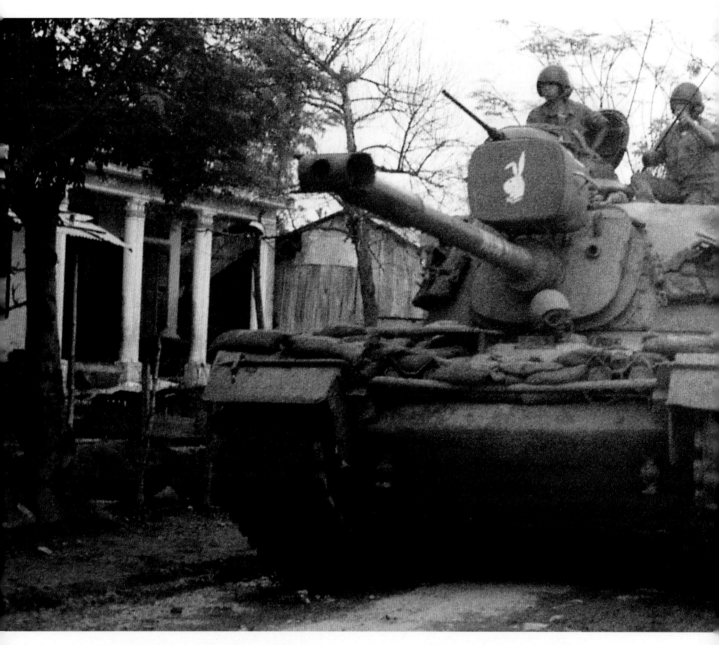

Clank. Clank. Clank. Here come the tanks! The ground vibrated like an earthquake upon their approach, but riding atop one was like cruising on a tug boat, smoothly floating along.

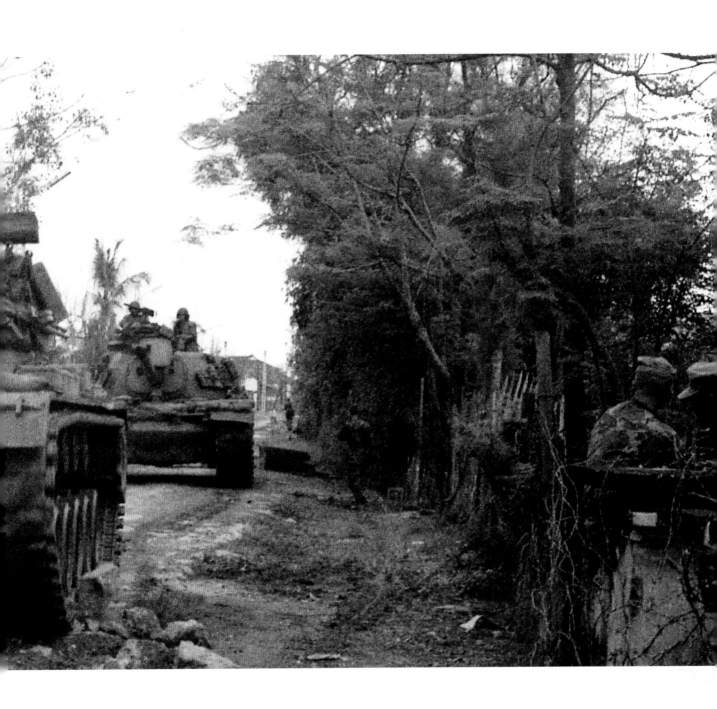

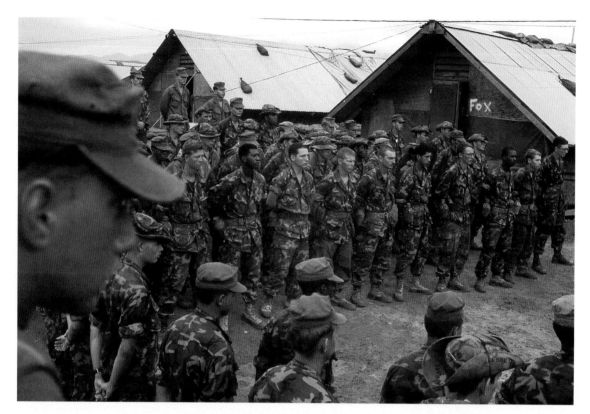

A rare moment—we pause to reflect on our recently lost comrades before heading back out.

Holding memorial
services next
to symbolic
representations of each
fallen Marine in our
recent operations

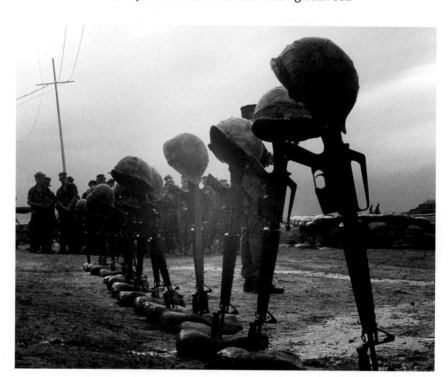

BROTHERS IN ARMS

WE ALWAYS SAID, "WE ALL WEAR GREEN; WE ALL BLEED RED." I FIND IT REMARKABLE THAT THE HORRORS OF WAR CAN BRING OUT THE TENDER HUMANITY IN MANY OF US.

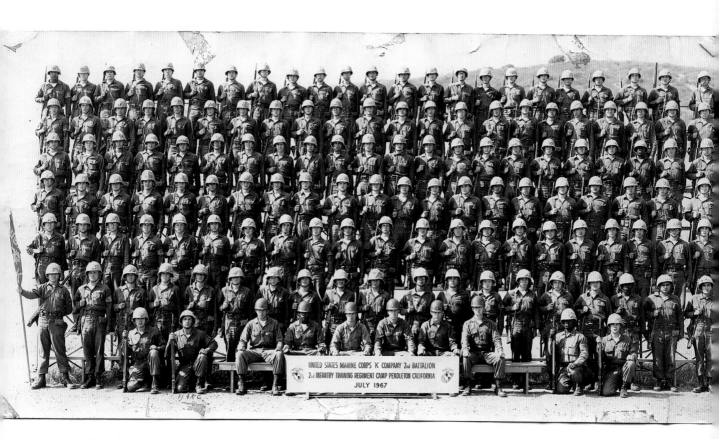

My infantry training regiment at Camp Pendleton. I am kneeling in front, immediately to my instructors' right.

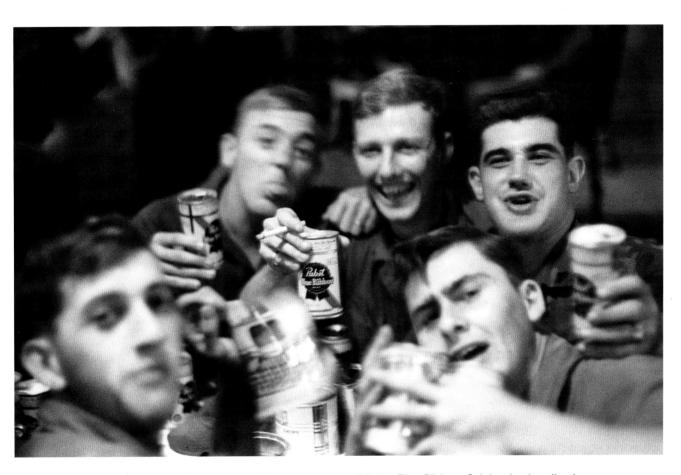

"Good enough then. Good enough now." Pabst Blue Ribbon. Celebrating heading home.

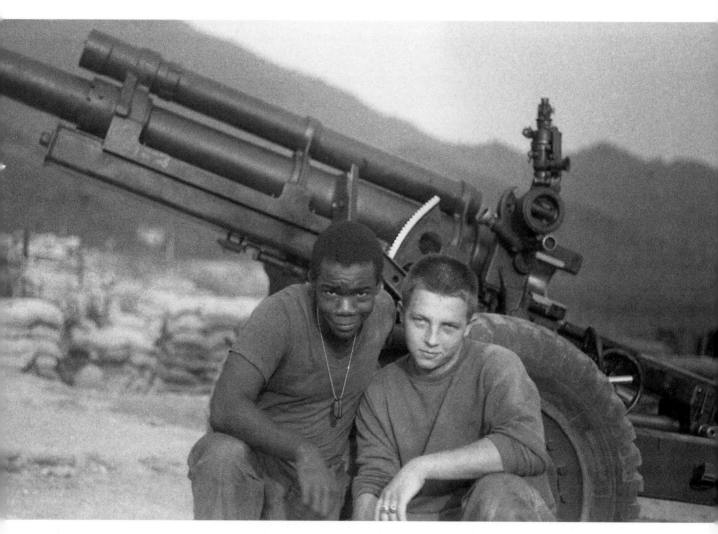

Boys and their toys: 105mm howitzer with a couple of crew members. These field artillery pieces fire a 96-pound high-explosive (HE) round.

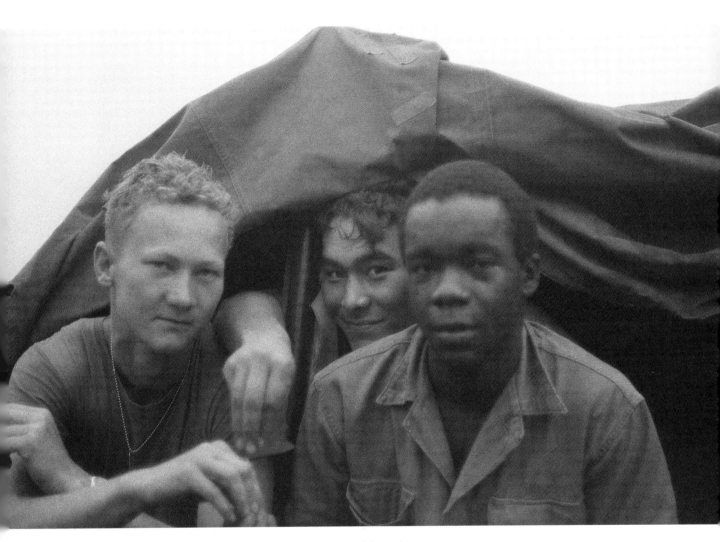

In my three tours, I never saw any racial tension.

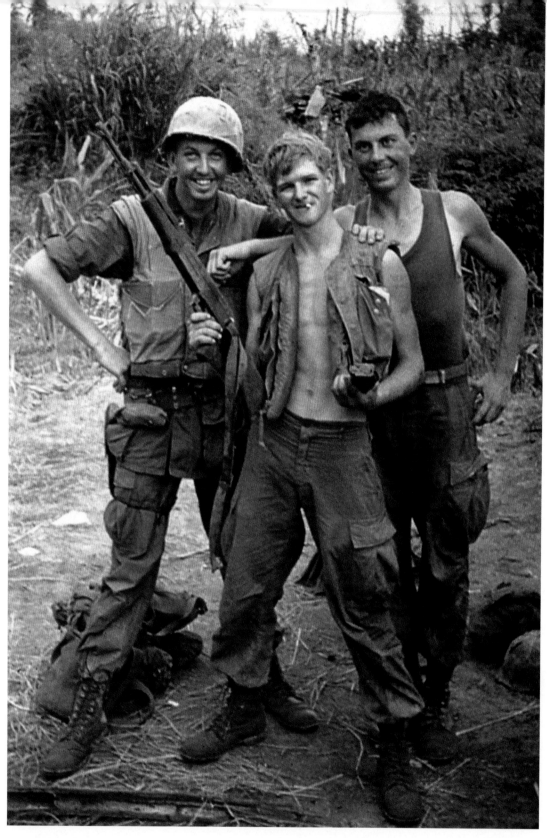

The aftermath of a battlefield victory: showing off a captured enemy machine gun.

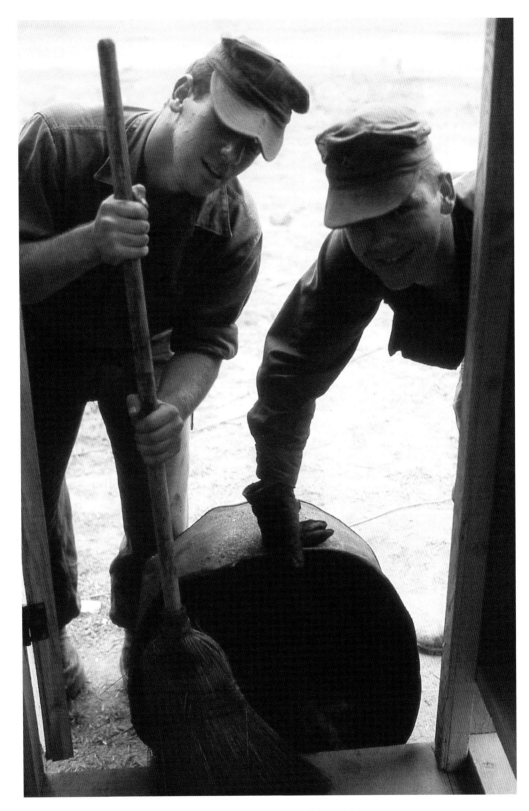

Burnin' the shitters. Shared misery heightened bonds of friendship.

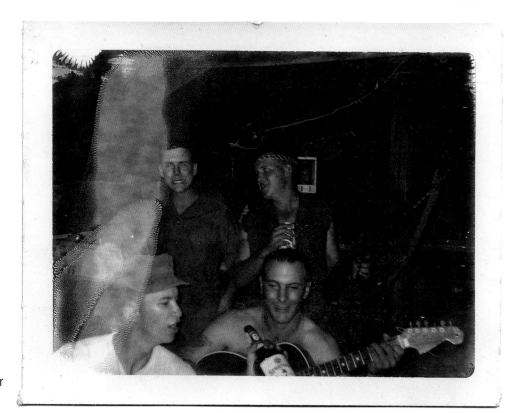

Booze always made my guitar playing better.

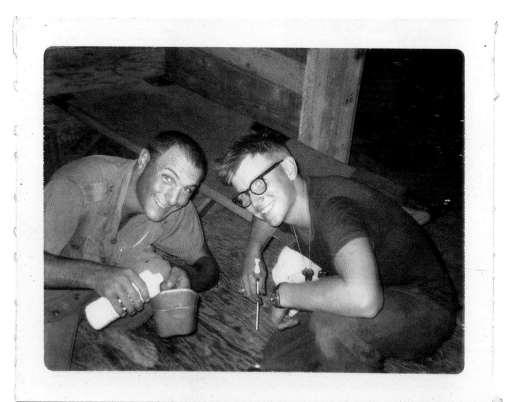

My first best buddy in 'Nam, Jack Vitou. We are pouring whiskey from a 409 detergent bottle my mom sent in a package from home.

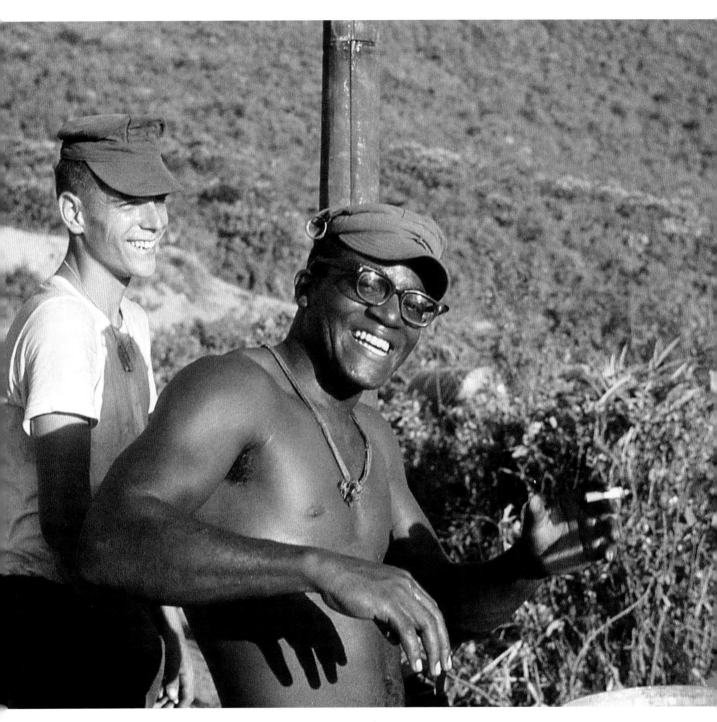

Hammin' it up for the camera. Note grenade pin as hat ornament.

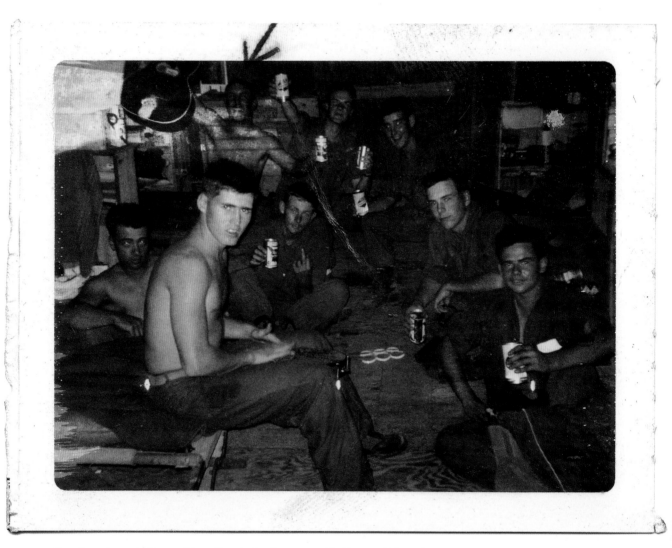

Hooch mates relaxing and bonding. In the foreground is Corporal Vinny Brennan, who made a point of welcoming newbies. He taught us the ropes.

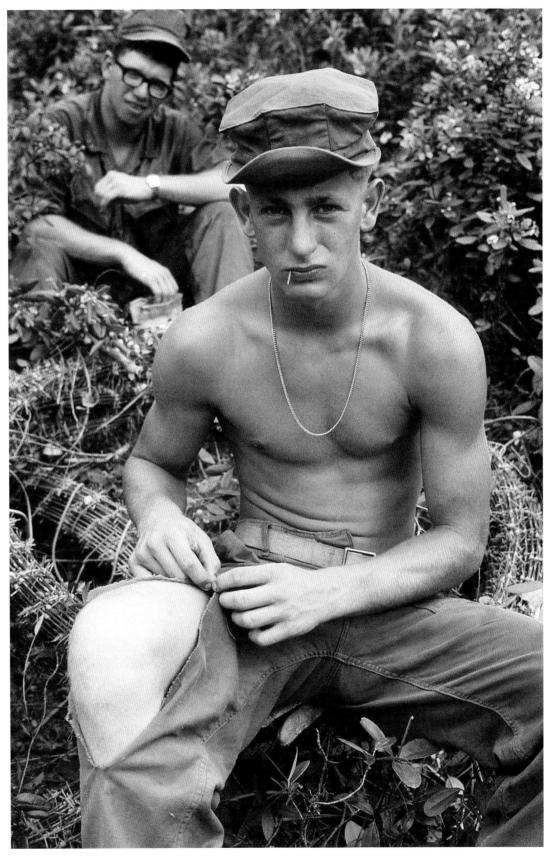

The hazards of laying barbed wire. We were so young.

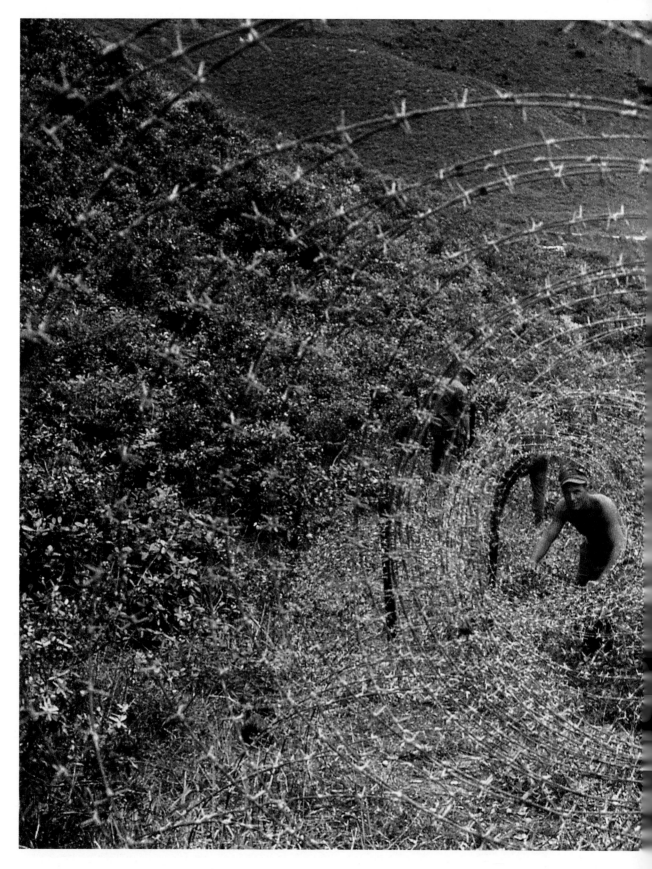

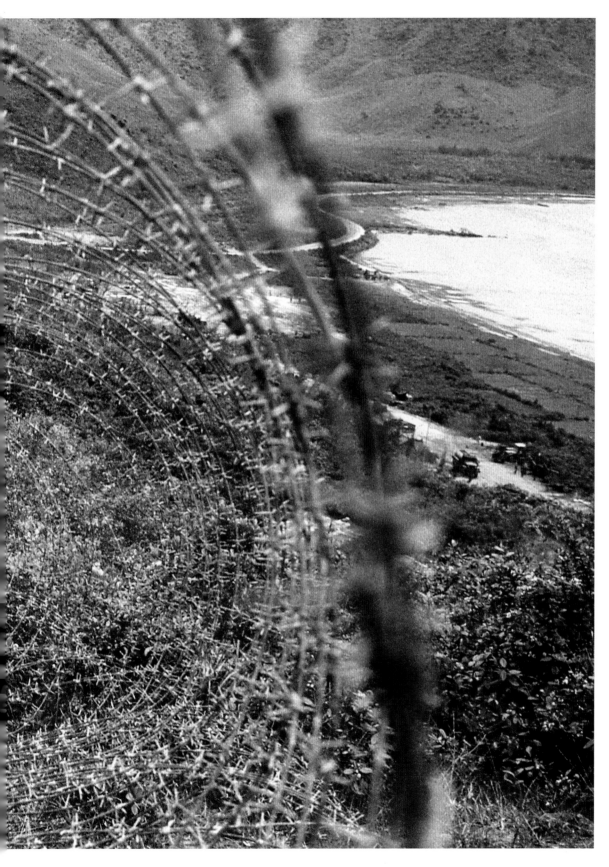

Vietnam was
a maelstrom
of barbed
wire.

Bleary-eyed troops welcome sunrise after spending the entire night on high alert because of heavy enemy presence and repeated perimeter probings. Blurred, in left foreground, is Sergeant John Hehr, who earned a Bronze Star here the next day, retrieving what he thought to be my corpse after a full-fledged enemy attack.

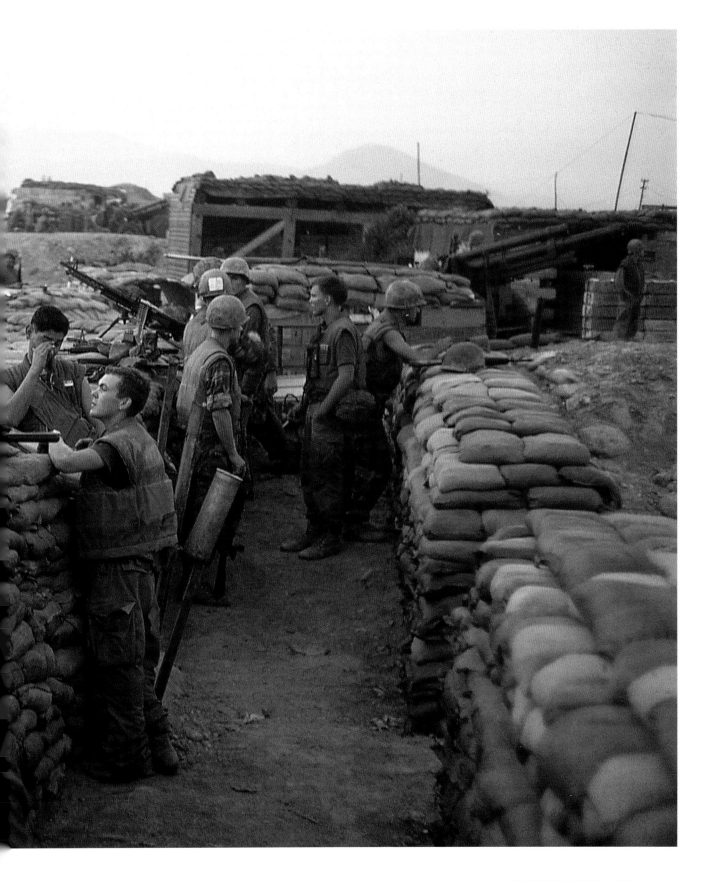

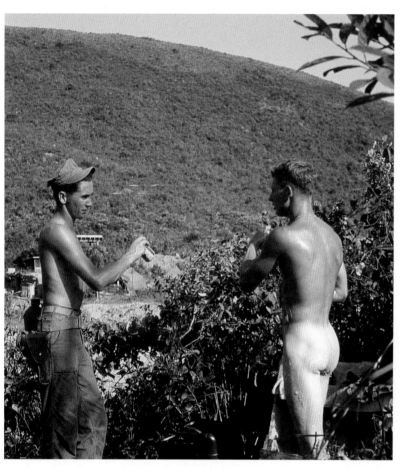

Hygiene is a deeply ingrained basic
aspect of trying to stay combat
effective (i.e., healthy) in a jungle
environment.

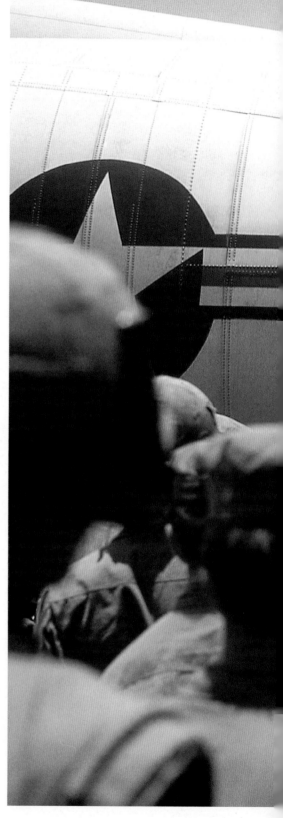

"Hurry up and wait" we
called it. Military life
sometimes seemed
like a series of "waiting
in line" events.

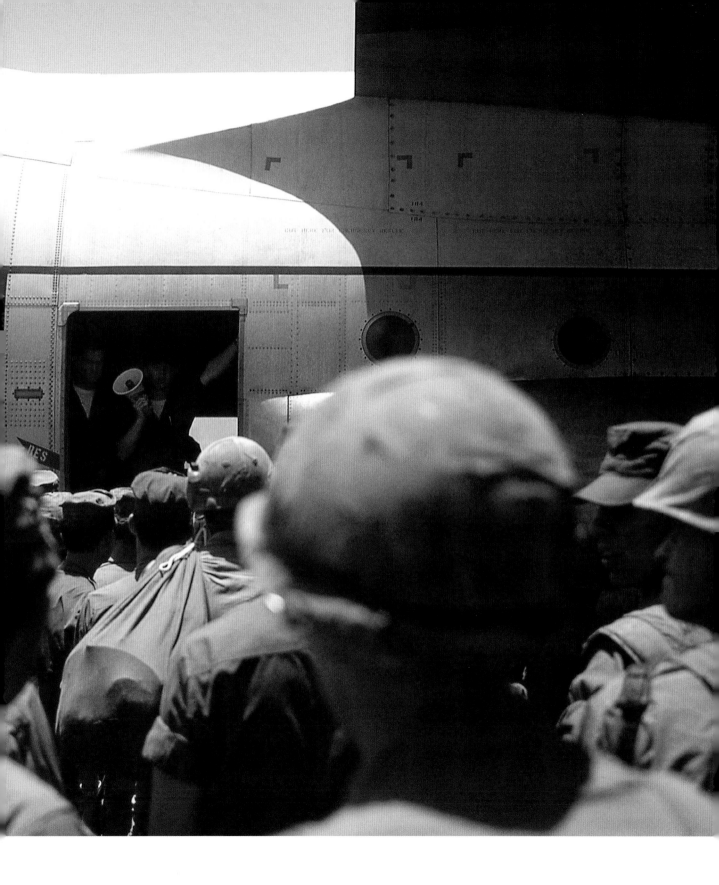

I wasn't the only one fascinated with events around me.

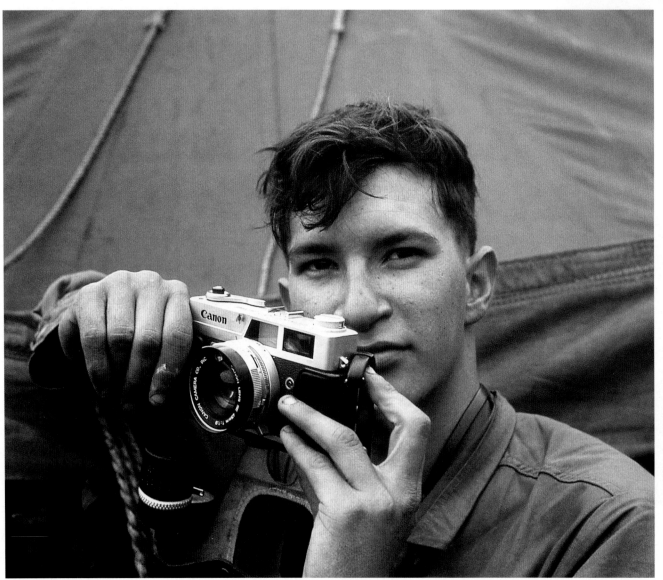

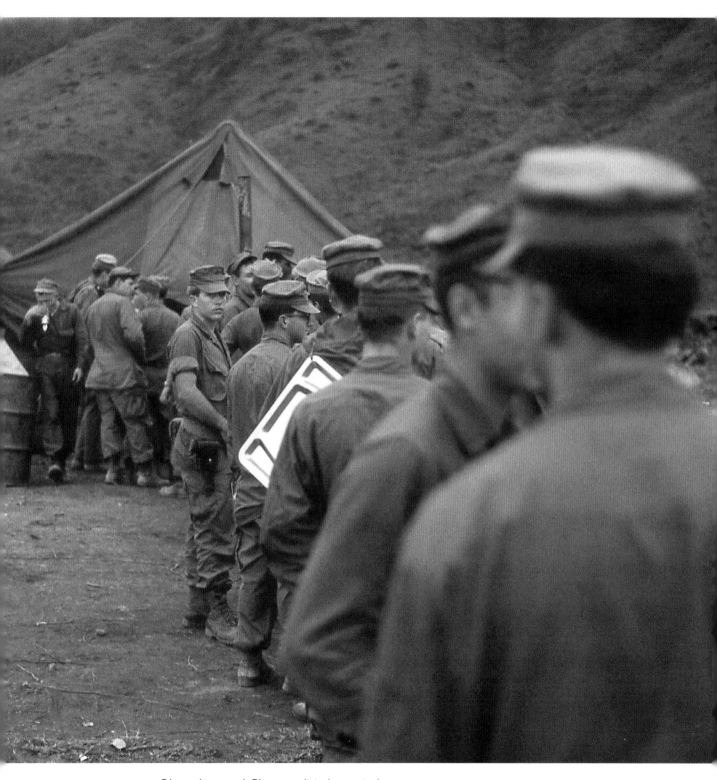

Dinner is served. Please wait to be seated.

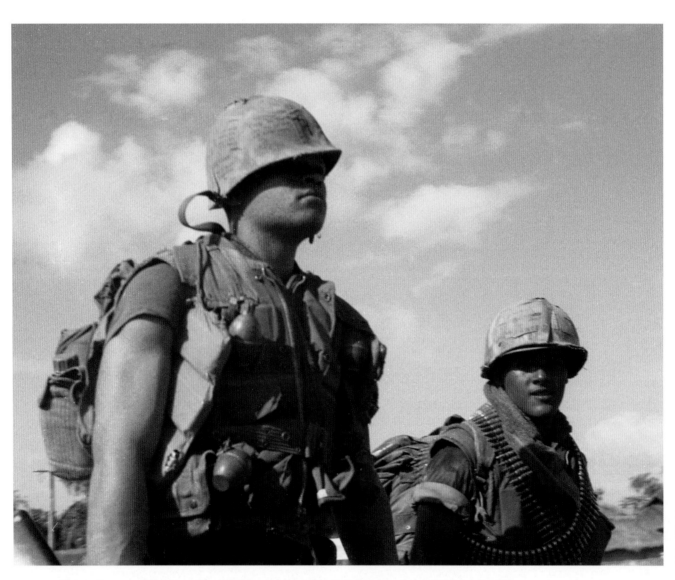

The aptly named Corporal Blunt (left), squad leader, 2nd Platoon, Fox 2/5. Even the lifers gave him a wide berth.

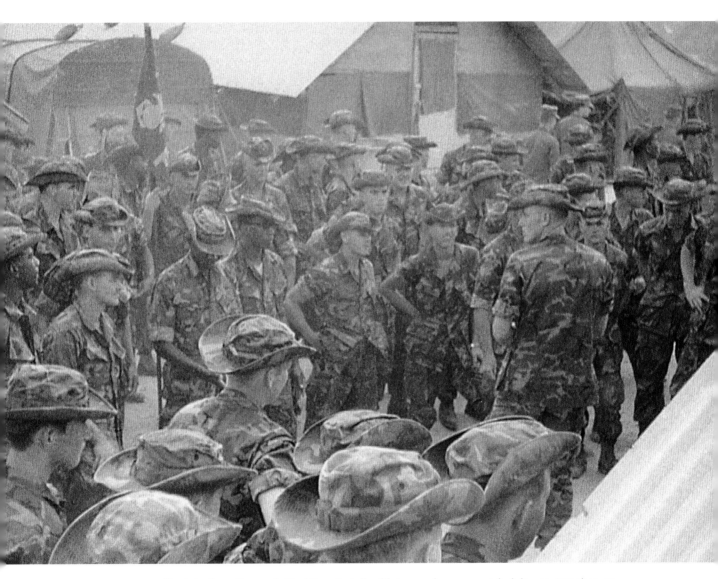

Captain Dave Brown, taking time to talk with troops he commanded. It was rare that we got pulled out of the field for a couple days at An Hoa to refit and recuperate.

Awards and promotions ceremony in the field. Two of these men would be killed by a booby trap the next day; another would have his eyes blown out of his head by a booby trap the next month. There were to be too many more.

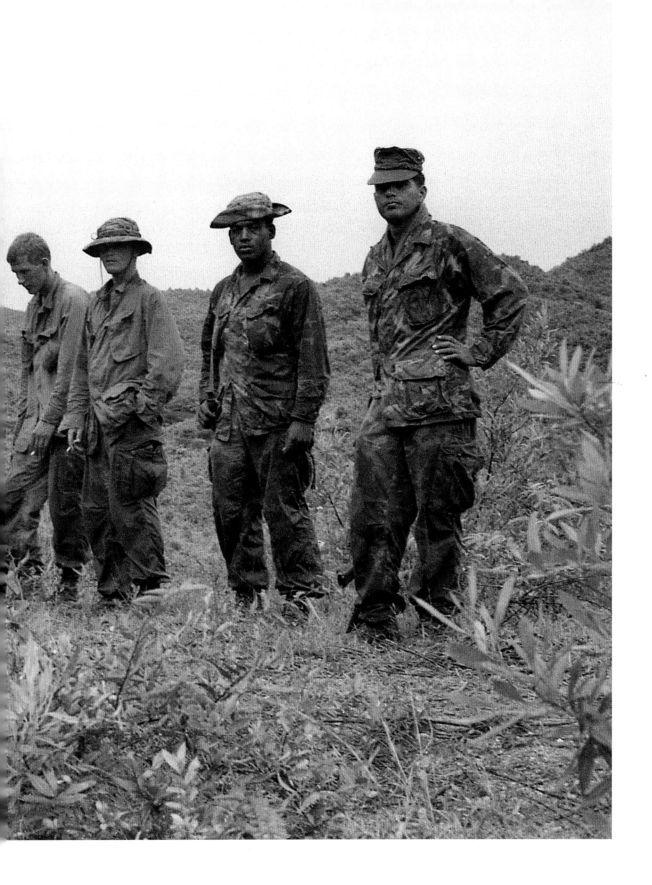

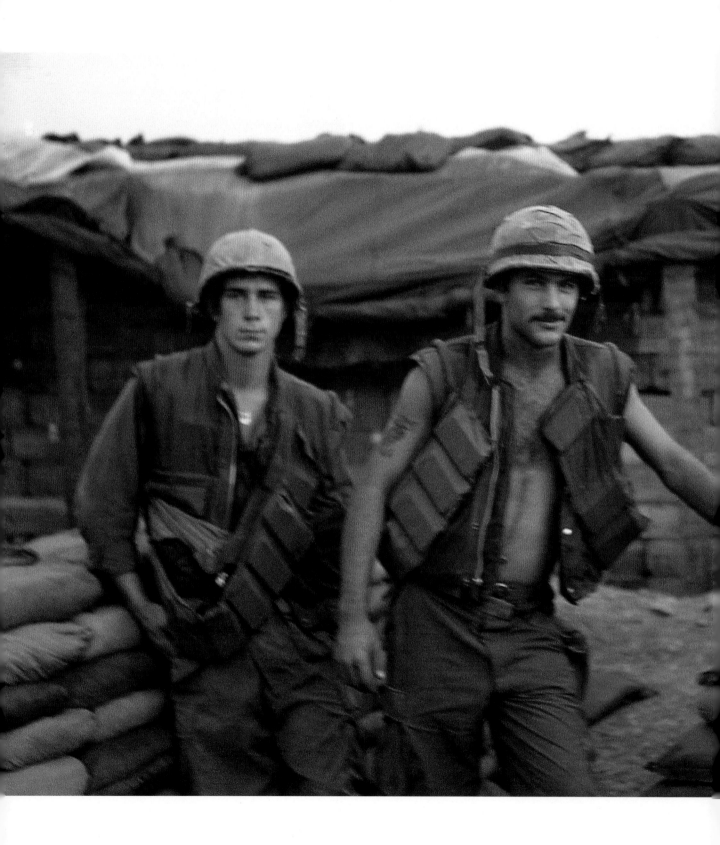

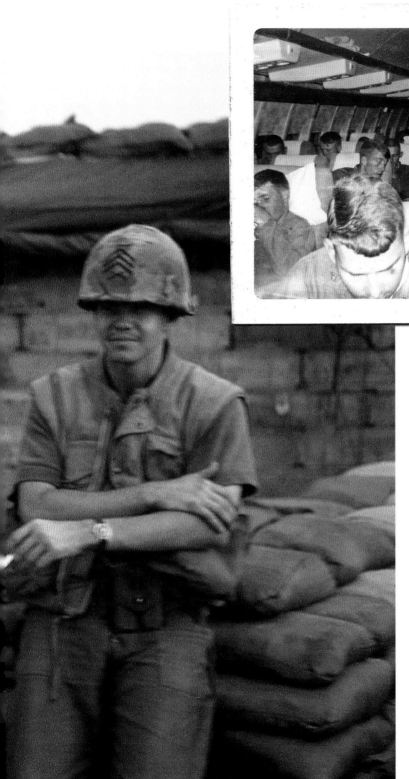

We went there together, but we came home alone.

The three amigos: John Hehr, myself, and Keith Frutchy, three artillery forward observers from Echo Battery 2/11. John would soon save my life on the battlefield.

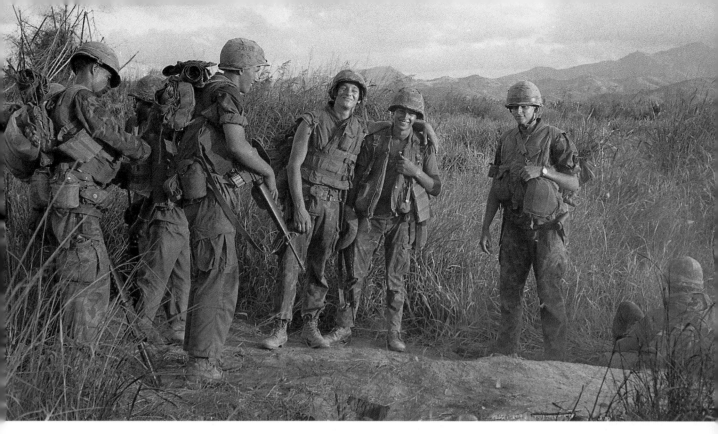

NO ONE KNOWS

No one knows how it feels
To be workin' side by side
Countin' days, monsoon mud
No one knows except for you

No one knows how I feel
With my brothers all around me
Keep me laughing, keep me high
No one knows except for you

No one knows how this feels
In the jungle every step
Is a wager with the devil
No one knows except for you

No one knows how it feels
Hell breaks loose and the bullets fly
A brother dying, am I crying
No one knows except for you

You're my brothers, you're my friends
Like I'll never have again
Men I'd die for if I was called
No one knows except for you

No one knows how it feels
Heading home with solemn vows
To remember to get together
No one knows except for you

No one knows how it feels
Seeking peace and reaching out
Pull together or let it go
No one knows except for you

You're my brothers, you're my friends
Like I'll never have again
Men I'd die for if I was called
No one knows except for you

—Marc Waszkiewicz and Lea Jones

A kaleidoscope
of people thrown
into the Jiffy Pop
pressure cooker
of war creates
comrades.

TWILIGHT

AS DAYLIGHT FADED, OUR MINDS FILLED IN THE BLANKS. REAL AND SURREAL BECAME ONE.

IMPRESSIONS

Day is done, gone the sun . . . "Taps" is ceremonially played at the official end of the military day, as well as at military funerals.

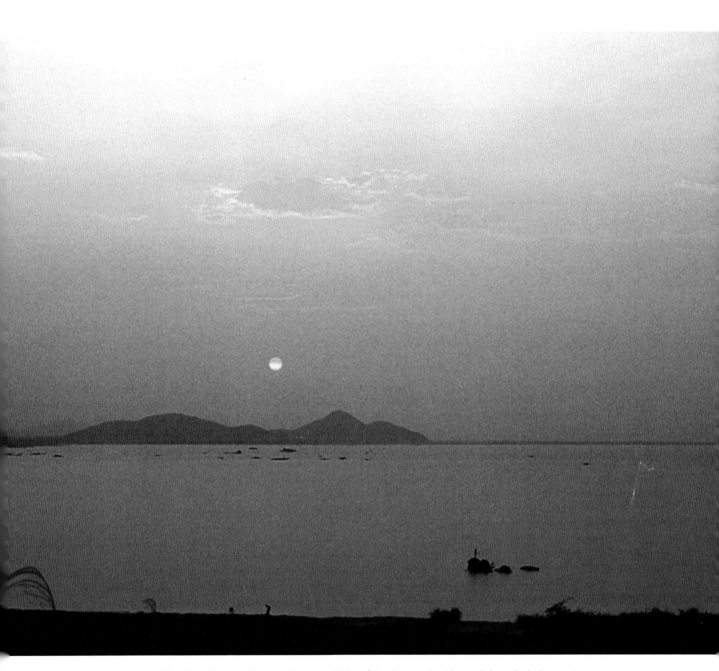

Cau Doi Bay looking north toward Hue City, the ancient imperial capital—home to
the kings of Vietnam's antiquity and the focus of the Tet Offensive in 1968, the
largest operation and turning point of the war.

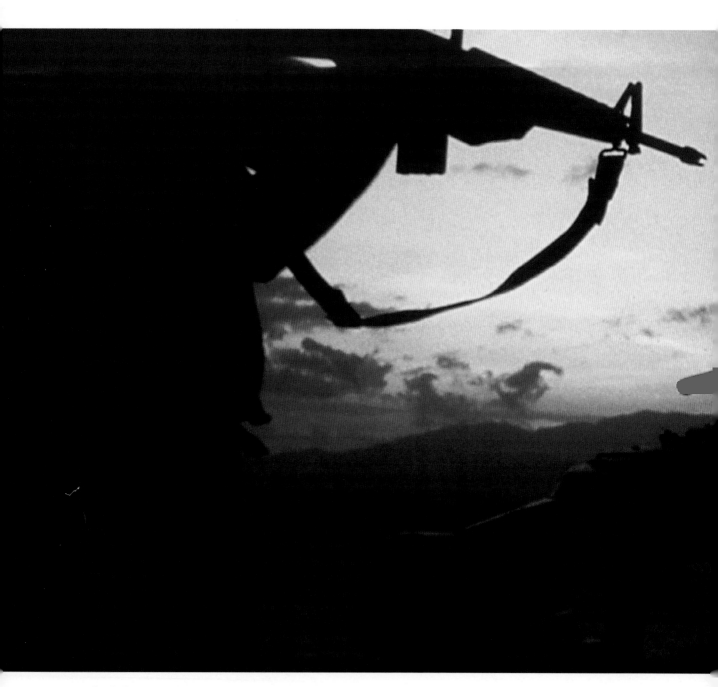

As darkness settles over an unsettled land . . .

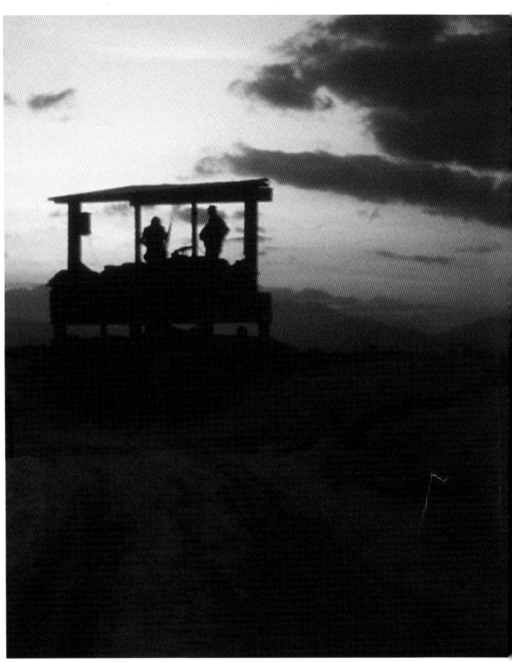

Two men up, two men down (asleep in the bunker below), we stand watch on the base perimeter nightly.

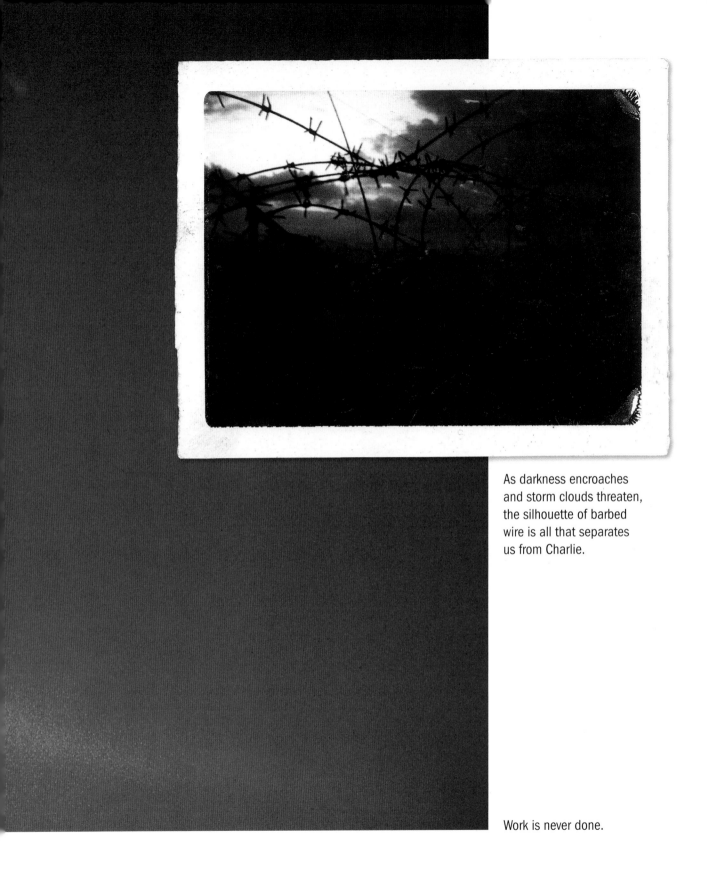

As darkness encroaches and storm clouds threaten, the silhouette of barbed wire is all that separates us from Charlie.

Work is never done.

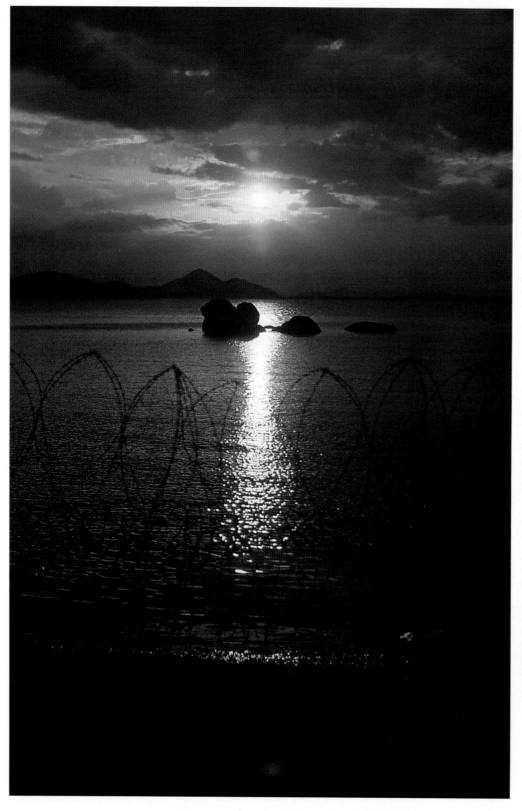

Paradise
denied

Our battalion "911 radio operators"—hope you're having a quiet night in the field!

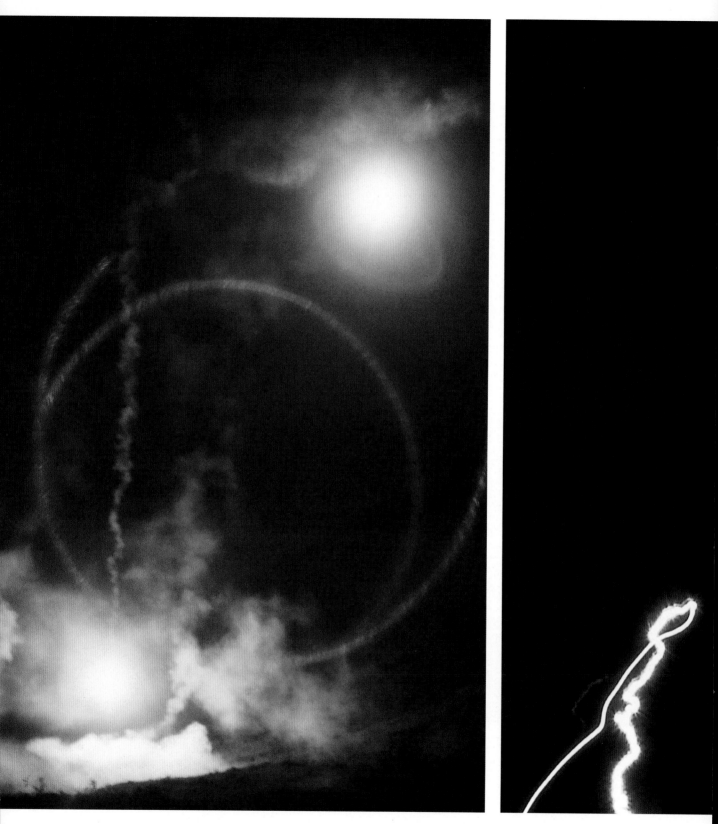

Nighttime illumination flares diminish Charlie's nocturnal advantage.

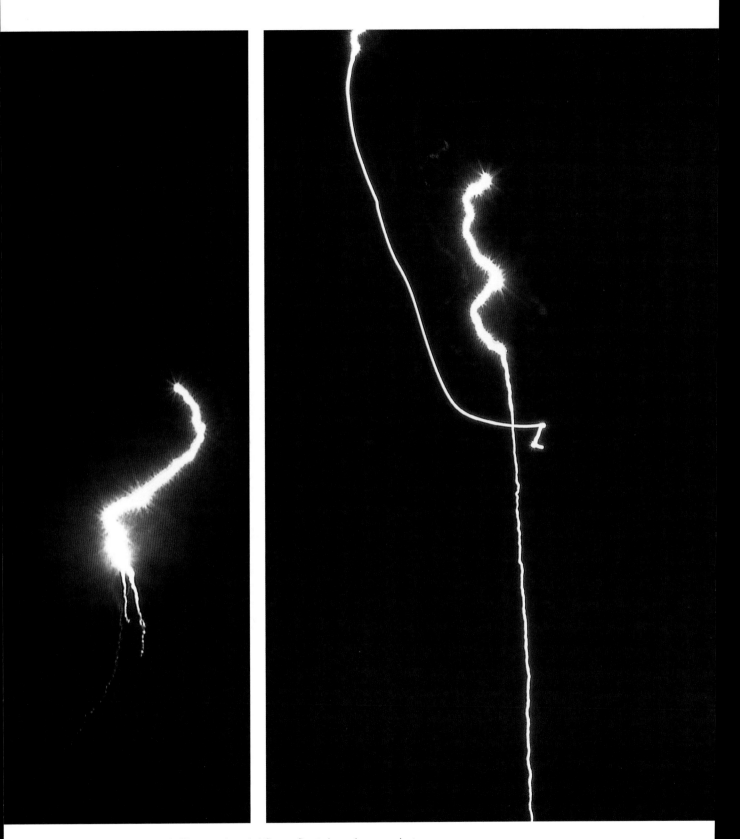

Artillery and aerial flares float down by parachute.

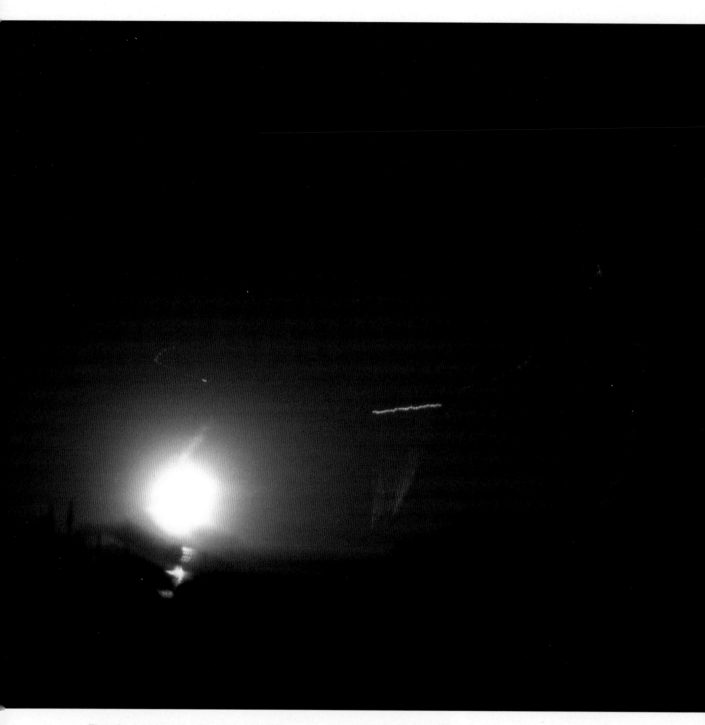

Time-lapse shot of a Douglas AC-47 Spooky—also called "Puff the Magic Dragon"—circling a nighttime engagement and dropping illumination flares. Note the mini-gun burst.

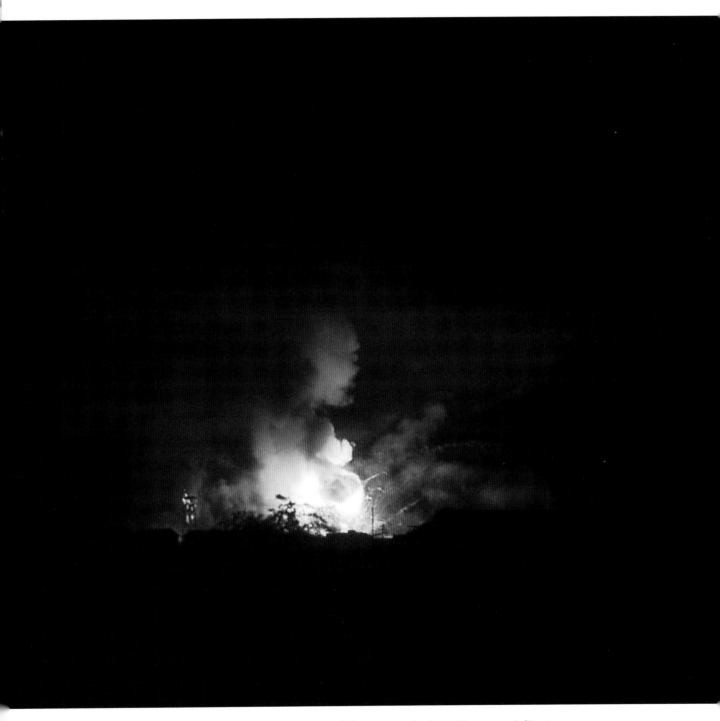

Artillery ammunition dump exploding as a result of suicide sapper infiltrators. The 40-foot air traffic control tower in flames on the left gives a sense of the magnitude of the flames and explosions.

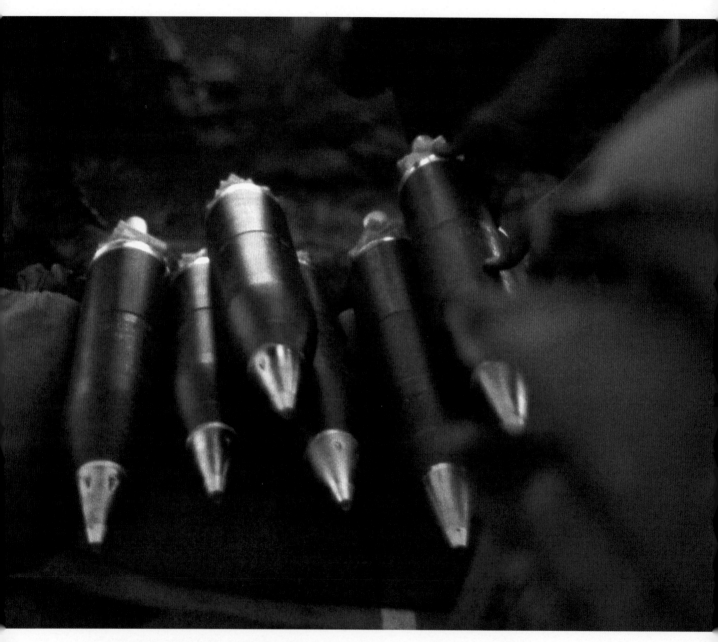

Four-Deuce mortar rounds ready to go. The 4.2-inch mortar is considered an artillery piece, comparable to a 105mm howitzer.

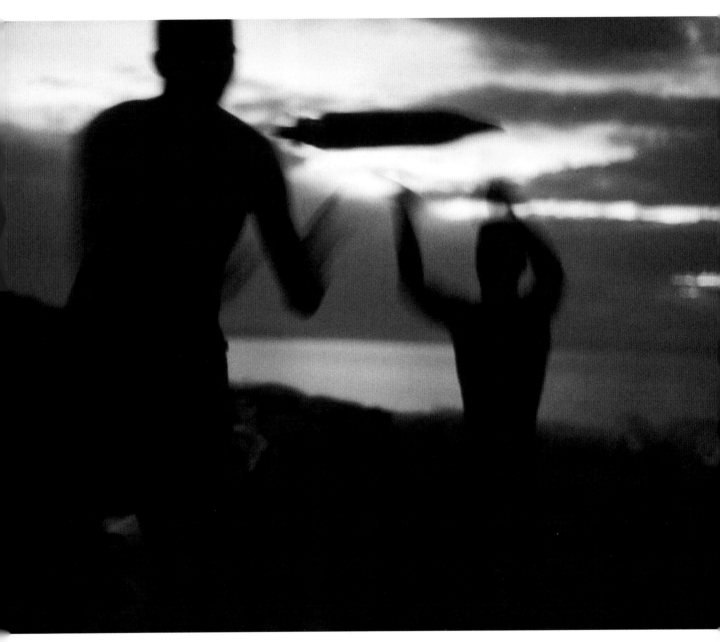

Hustling live fused rounds to the gunner

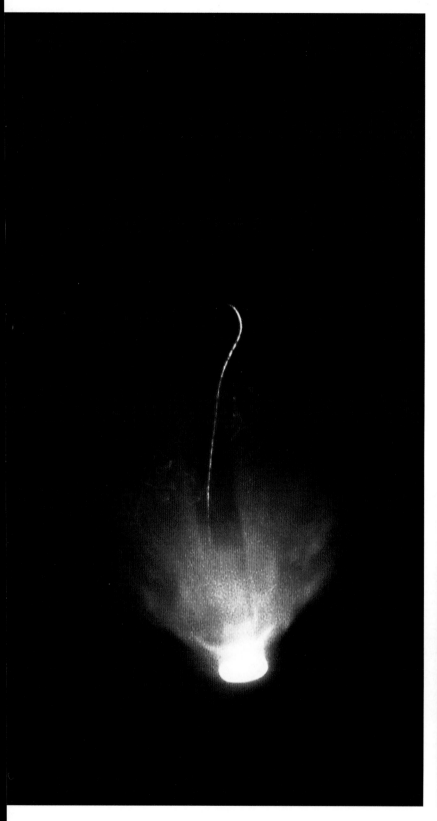
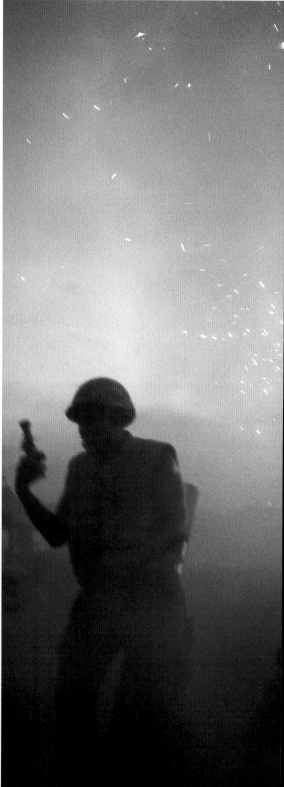

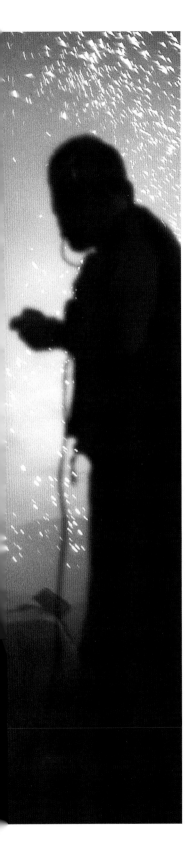
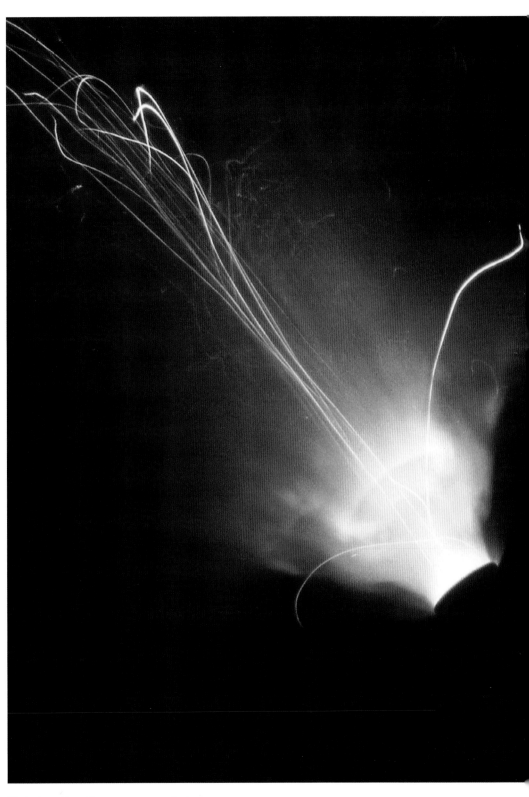

Nighttime Four-Deuce mortar mission

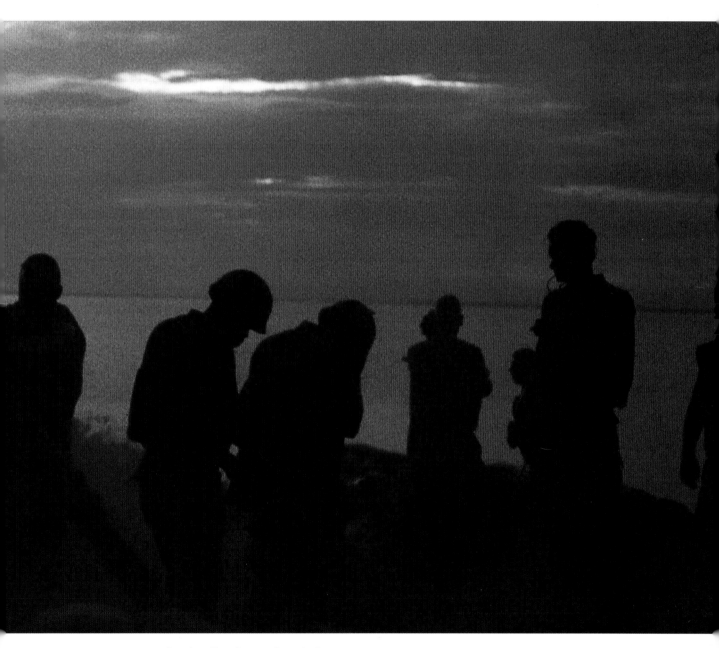

Another Four-Deuce fire mission

UNDER FIRE

THOSE BRIEF, UNPREDICTABLE, AND INTENSE MOMENTS WHEN VULNERABILITY REPLACED BRAVADO. IN THOSE MOMENTS, A MAN'S TRUE CHARACTER WAS REVEALED.

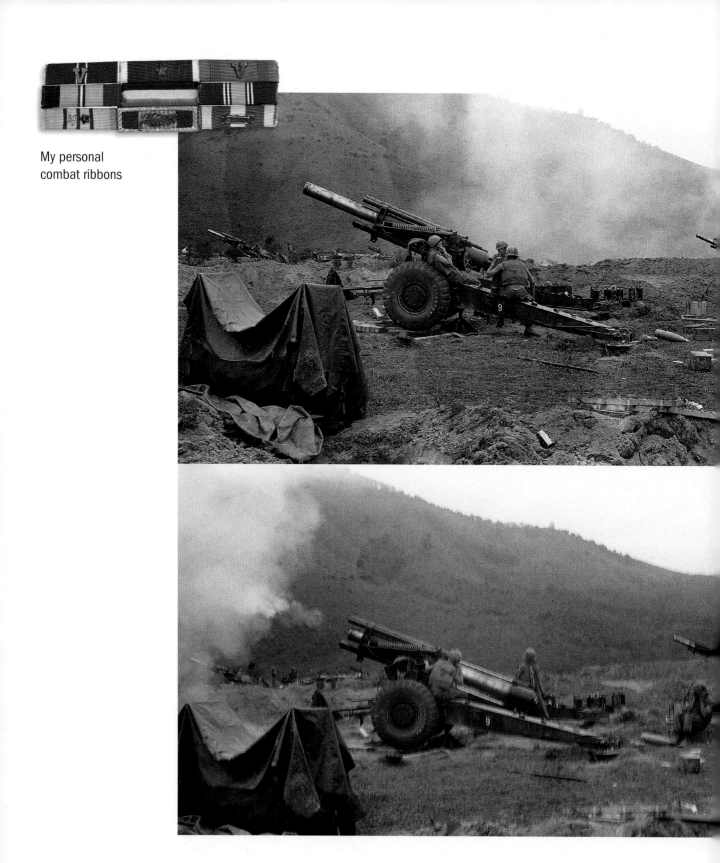

My personal
combat ribbons

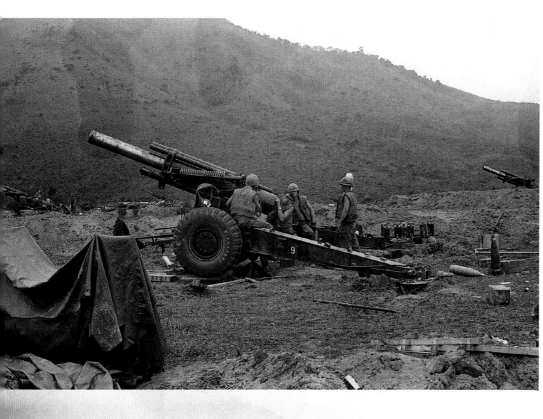

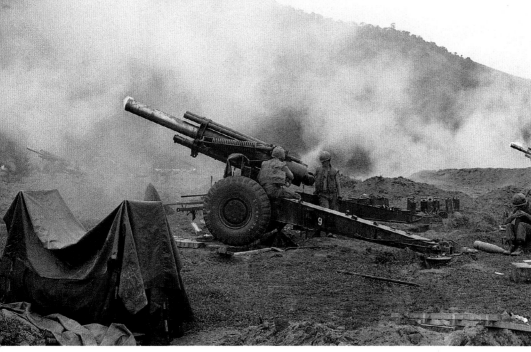

155mm towed
howitzers in action

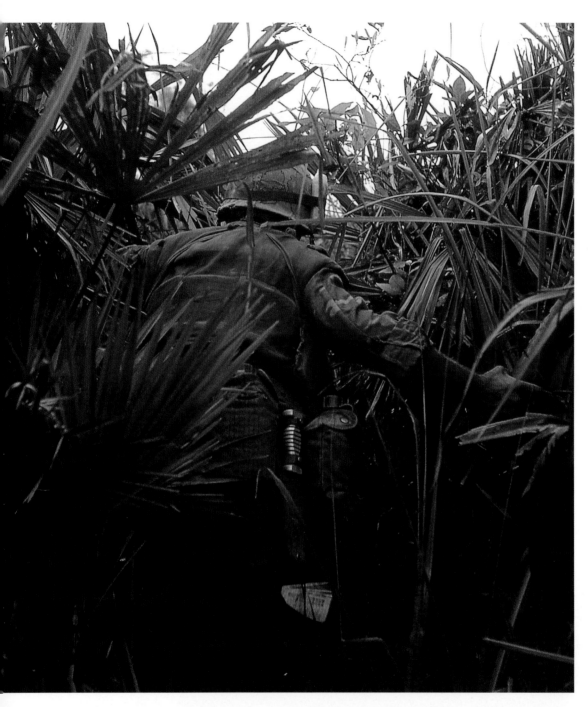

Our advance takes us through such dense jungle that I asked the Marines behind to take my picture to show how hard it could be to find anything, much less a skillful enemy. My father made that knife for me, and my mother crafted the scabbard, which I still have.

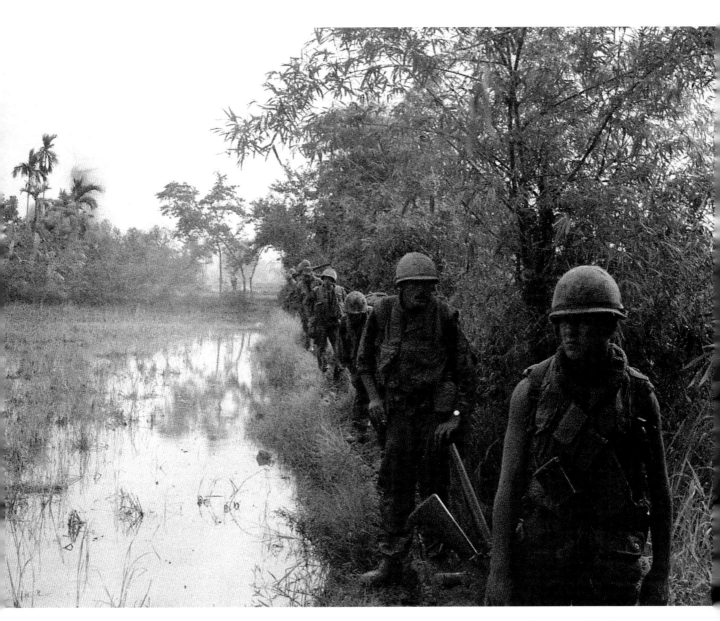

Search and destroy

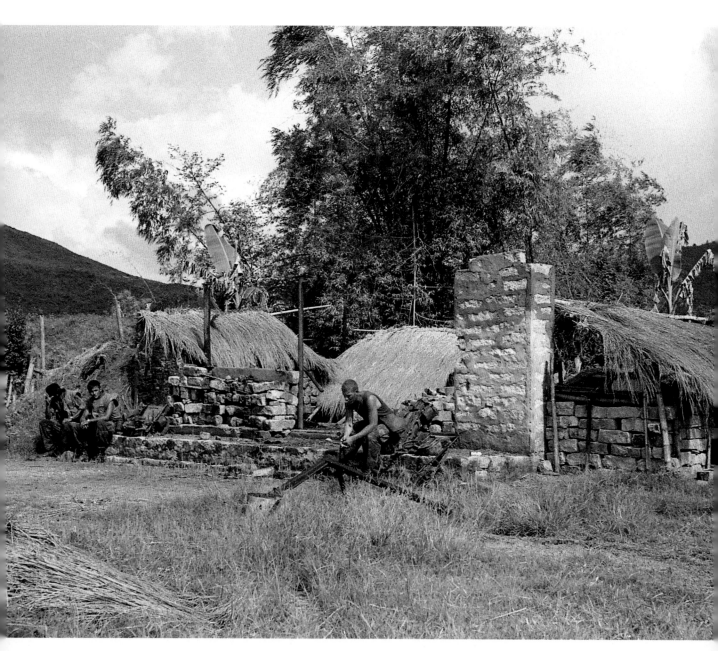

Battle-weary troops take a rest among the rubble of another artillery mission.

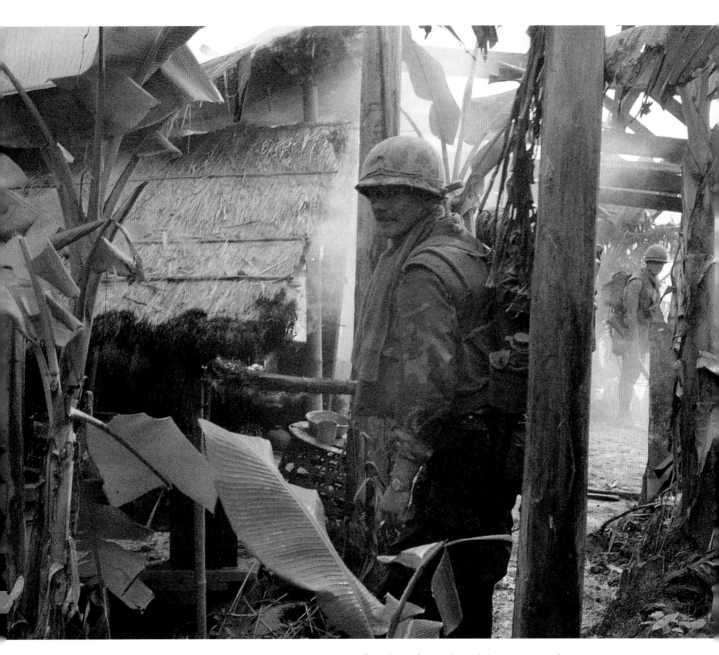

Zippo up! Burning hooches was a key function of search-and-destroy operations.

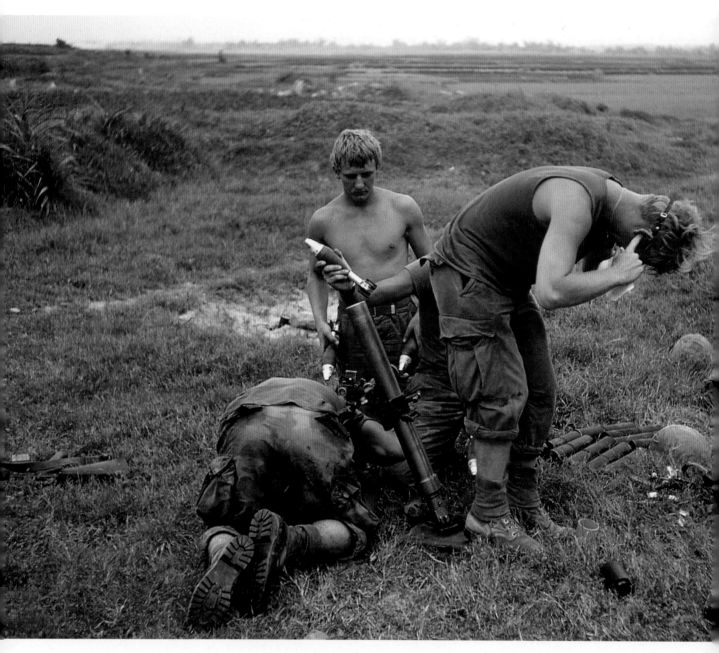

A 60mm mortar live-fire mission. These mortars were small enough that
we carried them in the field for close support.

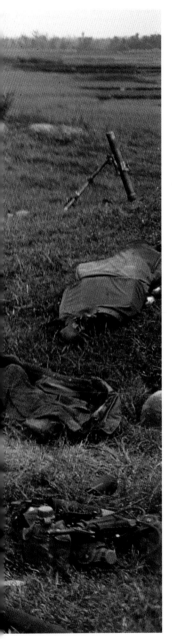

OV-10 Bronco aerial observer spotter plane

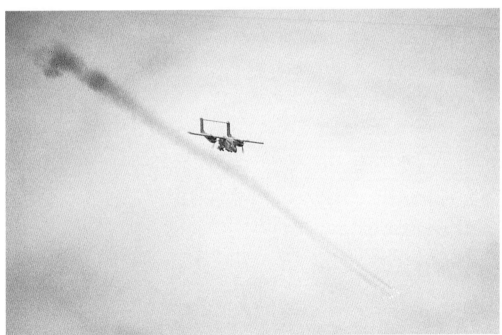

Firing rockets to mark targets for an air strike

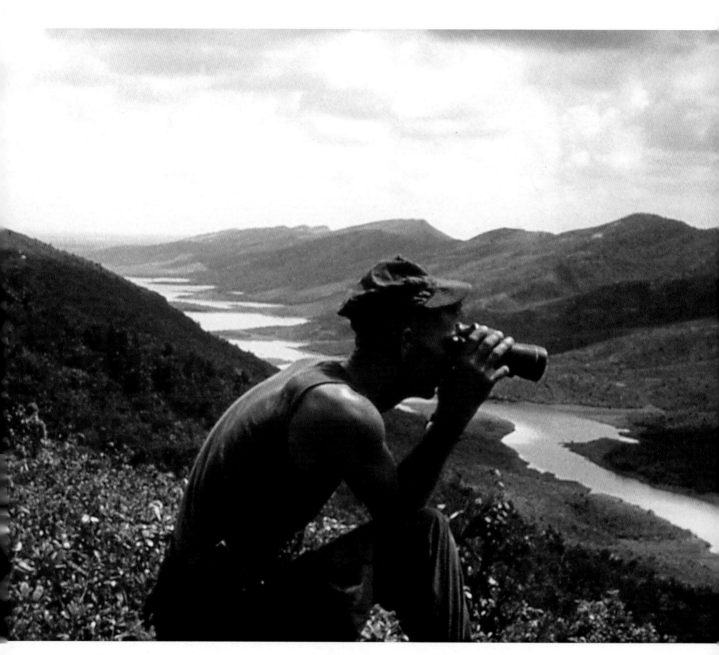

Observing enemy troop movements in the valley below

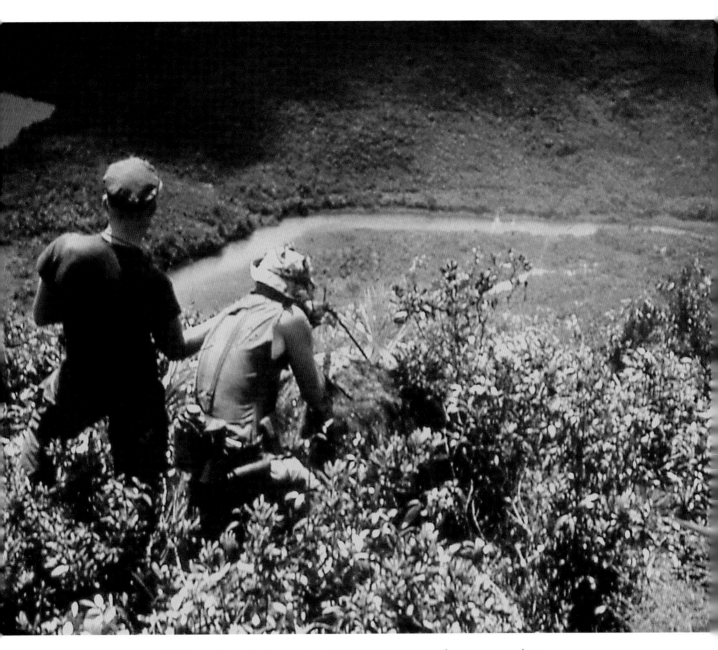

M-60 machine-gun team waxes enemy troops attempting to cross a river.

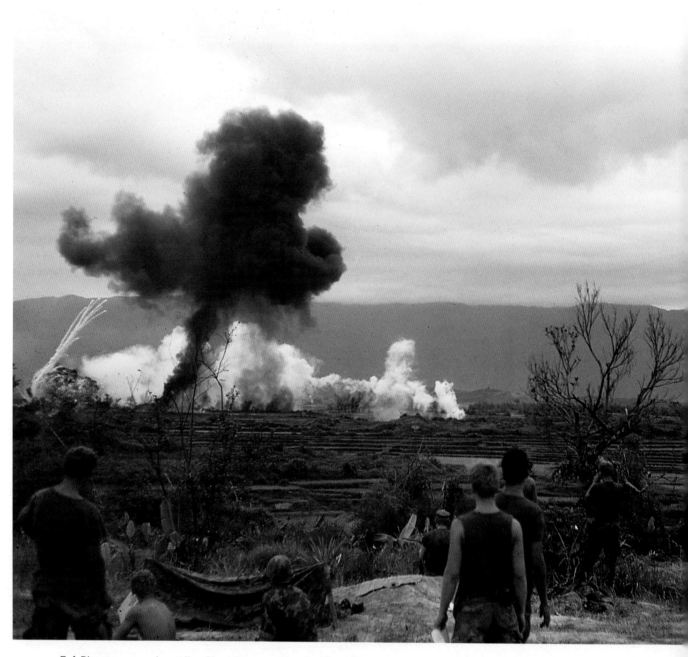

F-4 Phantom napalm strike. Air strikes combined with artillery were a powerful one-two punch.

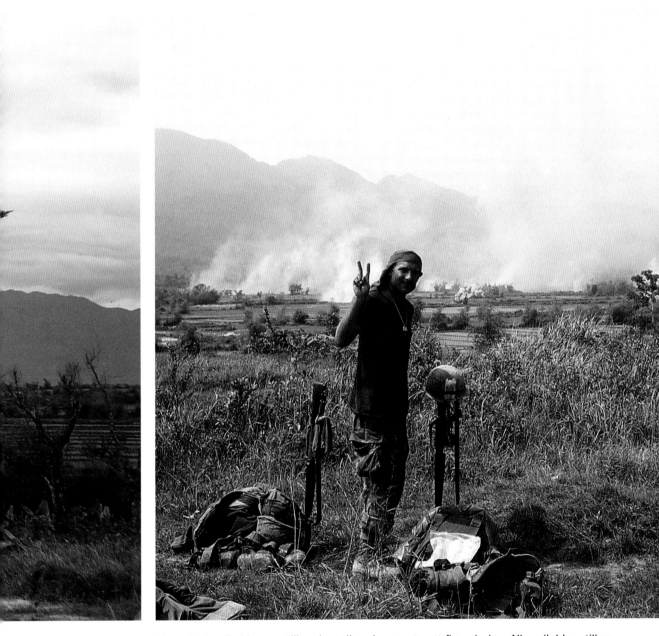

I have just called in an artillery battalion time-on-target fire mission. All available artillery batteries are brought to bear on one unsuspecting target, coordinated so all rounds land at the same moment.

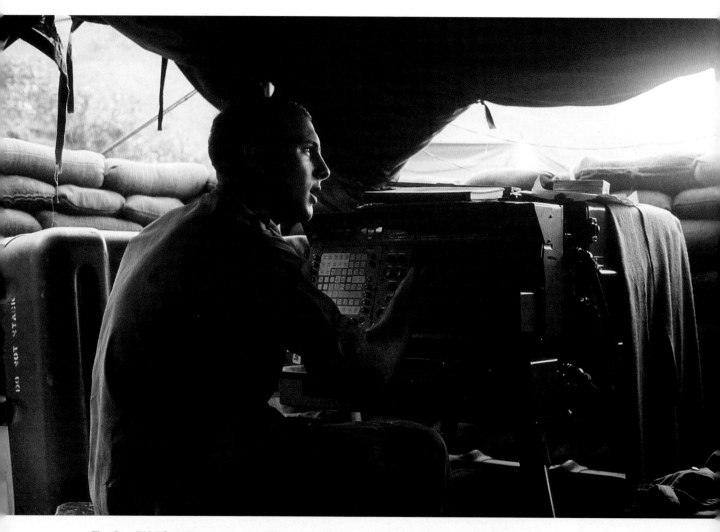

The first FADAC artillery computer. This was supposed to be an officer's job, but the Marine Corps didn't believe in computers, so even though I was an E-3 lance corporal at the time, I was designated the battalion FADAC training officer.

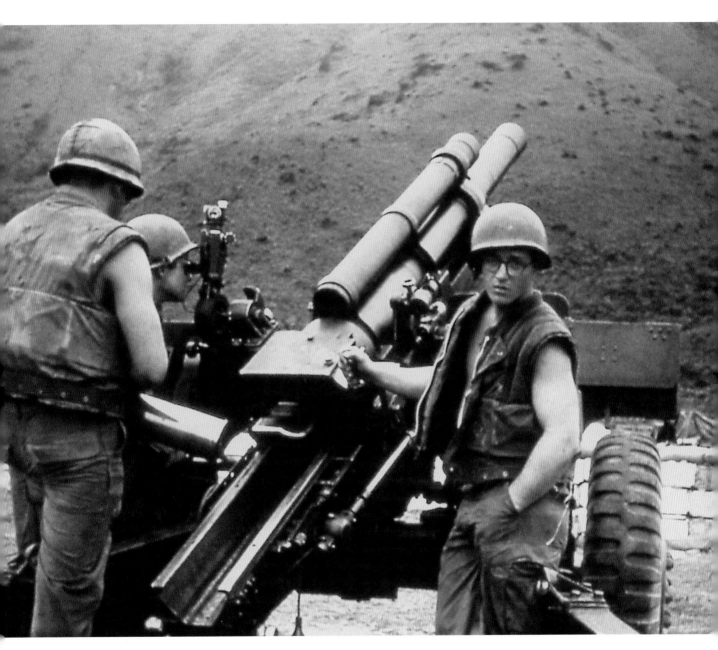

Artillery applications

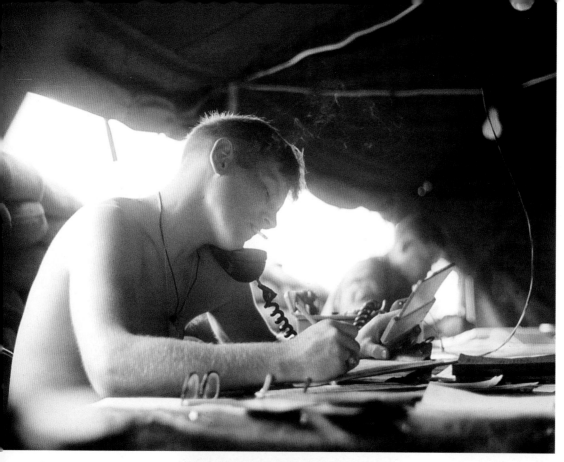

Relaying data to
the guns: elevation,
deflection, charge,
shell, fuse

Calculating range to a target

A 155mm self-propelled gun. Just like a 155mm howitzer, only on a tanklike body, affording greater mobility and crew production.

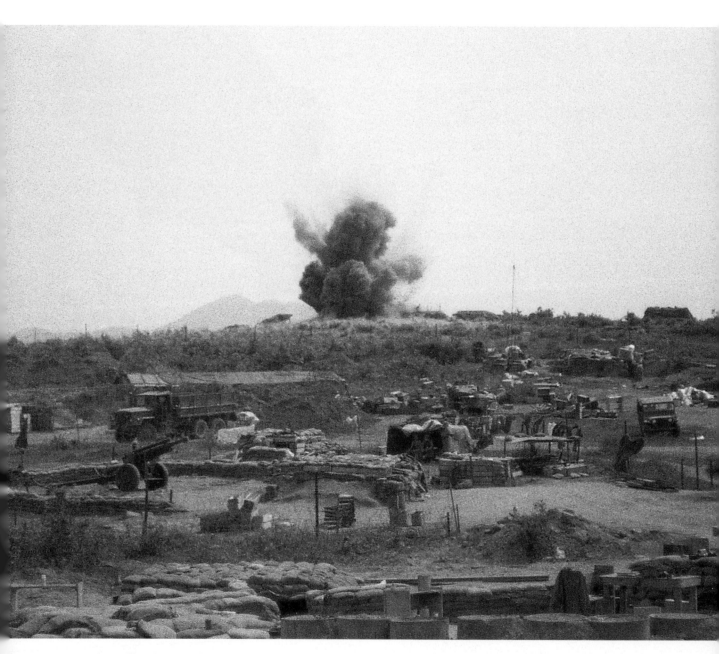

An artillery base under attack

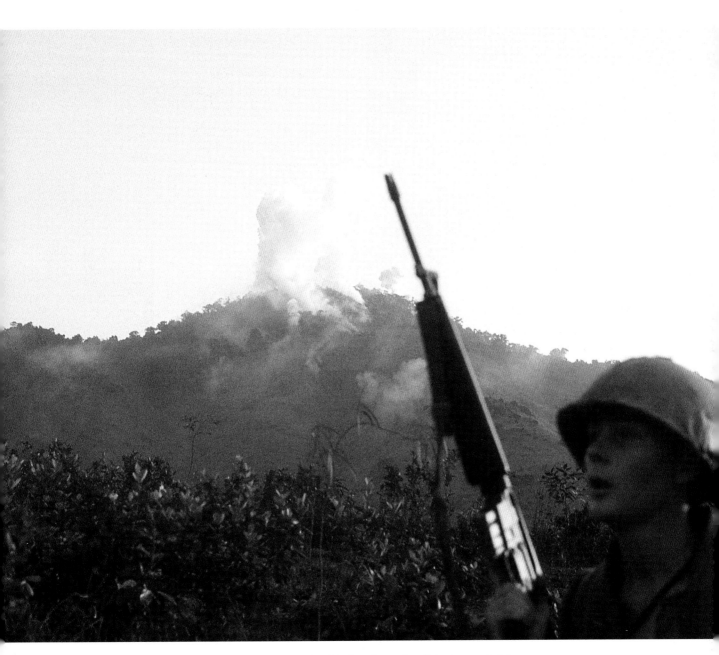

Another base, another attack—this time from the distant mountaintop

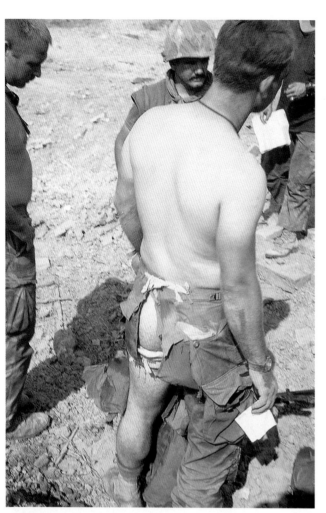

Ron Readon, a hometown buddy of mine from before either of us was a Marine. He was with our infantry company only a few weeks when he was shot through both buttocks. One bullet, four bullet holes—no permanent damage except to his pride. I ran into him shortly after we both got discharged, and I shared this and other photos with his fiancée.

More search and destroy: a burned-out hooch

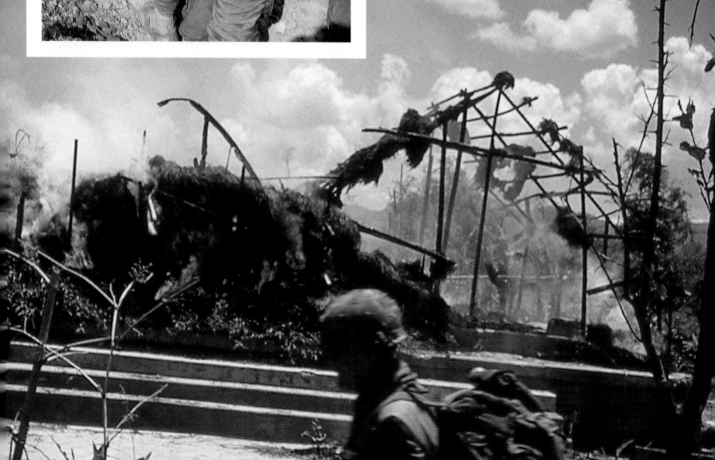

The aftermath of one of my artillery fire missions. When planning an advance through a likely ambush spot, obliterating the foliage (and anyone hidden there) was a reasonable precaution.

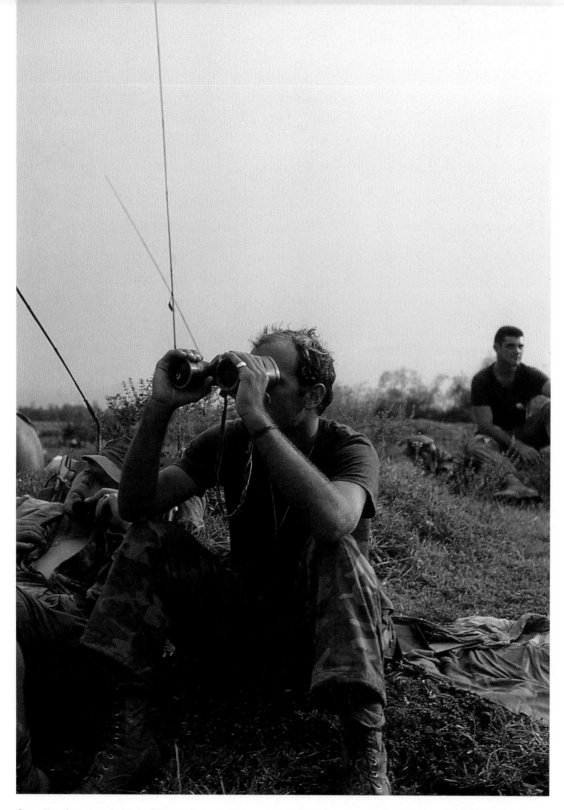

Coordinating the multiple flight paths of artillery being fired from multiple locations. The AO (aerial observer) directs the helicopter gunships and F-4 Phantom jet low-altitude bombing and strafing runs. We coordinated "pathways in the sky" for one another in order to avoid shooting down our own aircraft.

DOWNTIME

SIT BACK, RELAX,
AND LET YOUR MIND UNWIND. . . .

My weeklong R&R pass. From Hawaii I flew home to California to hook up with my fiancée. This was strictly forbidden, and if caught, the penalty would have been severe. She was worth it.

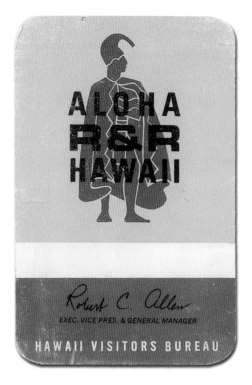

Mail call! This is the same bunker shown earlier on page 20.

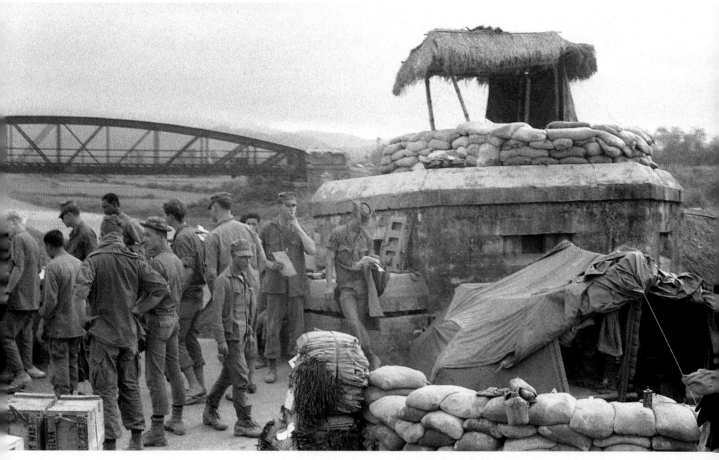

Thinking of home

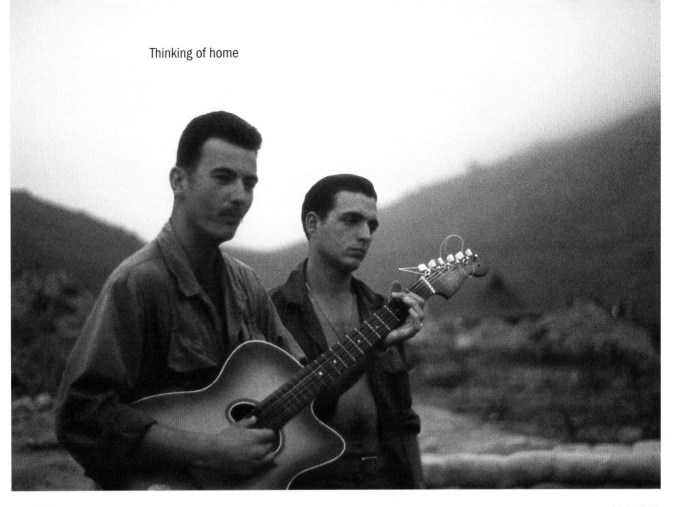

Singing the blues

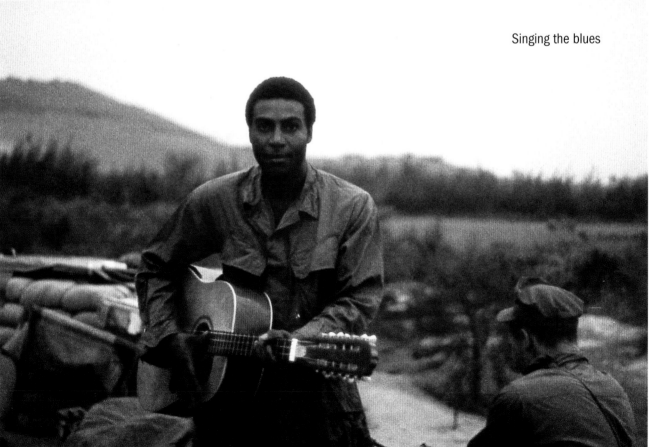

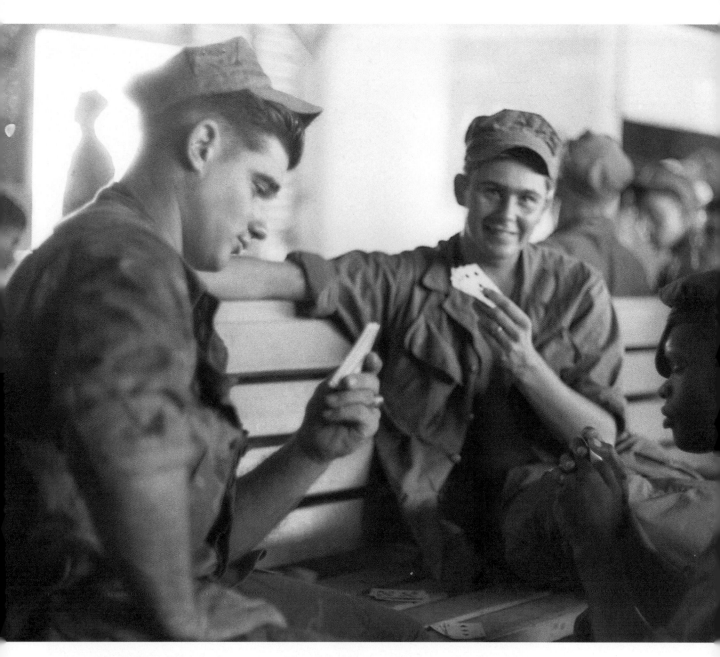

We waited for flights for hours, sometimes all day. Playing cards helped pass the time.
Cheating was encouraged.

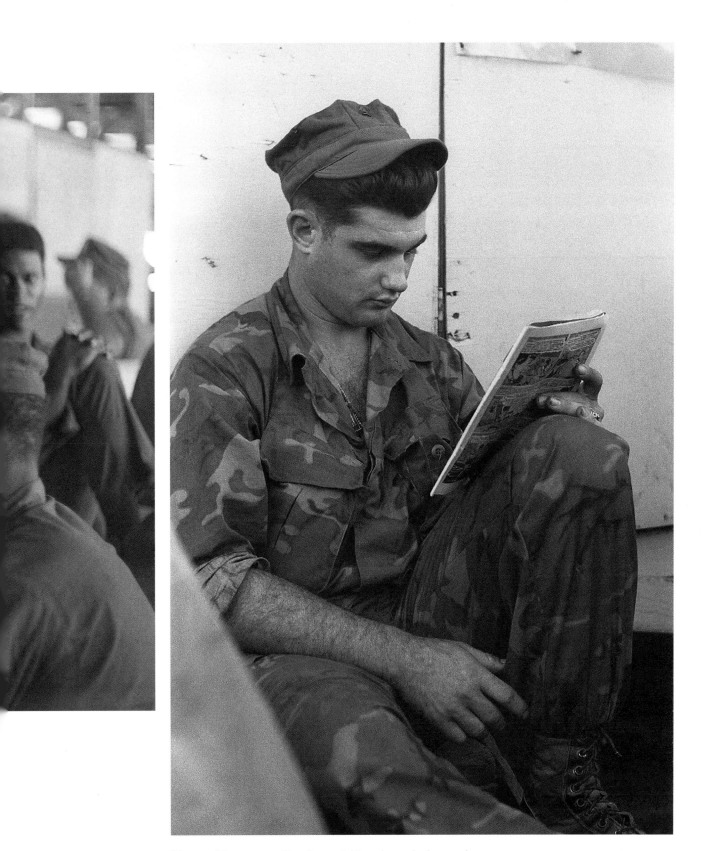

After a while, escape literature might replace playing cards.

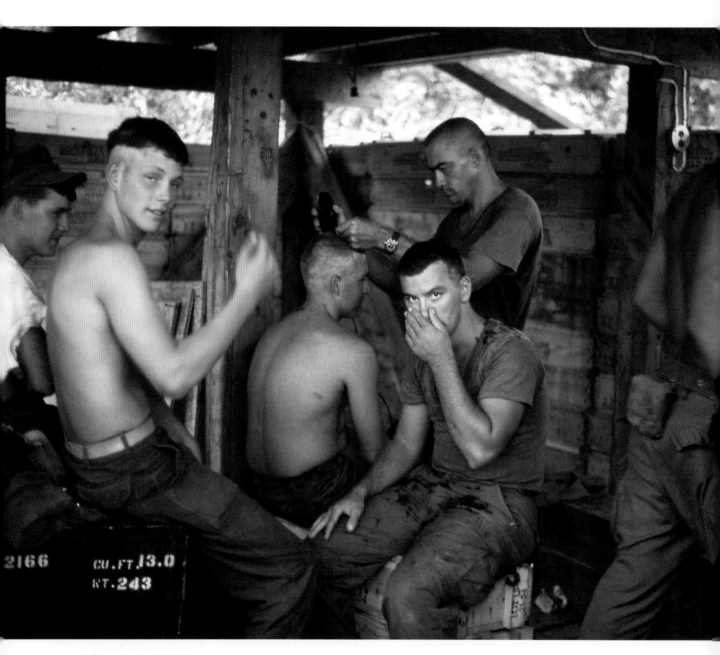

Homegrown haircuts

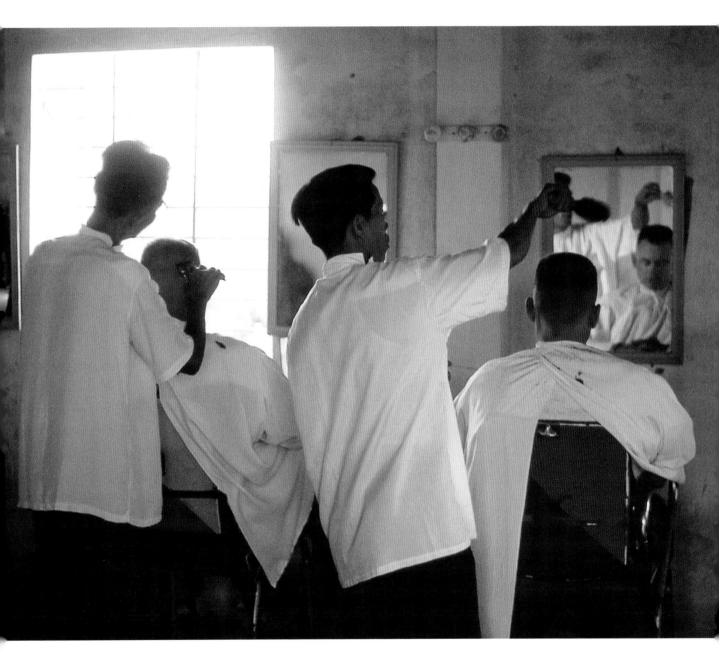

Downtown haircuts were always a good excuse for getting lost for the rest of the day.

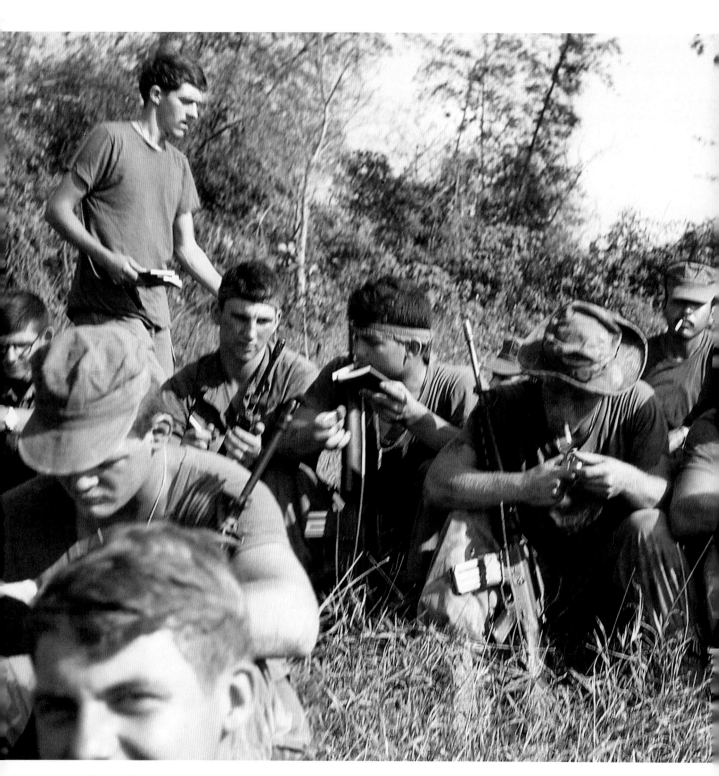

The perfect congregation—one foot in heaven, one foot in hell

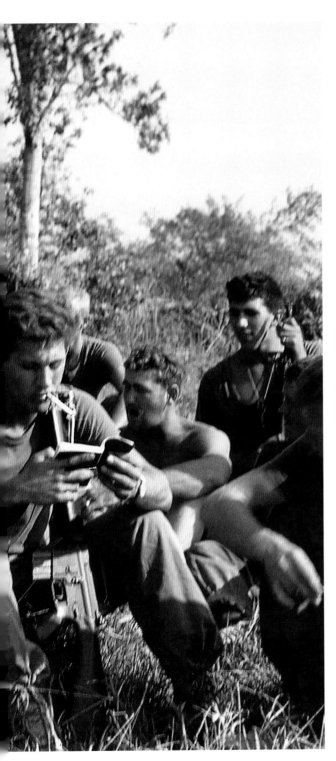

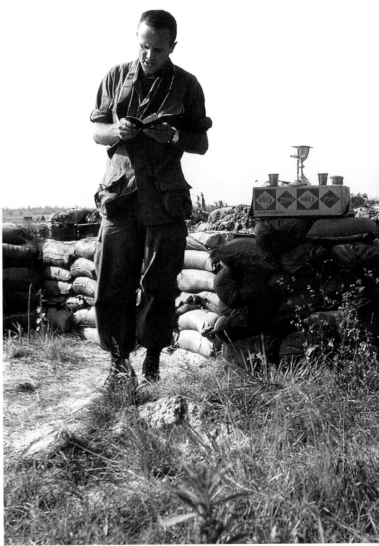

The seldom-seen chaplain in the field. He was always well received and embraced by the troops.

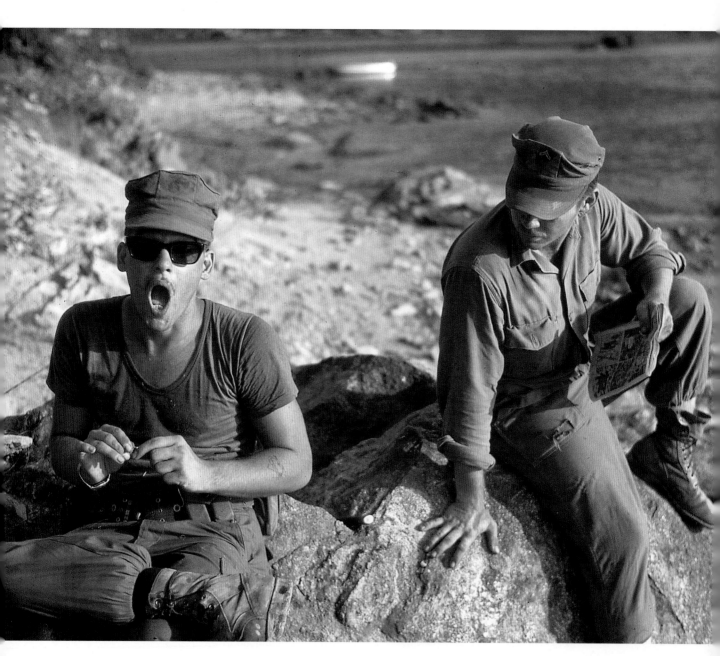
Two stoned friends relax on the beach.

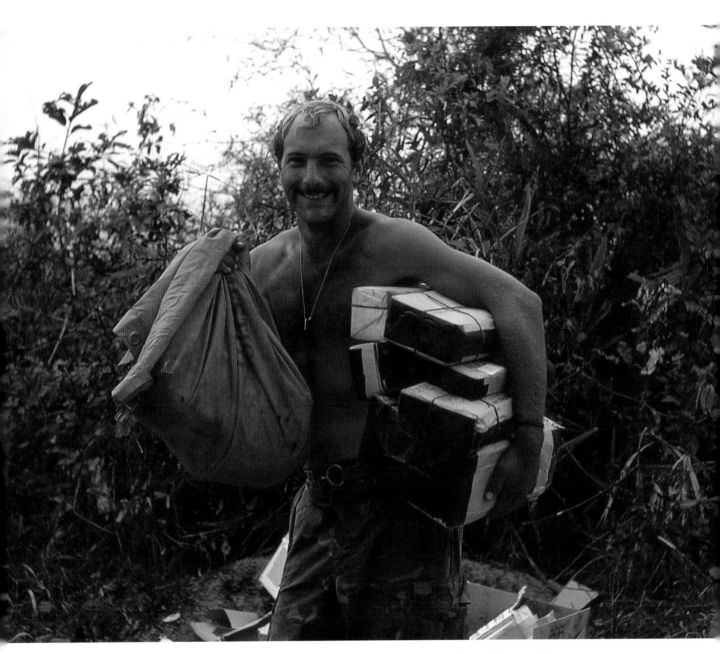

During this time, fighting was heavy, and other priorities prevented mail delivery. When mail finally came, this was my personal portion, right off the chopper. My mom was really worried about me and tried her best to keep me stocked up on contraband treats like whiskey or wine and the usual Pogey Bait (as we called candy, condiments, and other treats).

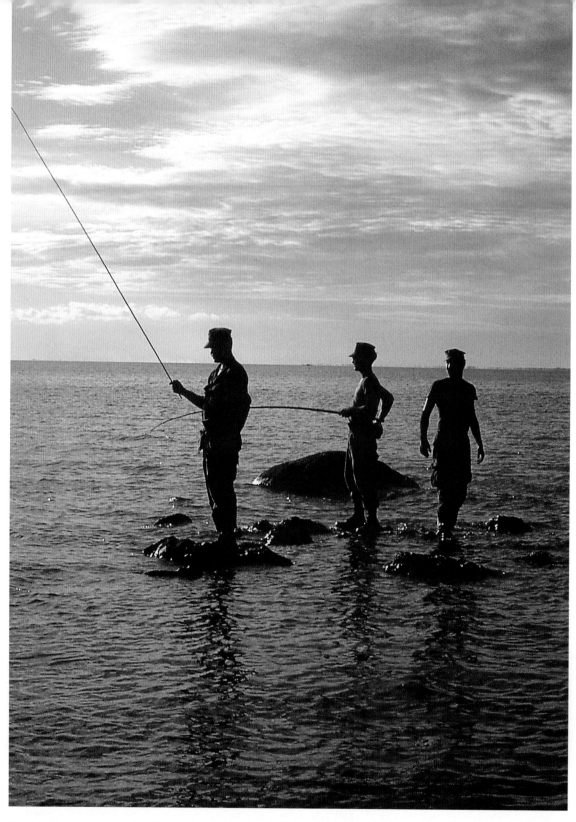

Smoking joints while pretending to fish. We had neither fishing line nor hooks, but this ploy kept the "lifers" at bay while we tripped out.

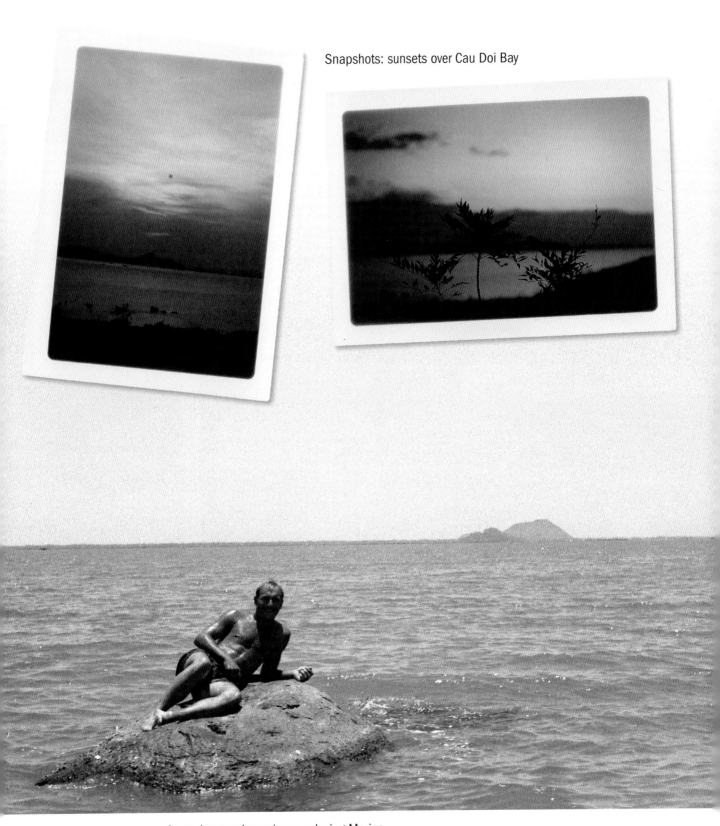

Snapshots: sunsets over Cau Doi Bay

An endangered species: a relaxing Marine

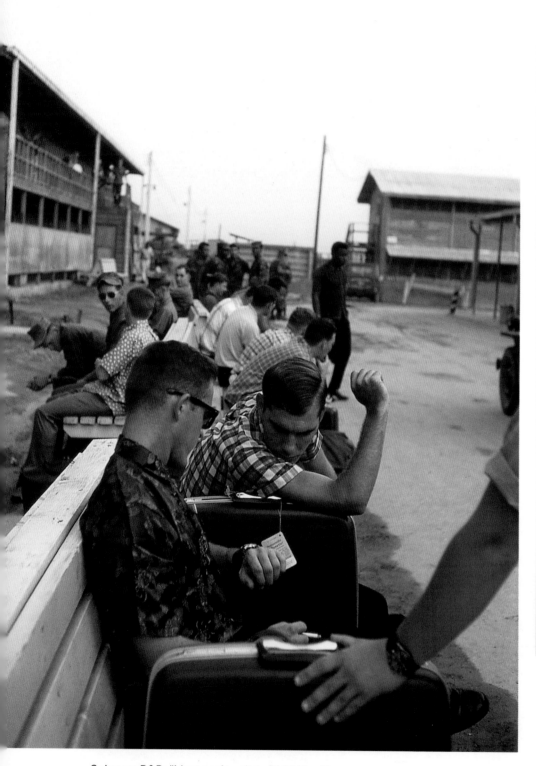
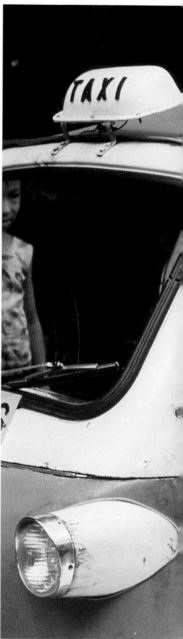

Going on R&R: "I just can't wait to Di Di Mau!"

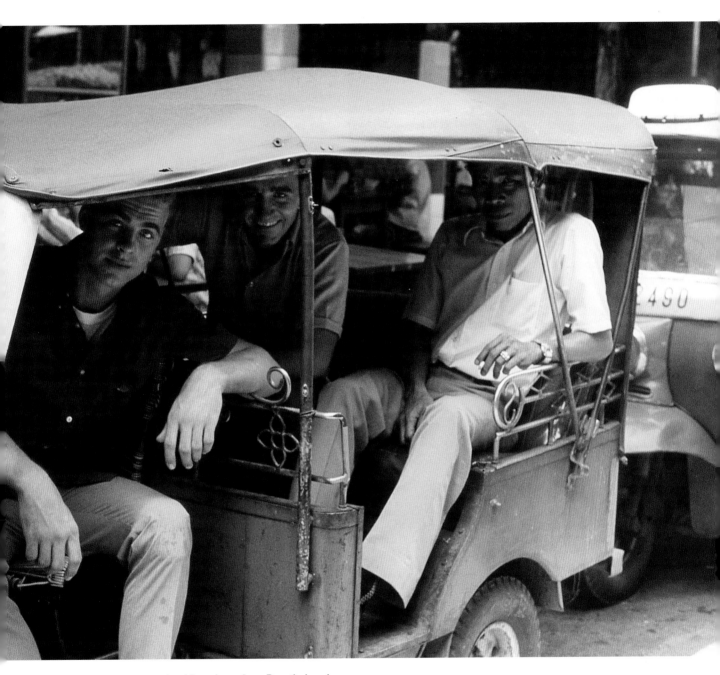

Looking sharp in a Bangkok cab

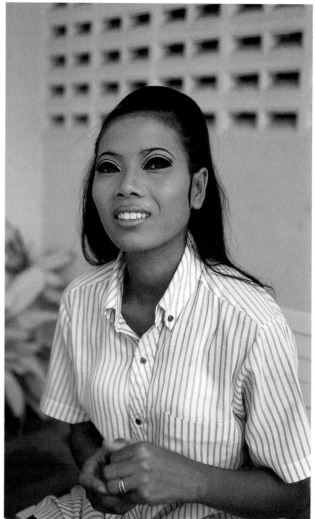

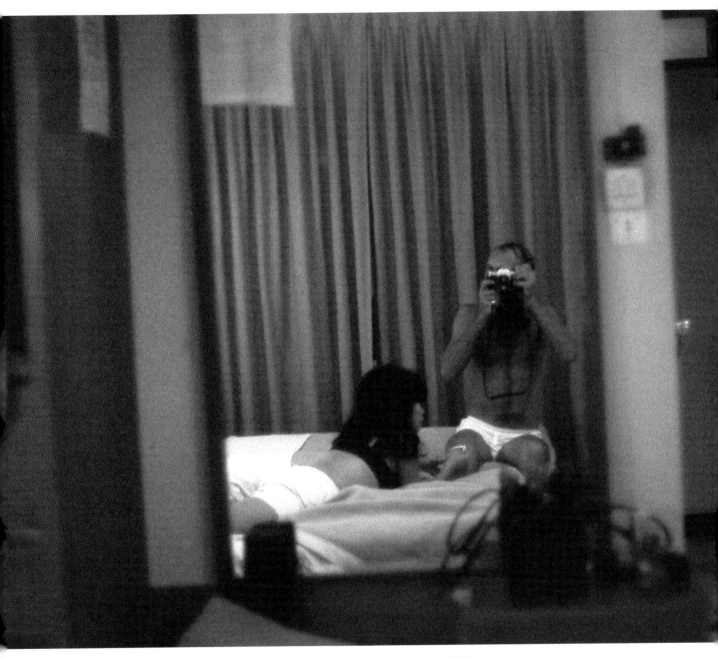

Some of my "temporary girlfriends" while on Bangkok R&R

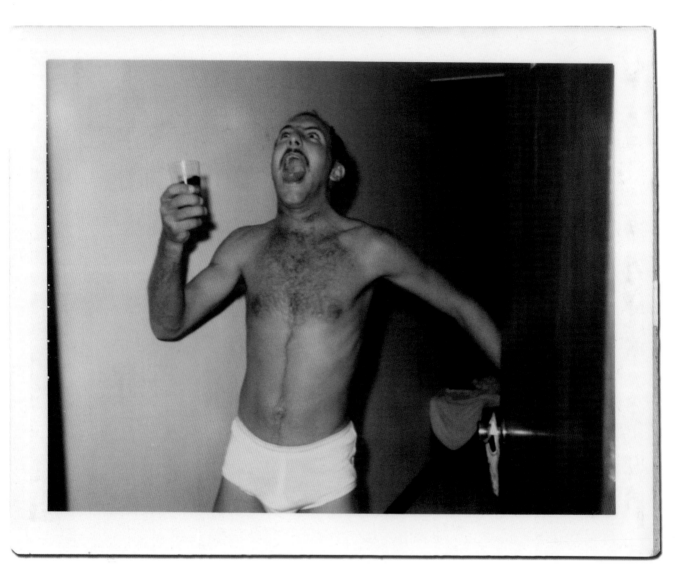

"Let's PAR-TAY!" Bangkok, 1969.

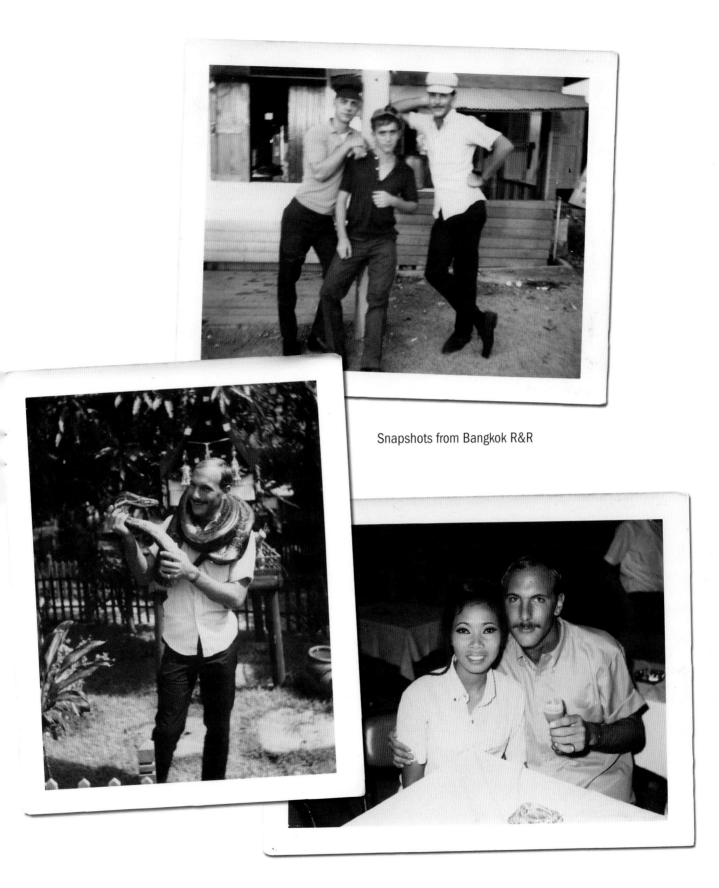

Snapshots from Bangkok R&R

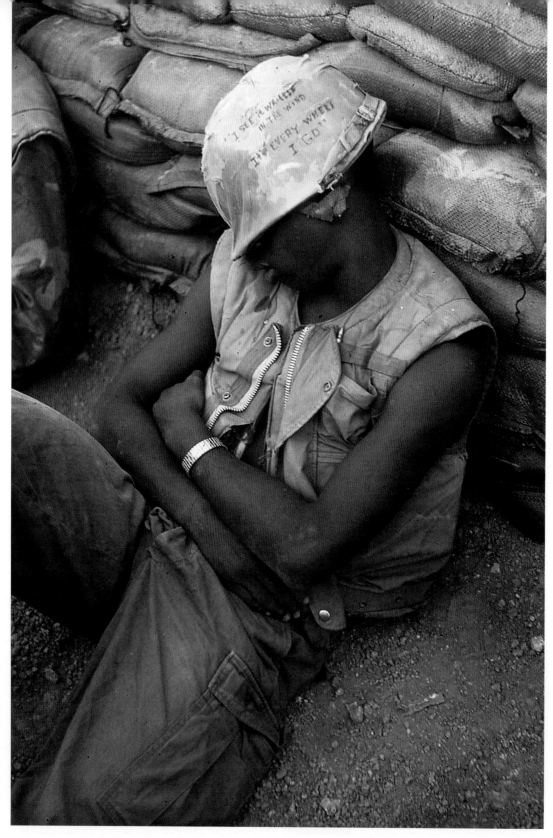

Coppin' Zs where ya can, when ya can

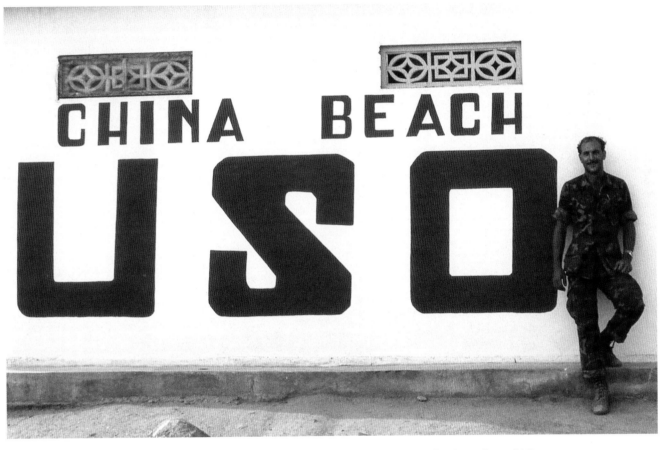

China Beach in-country R&R: barbecue steaks, surfboards, and Frisbees for three days of bliss

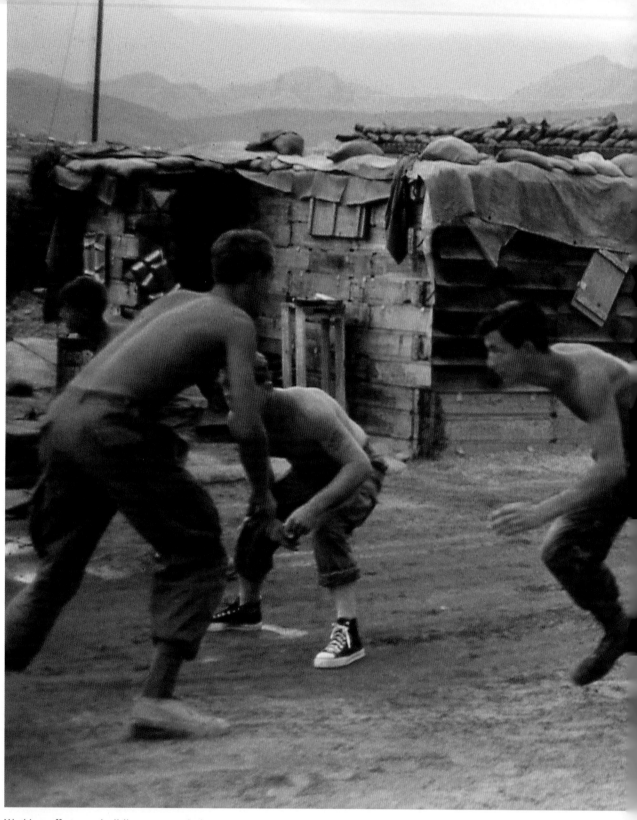

Working off stress, building camaraderie

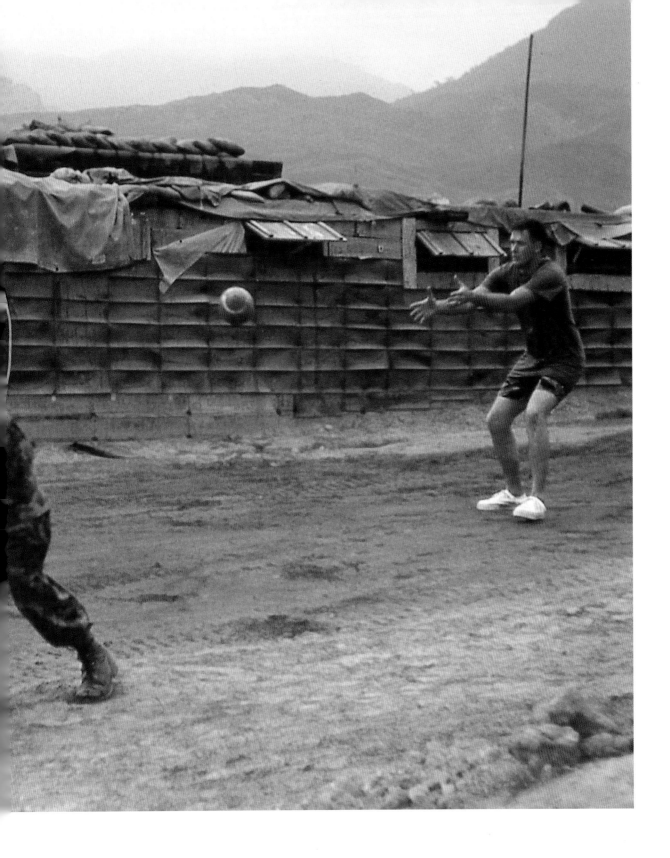

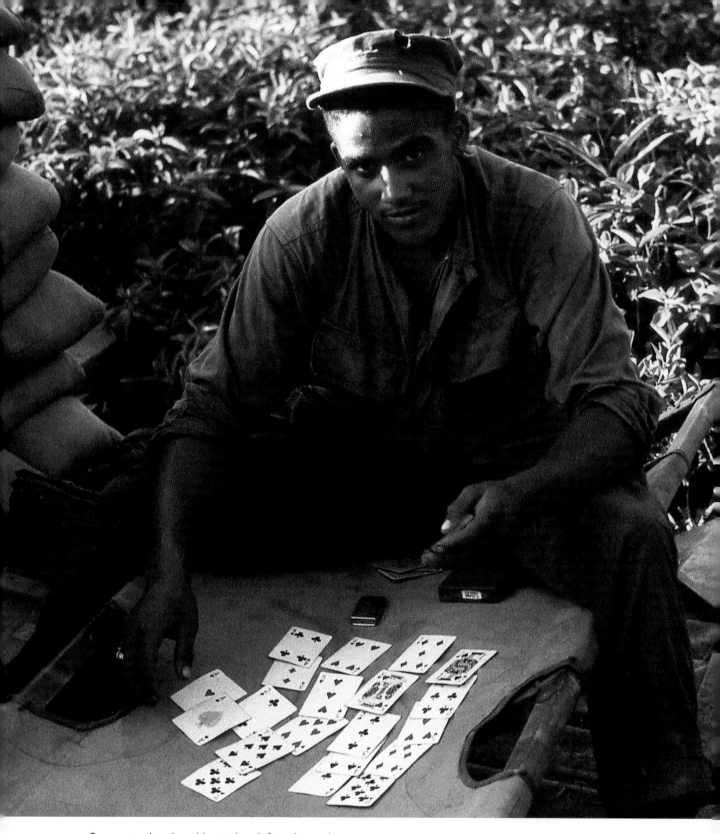

Some people relaxed best when left to themselves.

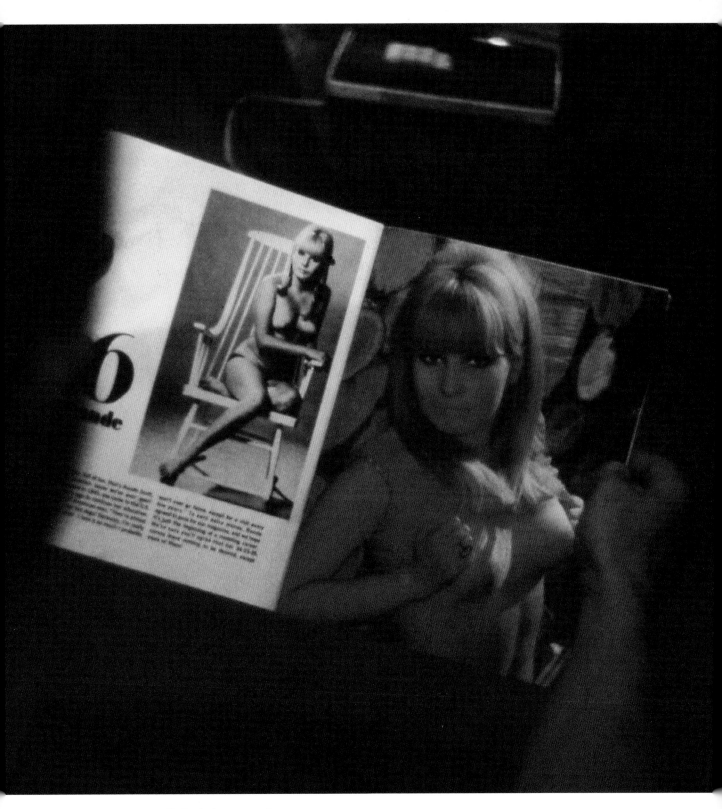

Solitude has many faces.

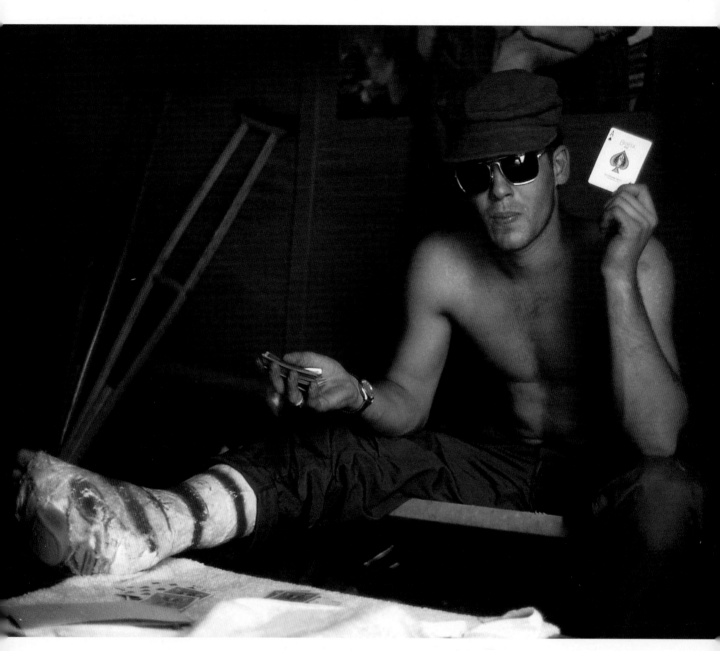

Corporal Ed Harris healing up in the rear at Phu Bai.

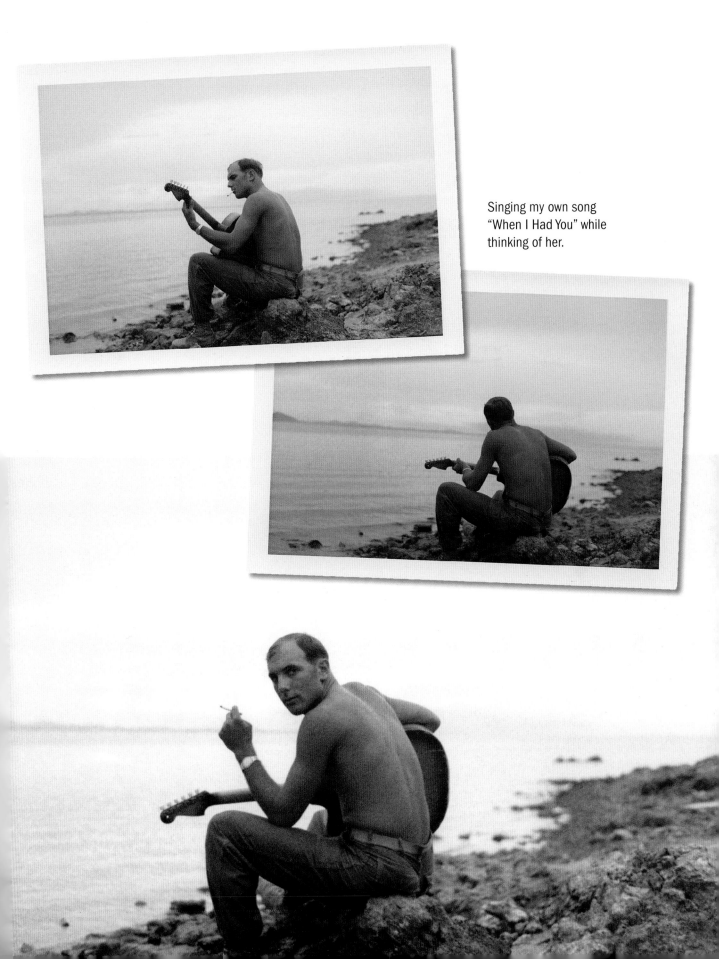

Singing my own song
"When I Had You" while
thinking of her.

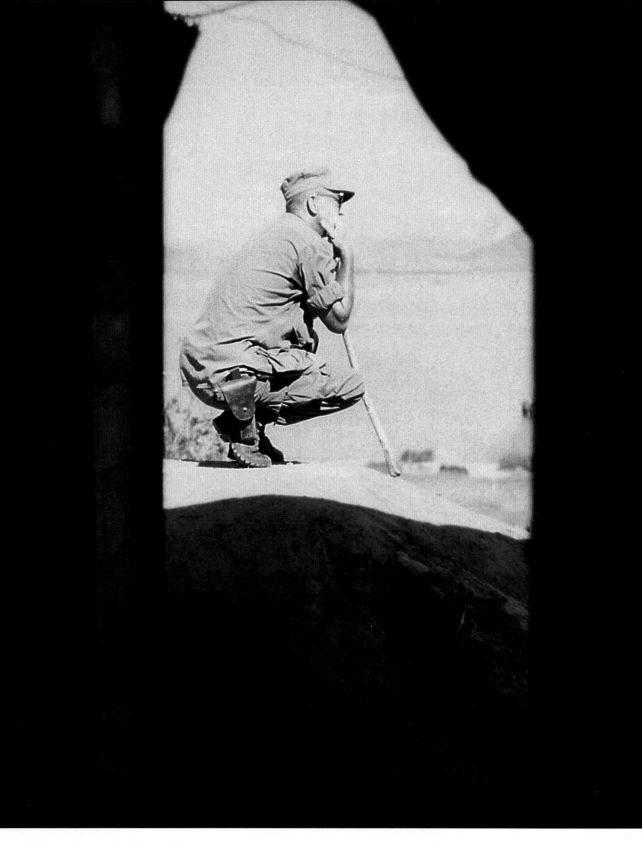

Thirteen thousand miles, so far away . . .

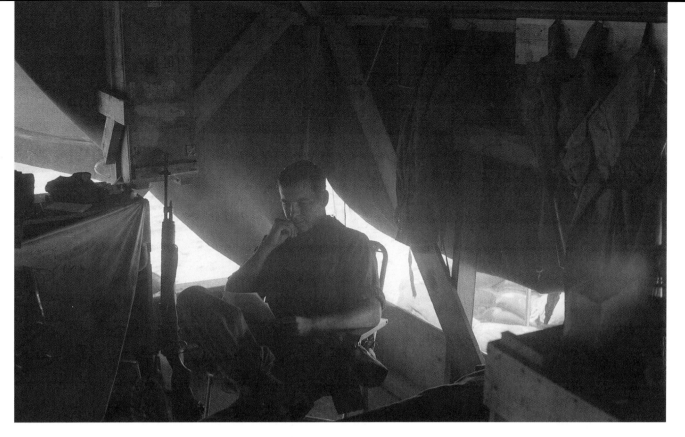

Mail from home was the lifeline; it kept us sane.

Some of us had the luxury of making a home, like here in my first unit, Headquarters Battery 2/11, south of Da Nang. Eight of us lived in a tent this size, and we even had a small refrigerator someone bought from the Seabees as they were packing up to leave after finishing construction of this base camp.

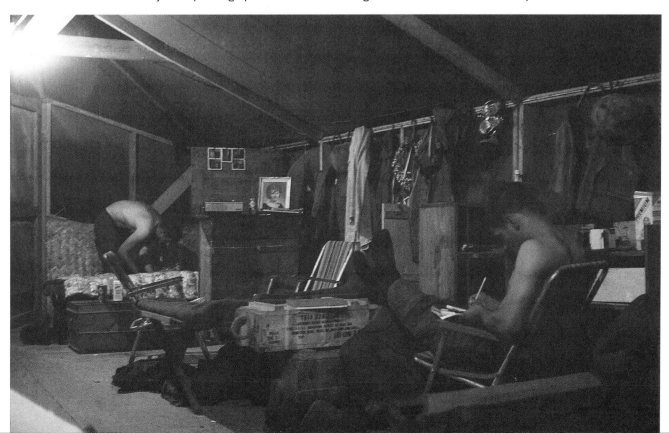

Thoughts of home

ADVERSARIES

THEY WERE STRONG, BRAVE, AND
PASSIONATE . . . JUST LIKE US.

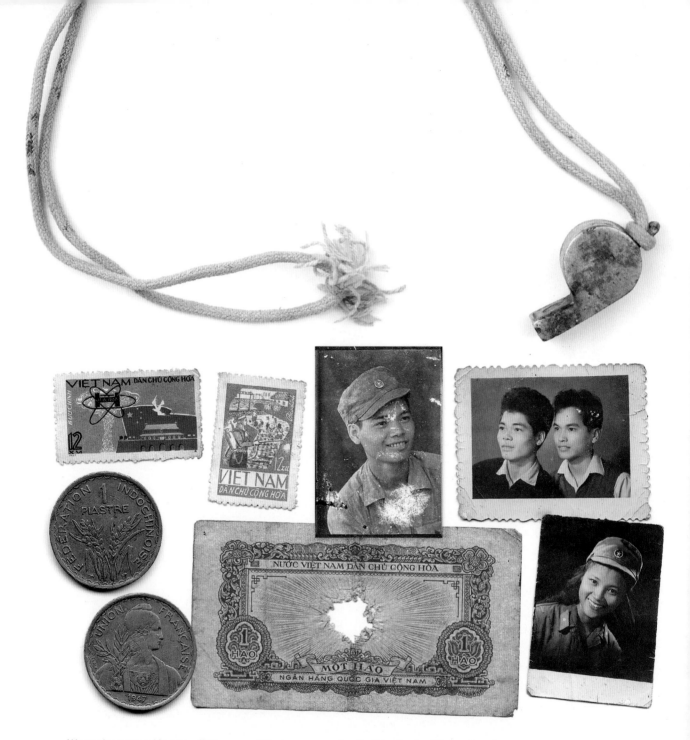

We took personal items off those we killed as souvenirs. To this day, I still wonder about the people in some of those images. The bullet hole in the dollar bill I found in a soldier's breast pocket speaks of his demise; the coin dating back to the French war (front and back shown here) reminds us of the endless struggles in that country; and the enemy squad leader's whistle echoes silent directions to troops long dead.

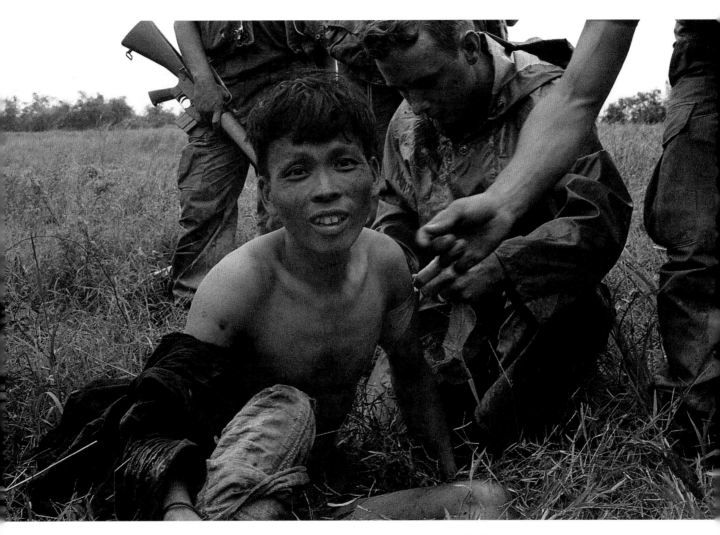

In most cases, we treated captured enemy with care and dignity. Here a corpsman tends the wounds of an NVA prisoner of war.

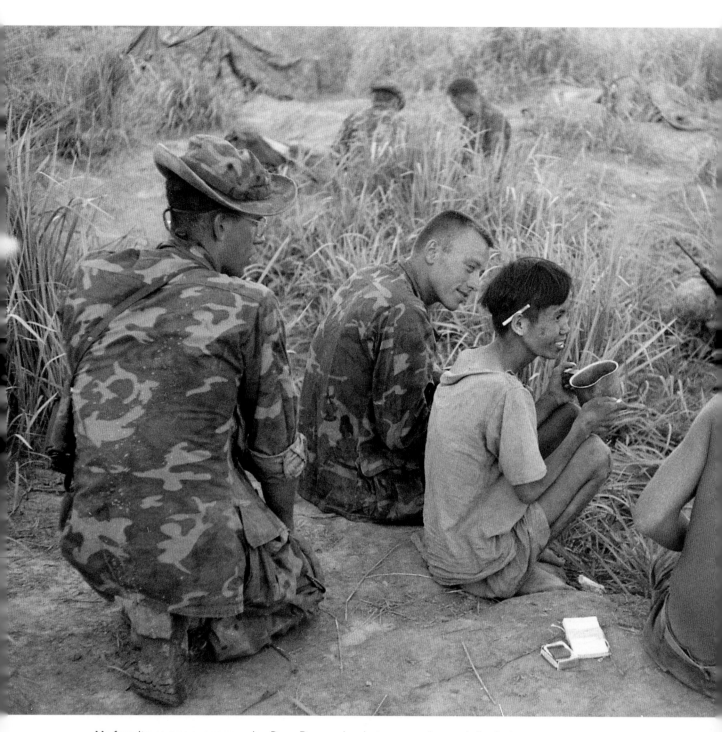

My favorite company commander, Dave Brown, showing compassion and dignity to a former enemy soldier. This approach produced immediate positive results, as this soldier's grin testifies, giving us much-needed information about the battlefield and enemy troops we faced.

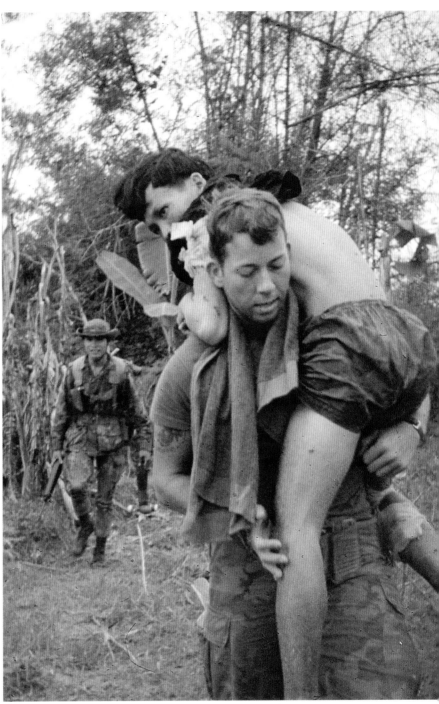

A wounded enemy POW is gently carried to the LZ for helicopter transport to the hospital.

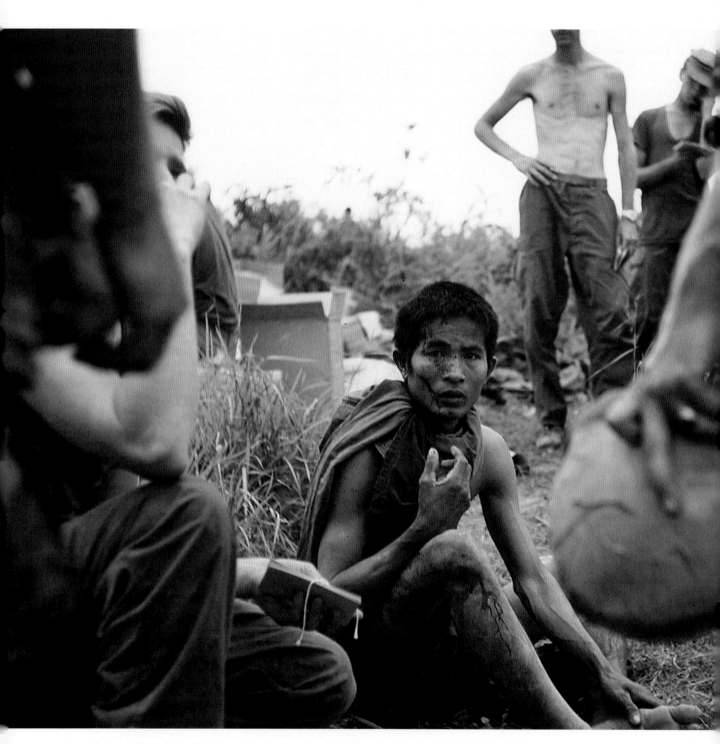

Responding to our kindness, a wounded enemy POW provides important information during the brief few minutes before his evacuation.

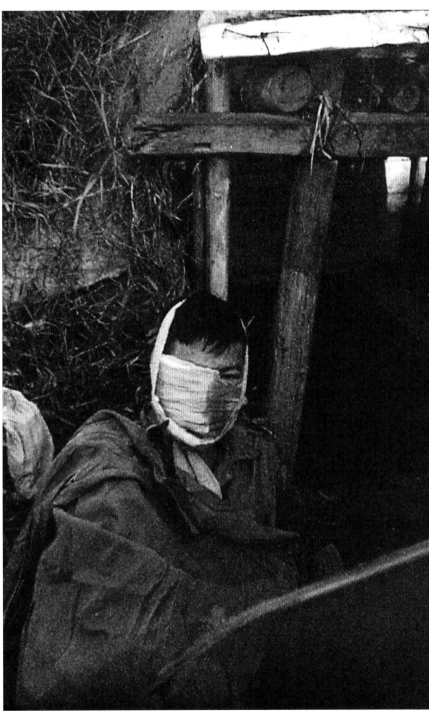

A bandaged NVA soldier next to the bunker he was guarding awaits transportation by helicopter for interrogation.

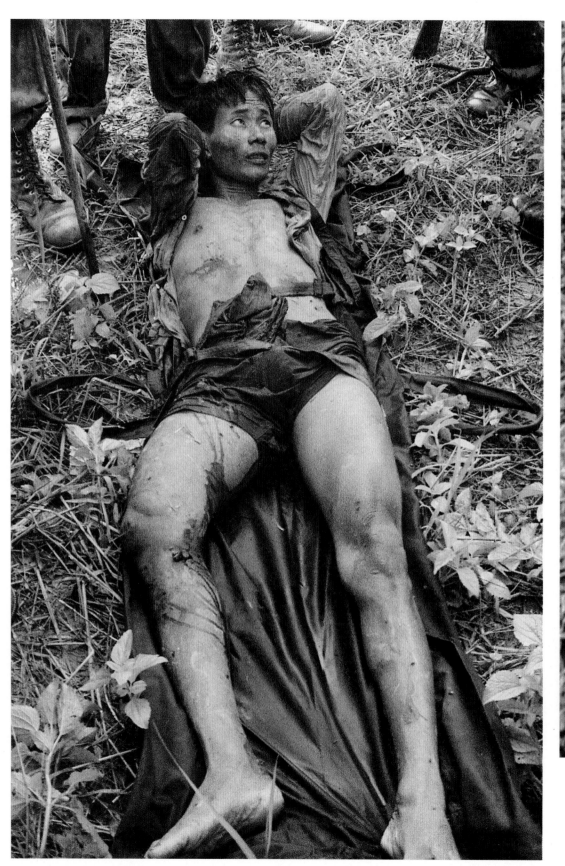

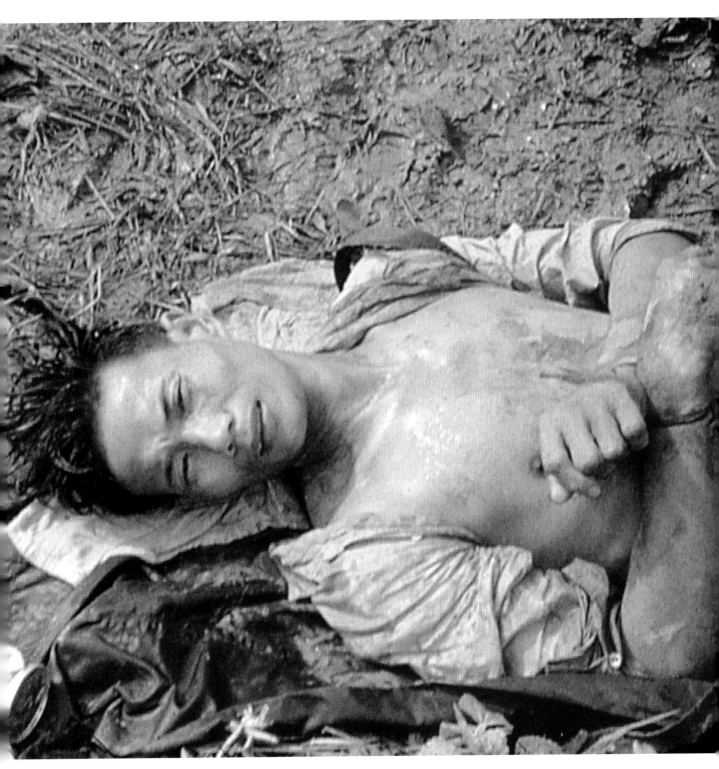

Some hard-core cases, however, refused to talk at all.

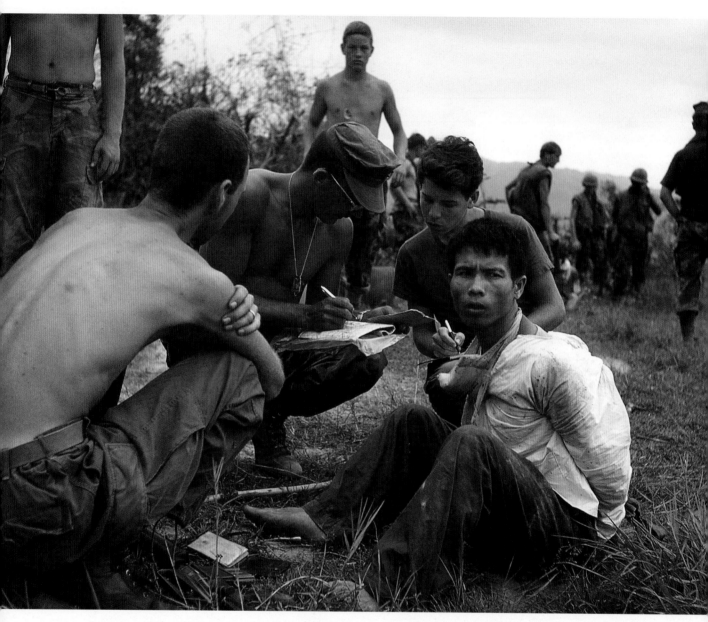

At one point, the need for the critical information prisoners could provide moved our leadership to offer a three-day in-country R&R to each soldier who brought in a prisoner. Funny how quickly the numbers rose.

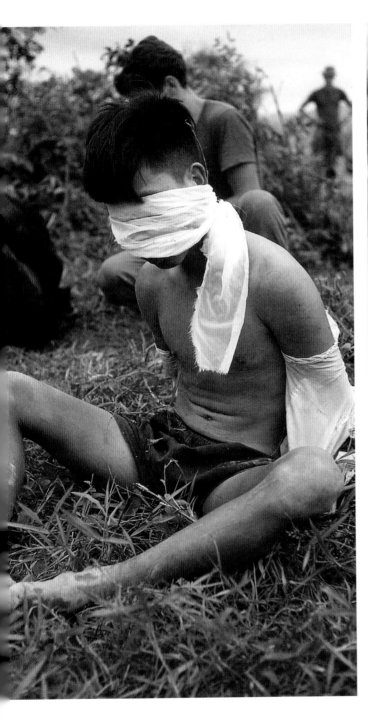
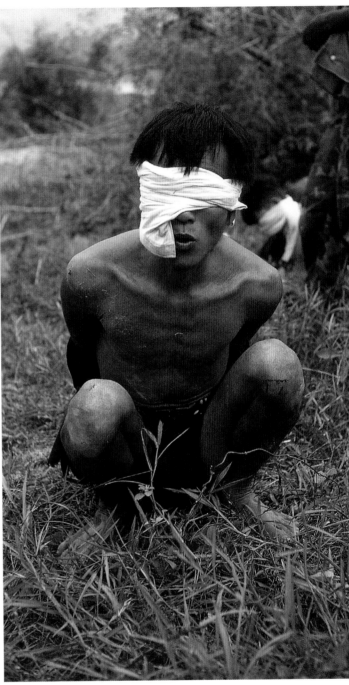

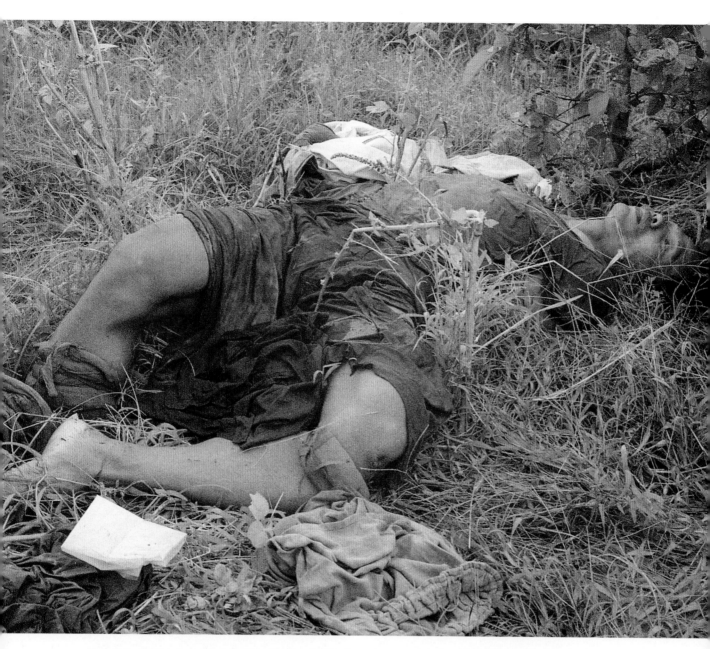

During the night, one of our two- to four-man LPs (listening posts) opened up. They reported capturing one enemy soldier with a single bullet wound in the leg. They tied his hands and muffled his mouth. At first light we came up to them, and this is what we found.

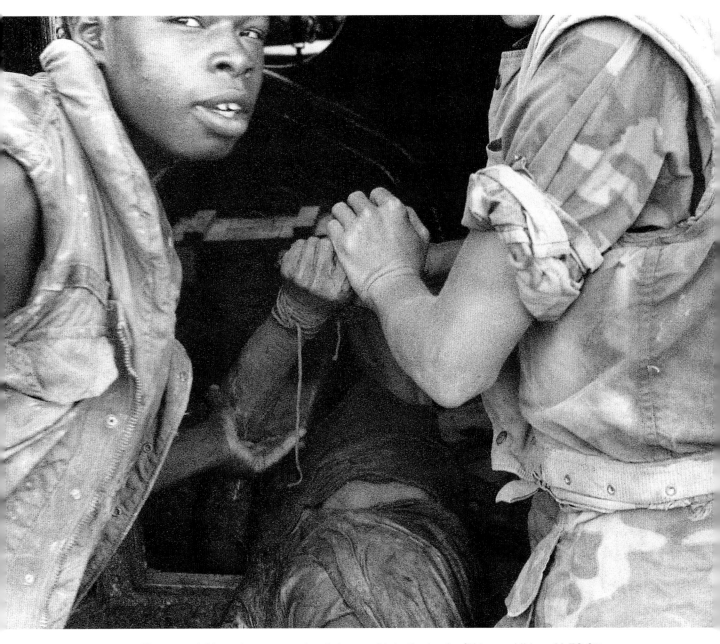

He was quickly and unceremoniously jammed into the back of this amphibious M-76 Otter and whisked away.

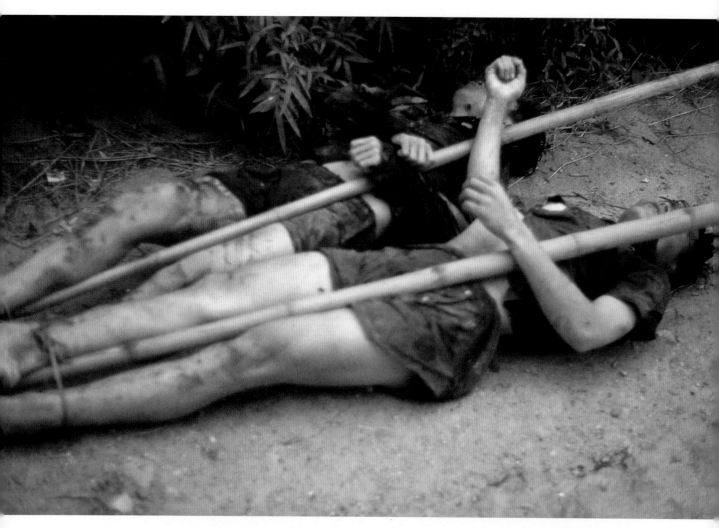

Two local farmers secretly working as Viet Cong by night were killed in an ambush by South Vietnamese troops and carried on tiger poles to be deliberately left by the roadside as a warning to others.

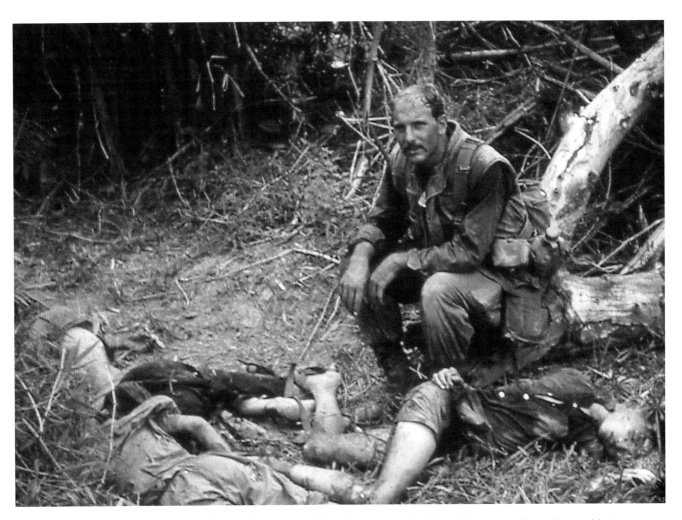

Only moments before, these soldiers were trying to kill me. They were all cut down exiting the same bunker doorway.

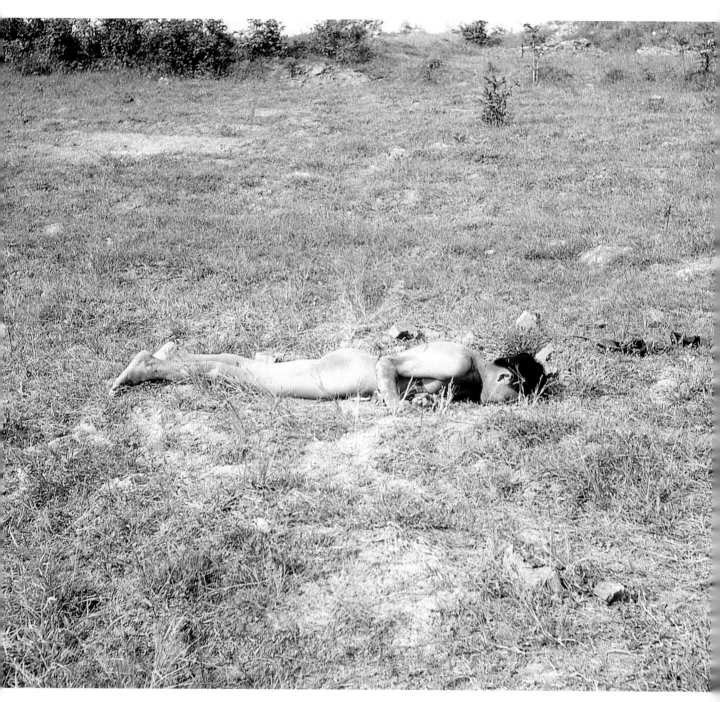

The naked and the dead. We stripped enemy soldiers for the information their clothing and equipment might yield to intelligence teams back in the rear.

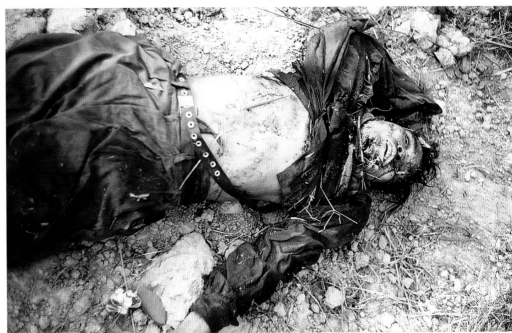

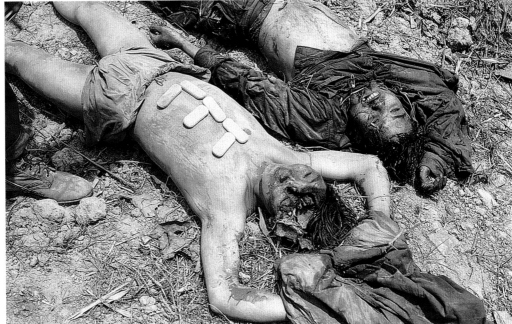

On this occasion we did not have time to strip the dead, so we thoroughly searched them—a grisly job if ever there was one. We left a calling card with compressed Sterno heat tabs meant for cooking C-rats—but in this case letting their buddies know Echo Company took credit for these kills. Like counting coup, but frowned upon by our social standards.

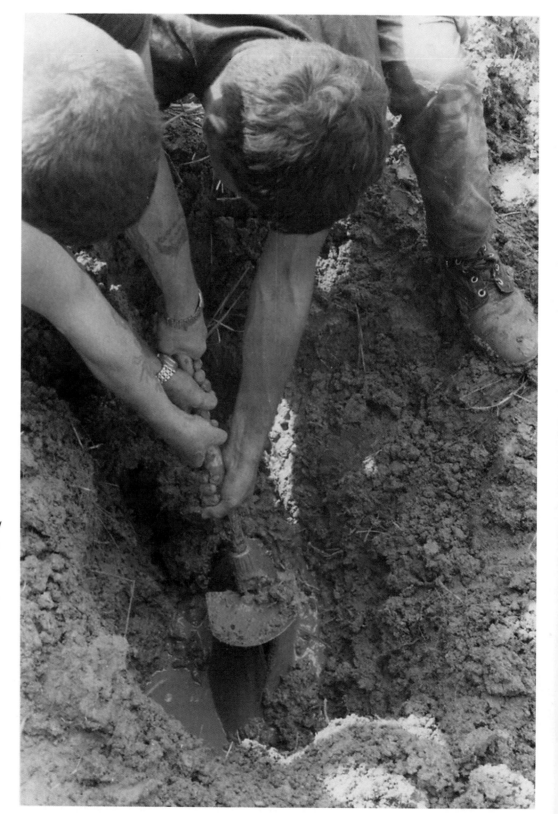

Searching for buried enemy uniforms and weapons caches, we didn't always find what we wanted. In this case, we found the shrapnel-riddled body of a baby girl. The stench was so pervasive that for days my comrades gave me and my digging partner, Donny Serowik, a wide berth.

BY AIR, LAND, AND SEA

FROM THE HALLS OF MONTEZUMA
TO THE SHORES OF TRIPOLI,
WE WILL FIGHT OUR COUNTRY'S BATTLES
IN THE AIR, ON LAND, AND SEA . . .

—FROM "THE MARINES' HYMN"

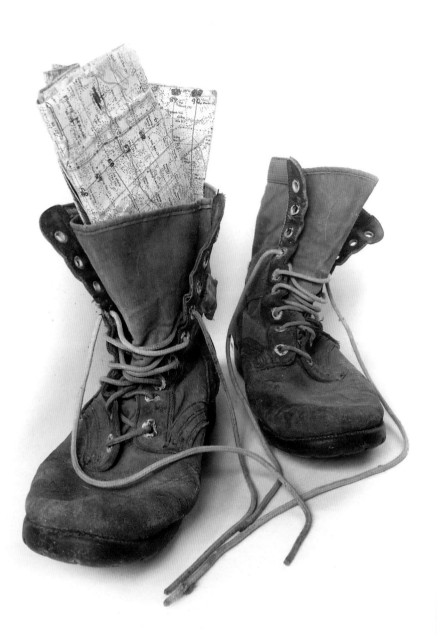

However Marines arrive on the battlefield, the bottom line is always boots on the ground. These are the last jungle boots and local maps I used.

An outdated whirlybird

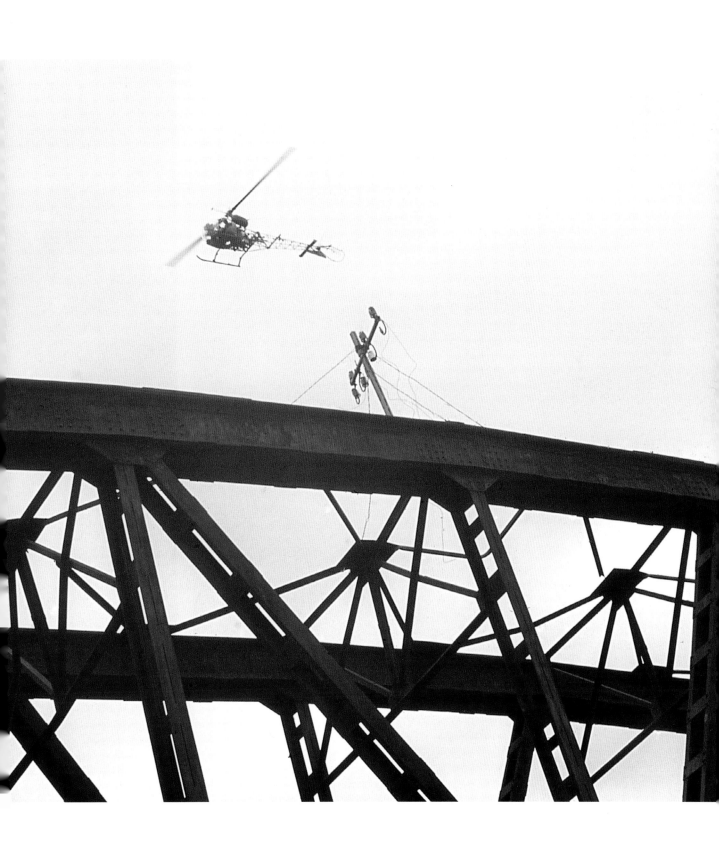

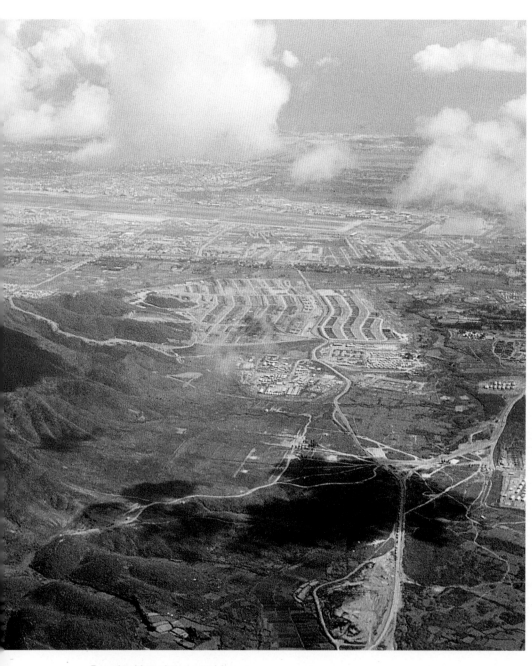

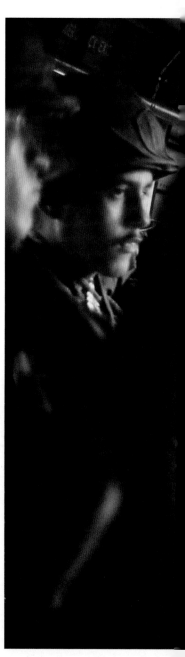

Breathtaking vistas outside

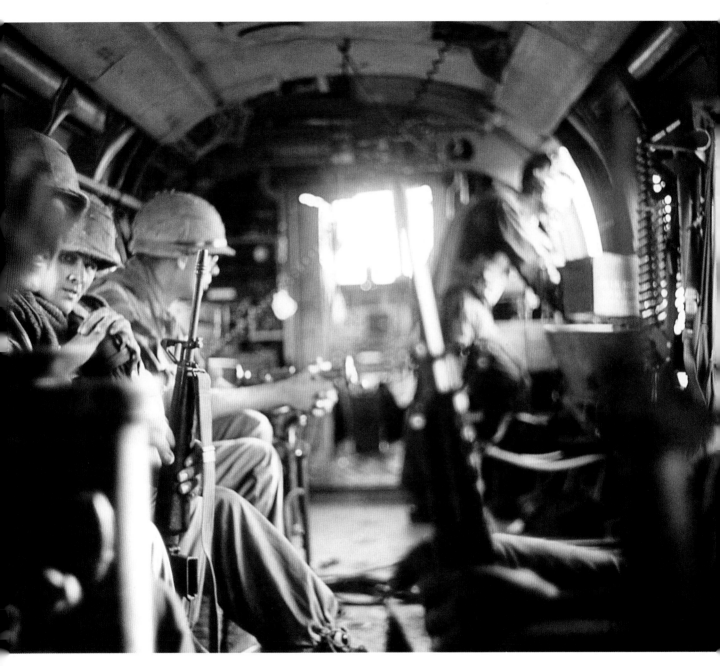

Breath-sucking anxiety inside

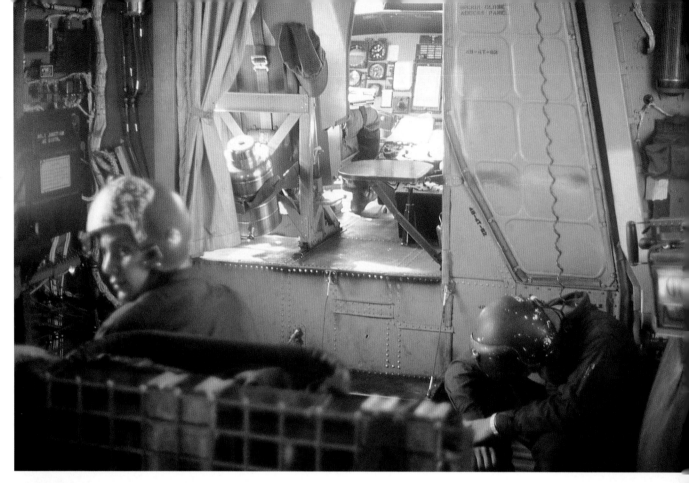

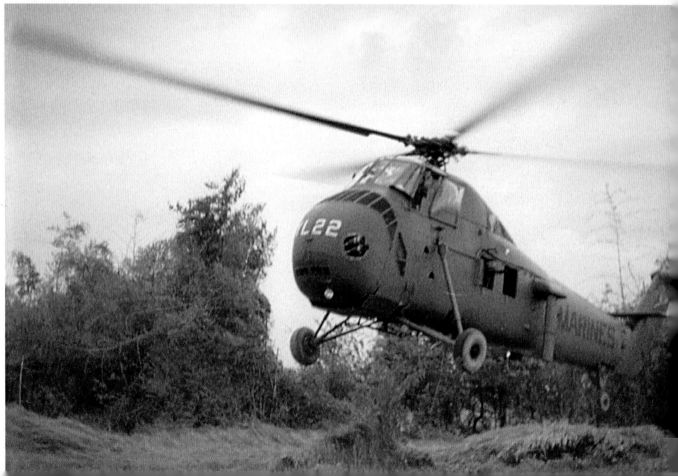

Inside a spacious CH-56 Sea Knight. They had a tremendous lift capability and could hook onto vehicles or artillery pieces to carry them where needed while being packed high inside with bodies, bullets, bandages, or beans (an old saying we used). Note exhausted crew member.

An old CH-34. They were phased out of use during the war. We often did not have enough medevac and troop transport choppers available, and these performed well in a pinch.

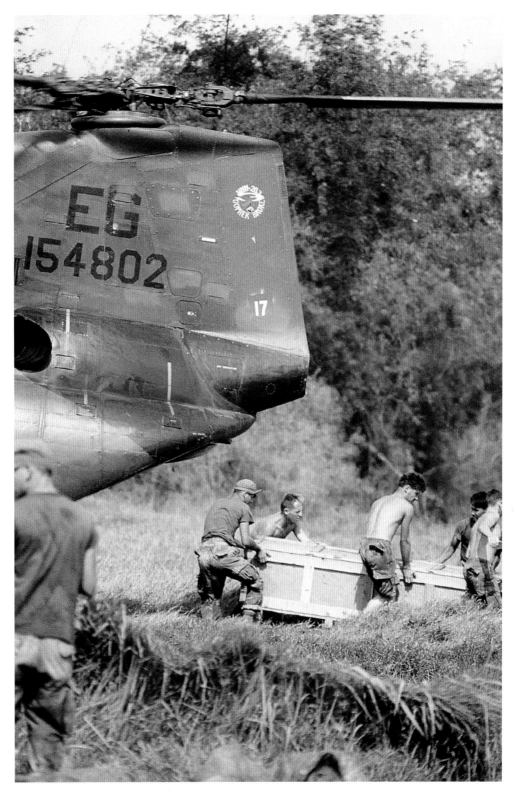

Boots on the ground, offloading heavy equipment by hand from the ramp of a CH-46, the workhorse of the grunts

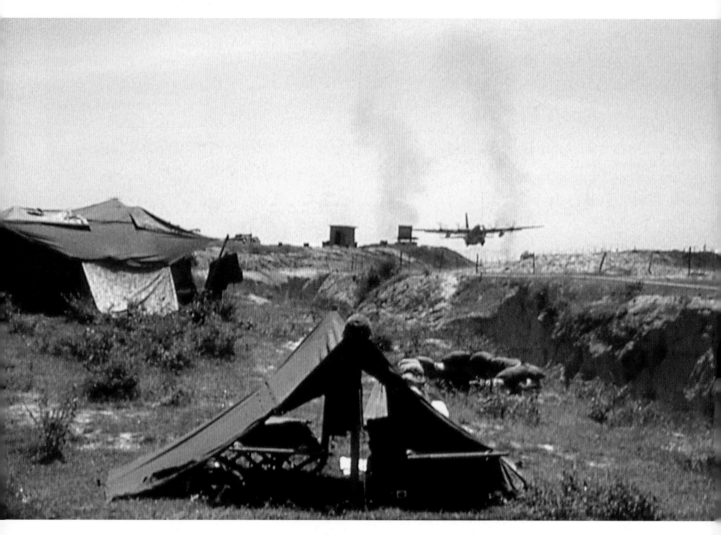

The huge buildup of An Hoa combat support base involved tons of equipment and material. Before we even had all our large tents pitched and sandbagged, an airstrip was made and C-130s were roaring in and out like freight trains.

It wasn't long before a helicopter squadron made An Hoa home. By then we were better built up and fortified. They even managed to come up with corrugated tin roofs for their tents. Note the air traffic control tower.

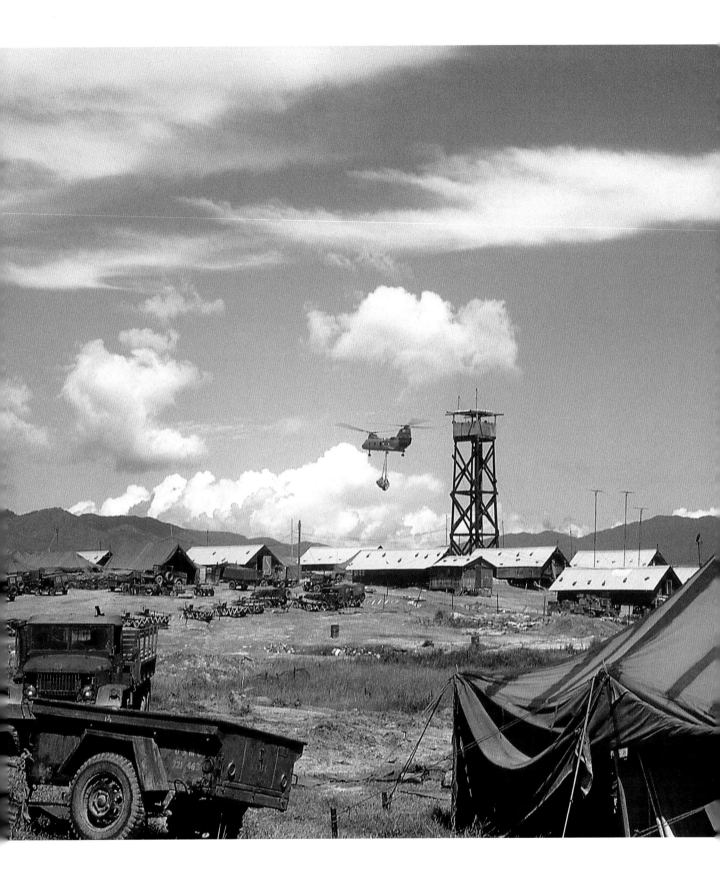

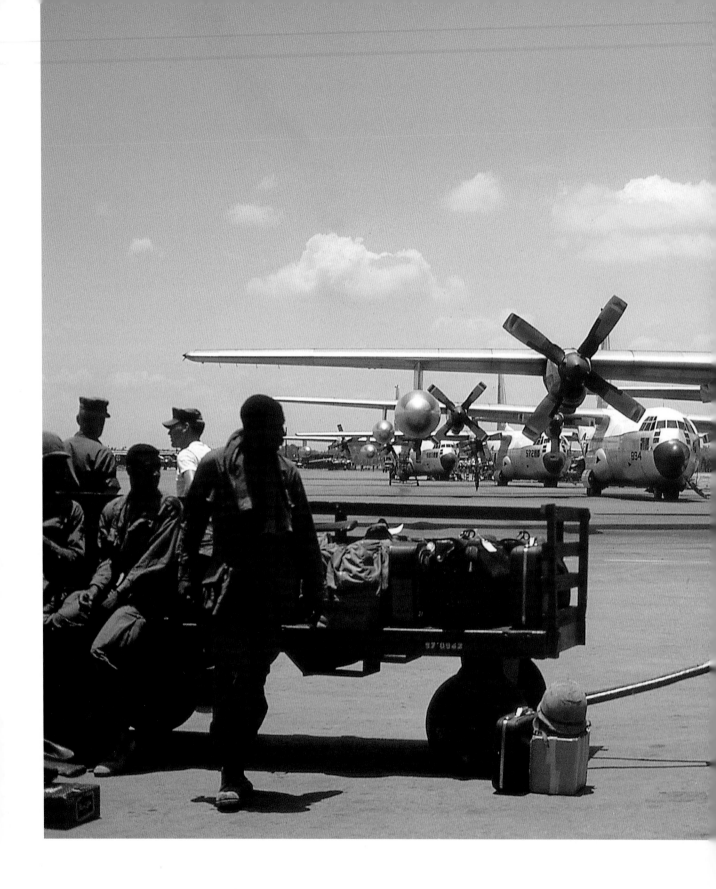

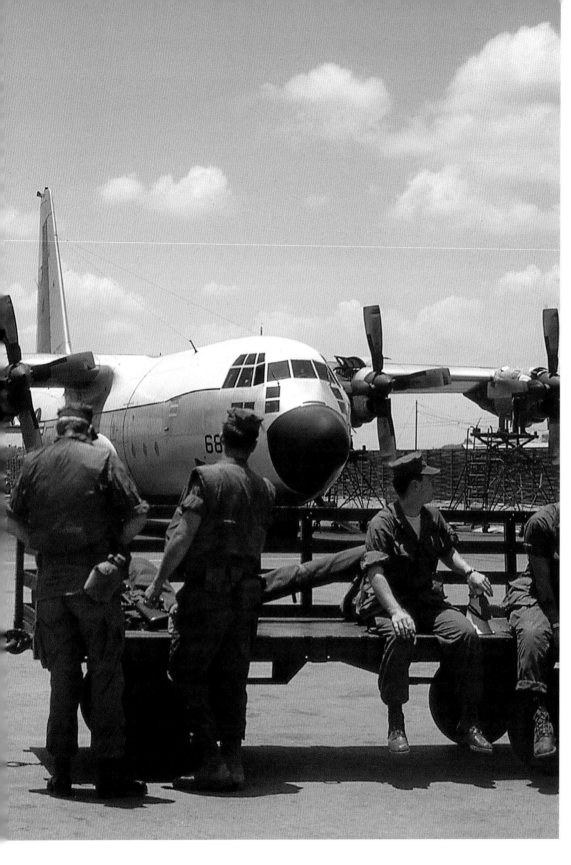

I've heard many times that during the peak of the war, Da Nang Air Base experienced more takeoffs and landings than any other airport in the entire world. I know firsthand that it was impressively busy day and night.

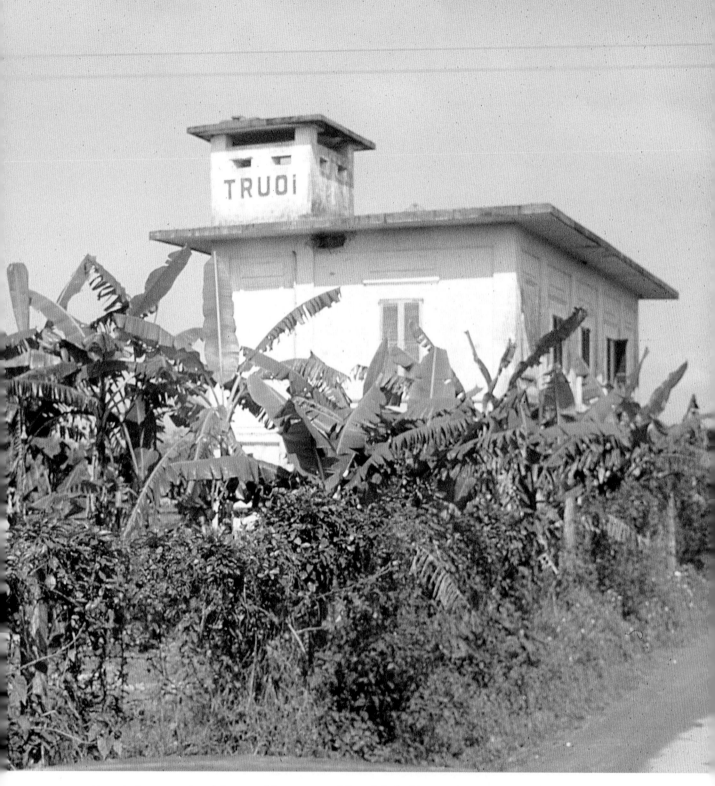

Years before we entered the war, this was part of French Indochina, and among other infrastructure creations was a narrow-gauge World War II–vintage railroad running from China to Saigon with many spurs and branches. This is the Truoi Railway Station, south of Hue/Phu Bai, abandoned and in disrepair.

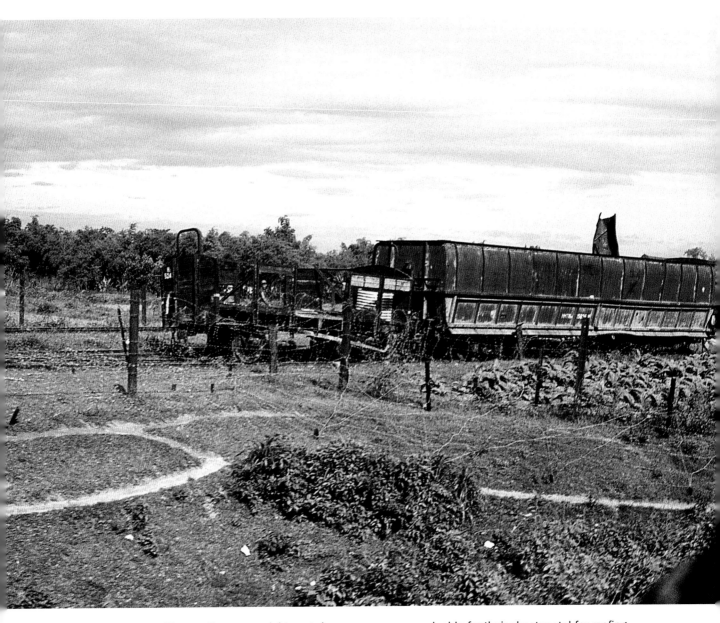

These railway cars, right next door, are now more valuable for their sheet metal for roofing and timbers for making bunkers.

The Truoi Bridge a few hundred yards down the road was made for train, vehicle, and pedestrian traffic. Enemy sappers snuck in at night, floating among river debris, and loaded the bridge with explosives. In no time at all, we bypassed it with a pontoon bridge. The Navy Seabees performed heroic acts of construction, repair, and engineering, just as in previous wars. (This is from the whirlybird picture at this chapter's beginning.)

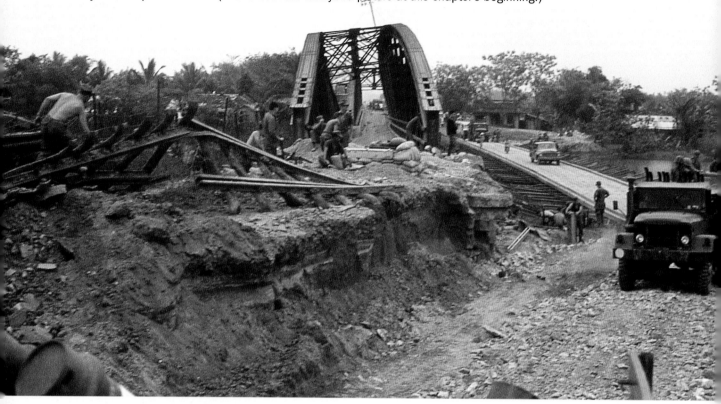

More sabotaged railway track just down the road. The local Vietnamese used the railway ties for framing small underground bomb shelters next to their homes to stay safe during times of fighting. The roof would be reinforced with actual rail sections crisscrossed like a checkerboard.

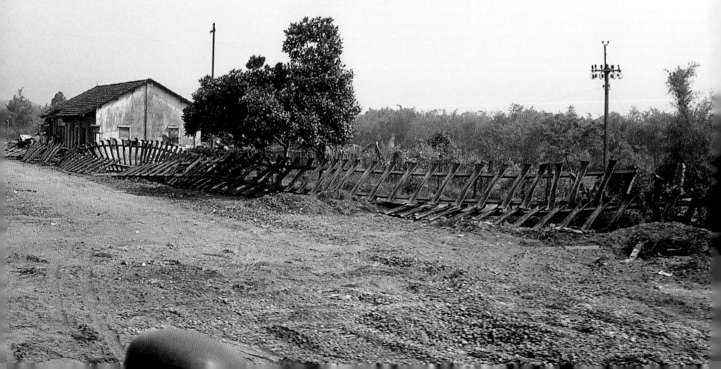

Roads needed constant repair and improvement, plus construction into new areas.
Again the Seabees were on the job.

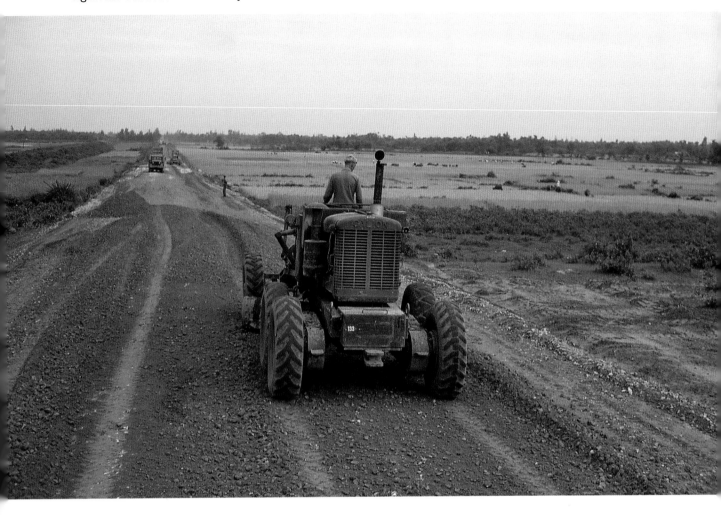

In more remote or contested areas, road travel was limited to convoys only for massive protection. Unaccompanied, these long-range self-propelled heavy artillery guns would make tempting targets. Note the convoy commander's jeep at the head of a convoy, waiting for more vehicles to join in line before heading out.

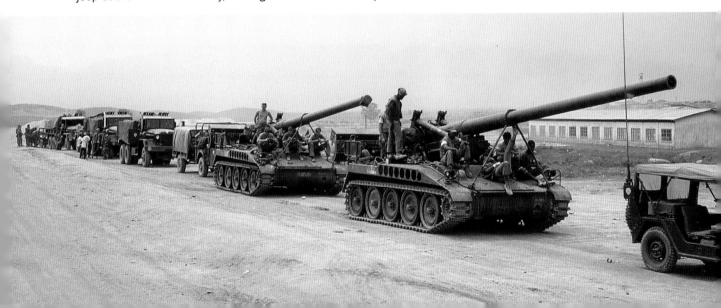

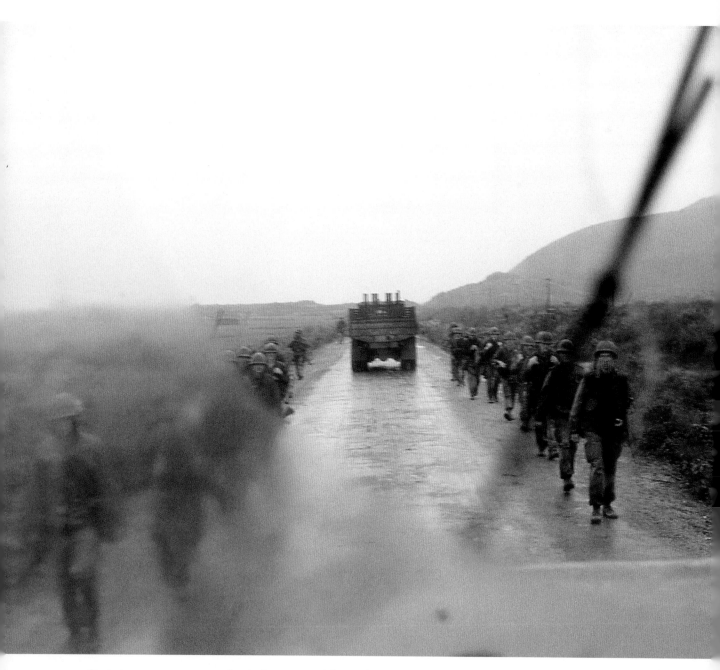

During monsoon season a few lucky grunts might catch a ride, but generally it was boots on the ground.

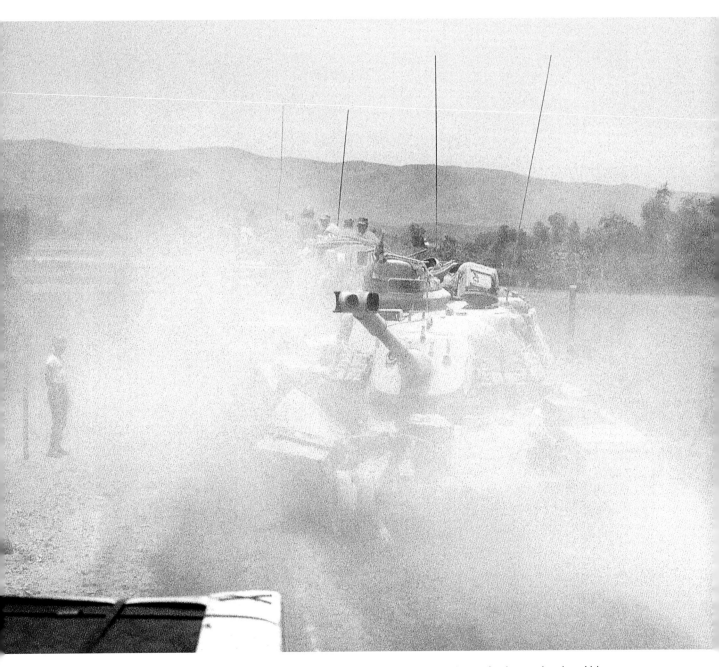

The hot summers brought dust clouds as thick as the monsoon rains had been. Again, maybe there'd be a chance ride on a tank from a kindly tank captain, but mostly it was just more humpin'. During my three tours, I was lucky enough to ride atop a tank only once.

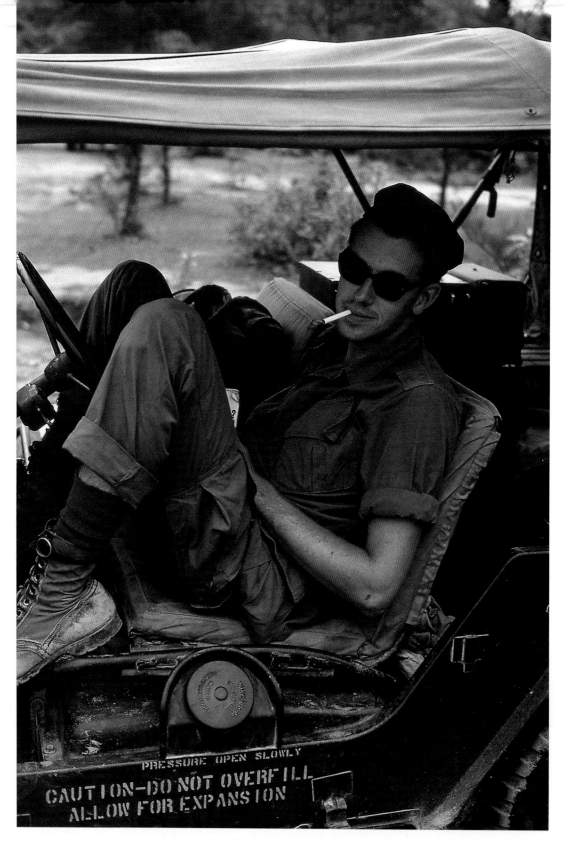

A convoy commander's driver patiently waits—sometimes for hours—for word to "Saddle up and move out!"

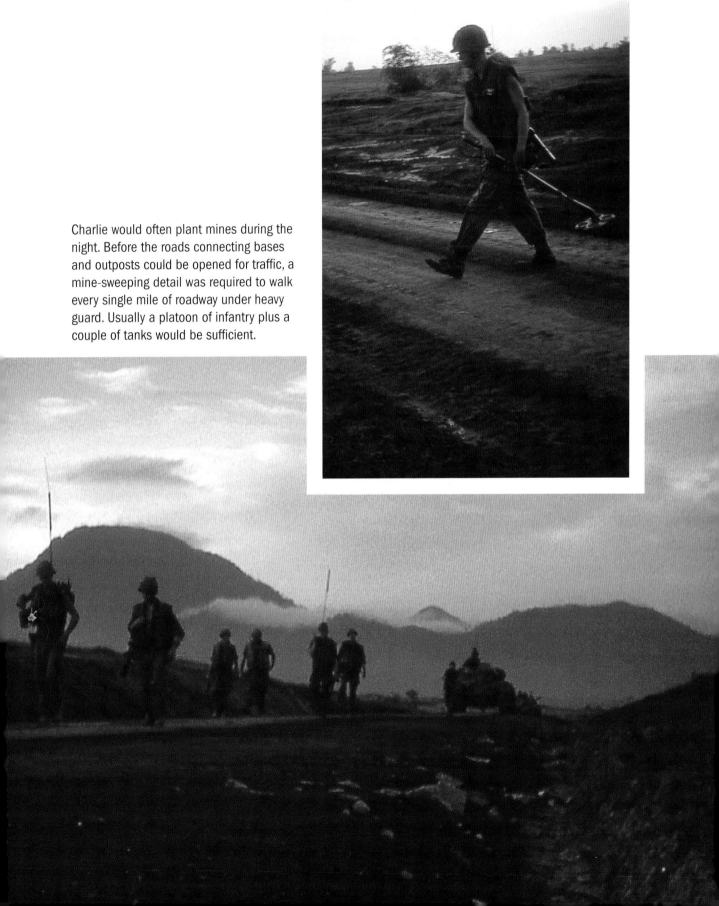

Charlie would often plant mines during the night. Before the roads connecting bases and outposts could be opened for traffic, a mine-sweeping detail was required to walk every single mile of roadway under heavy guard. Usually a platoon of infantry plus a couple of tanks would be sufficient.

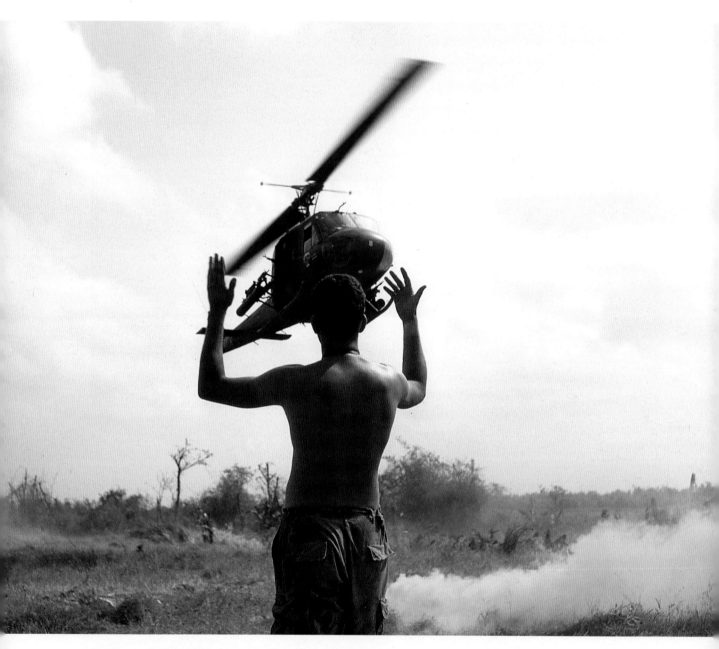

Guiding a medevac Huey down to the red landing cloth in the foreground. The yellow smoke marks our location.

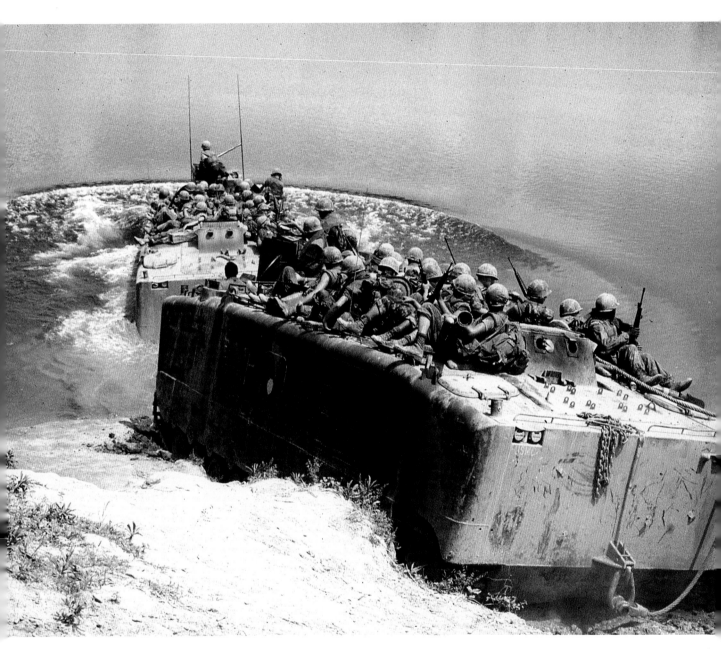

Amphibious river-crossing assault with "Amtraks." Originally designed to carry troops inside, practical experience dictated riding on top rather than within these easily sinkable tombs.

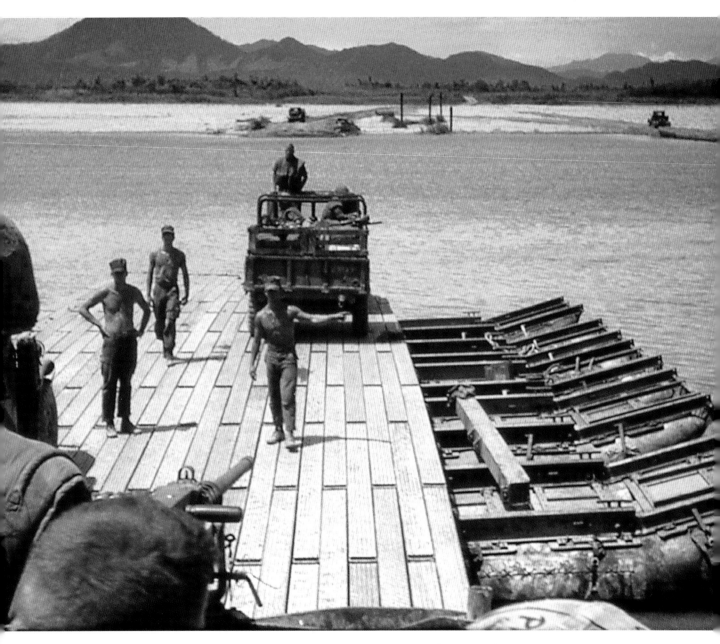

If bridges weren't available, Marine engineers would find a way. In this case, a pontoon raft attached to a cable with a winch on each shore allowed passage back and forth.

Facing page: A sampan's-eye view of my base. Charlie utilized the sea as well as the land for infiltration and attacks.

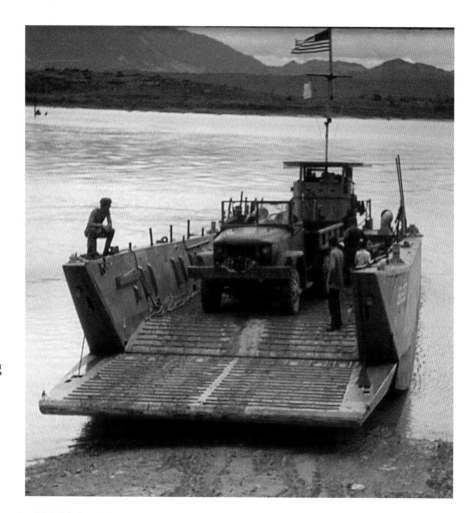

For larger water crossings, navigating where no roads existed, or even skirting the coast to new locations, the Navy would haul us where we needed to go.

GOOFING OFF

KIDS WILL BE KIDS, EVEN IN WAR.

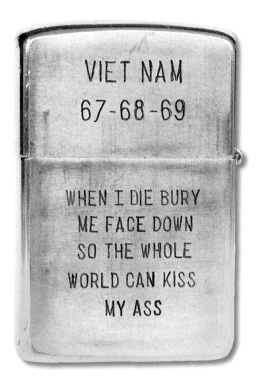

Zippo lighters have long been popular with soldiers, from well before the Vietnam War through today. Most of us had at least one. You could get them engraved for next to nothing at a local Coke shop. I still have mine.

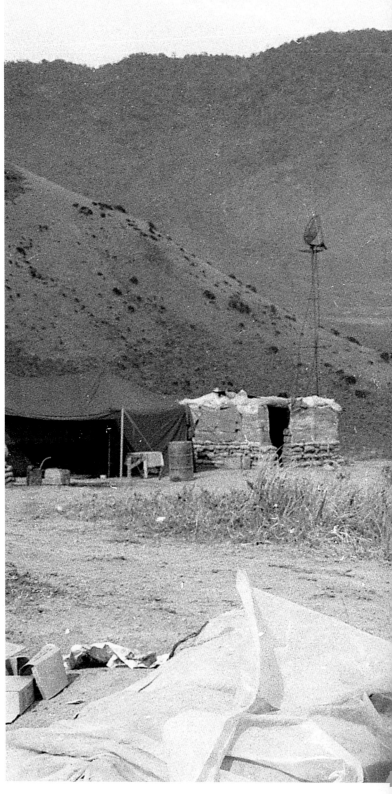

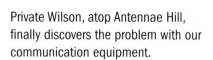

Private Wilson, atop Antennae Hill, finally discovers the problem with our communication equipment.

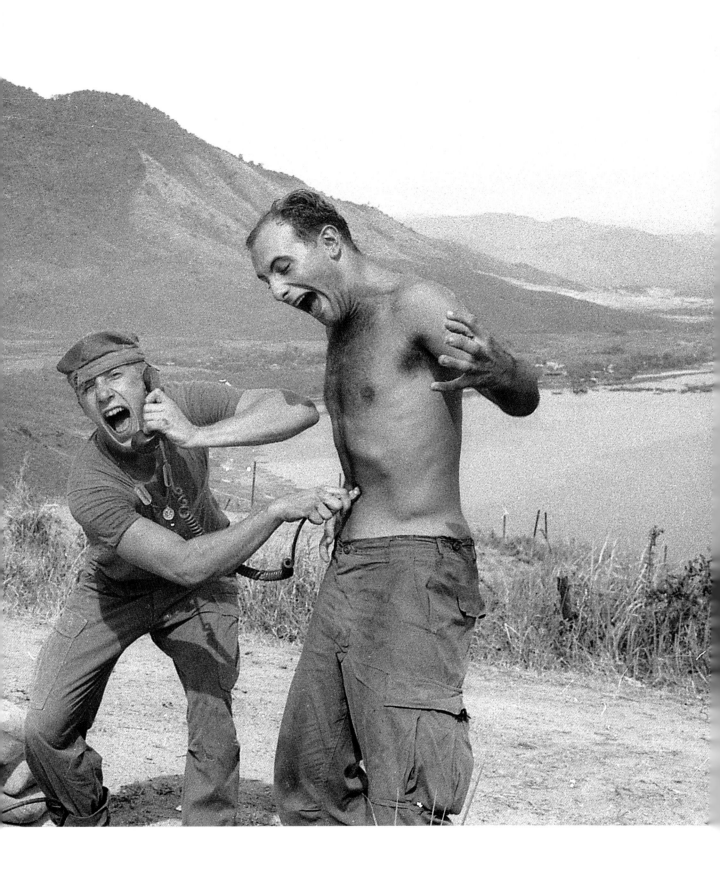

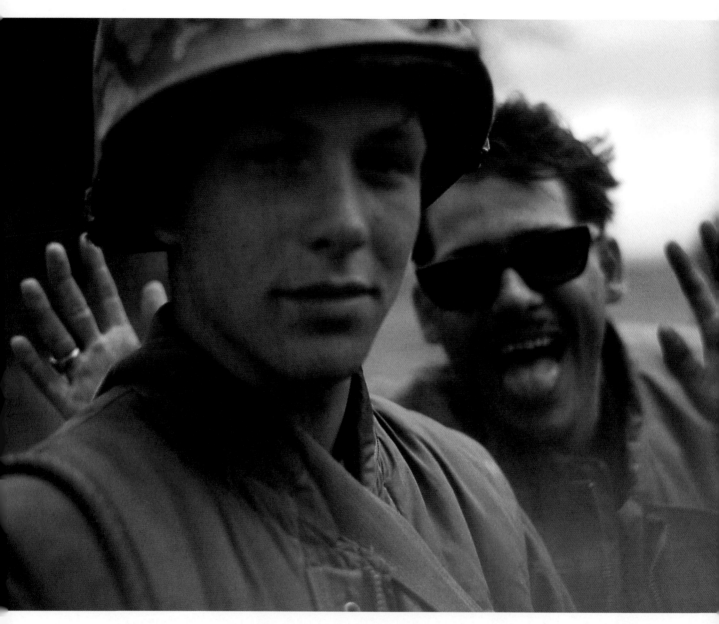

Corporal Ed Harris practices his photobombing skills behind an oblivious young Marine posing for a portrait home.

Facing page: Armed only with a bamboo spear (on the ground next to me) and a front-and-back pair of leaves, I have just returned from the river's sandbank in front of our dug-in line. I challenged and taunted the enemy troops hidden in the foliage on the opposite bank. "Come out and fight me man to man!" I repeatedly yelled in their language, along with other colorful phrases, to the amusement of my cheering comrades. To this day, I wonder what stories are still told about the crazy Marine witnessed by those enemy troops that day.

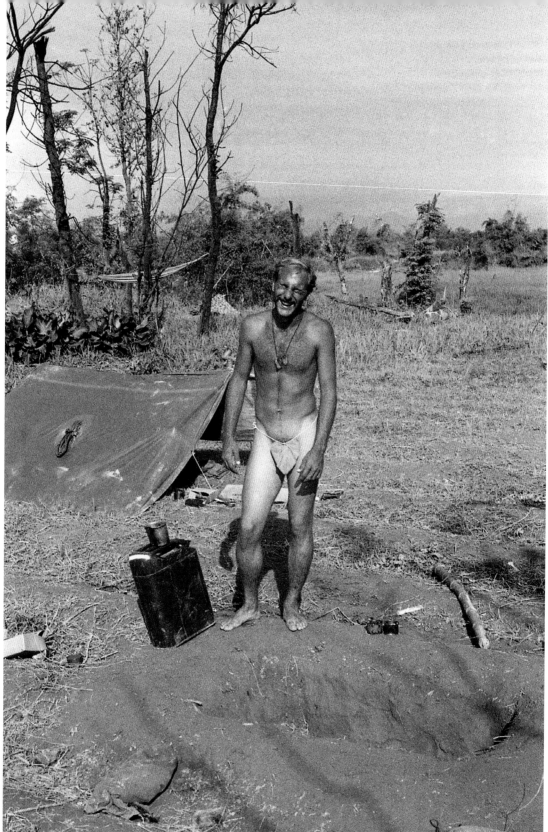

Farting contest victim

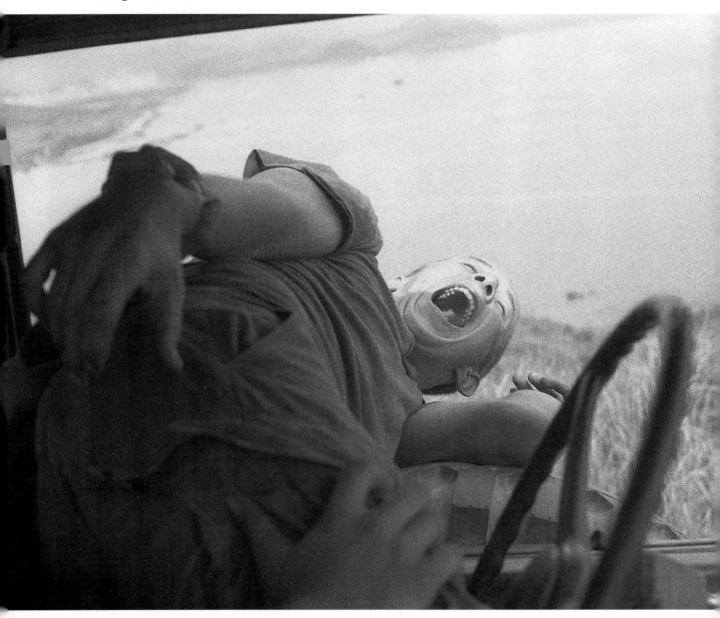

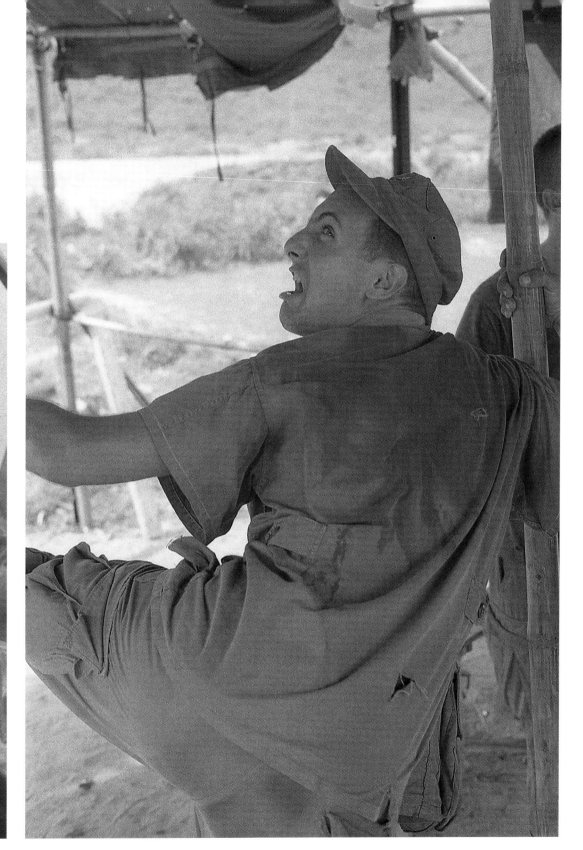

Farting contest winner

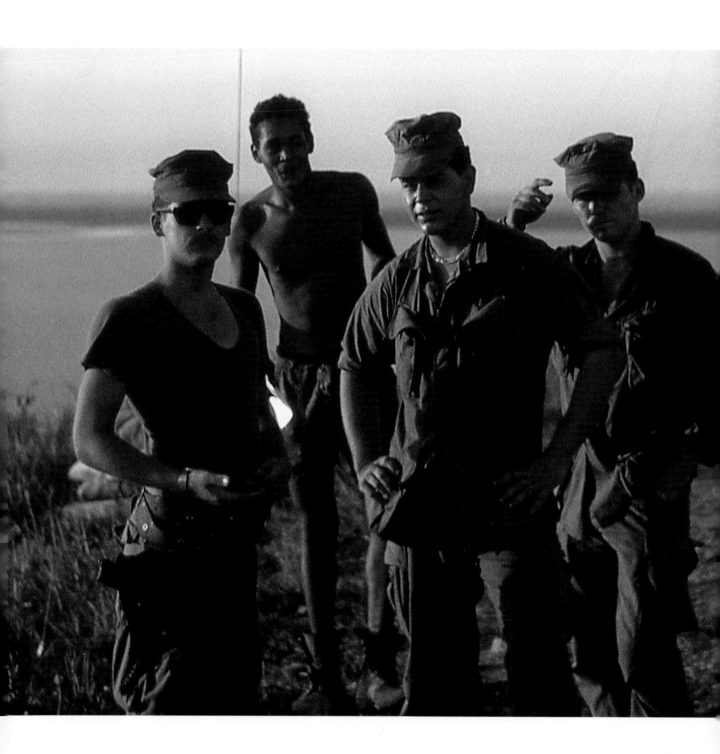

Where's Waldo? This isolated hilltop position was manned by one or two Marines to keep the radio relay gear up and running. Free from the regulations of life at the base, "individuality" would begin to show itself in some of these men. My correctly attired friends and I were sent up there to check on this man, as he had not been heard from in a while.

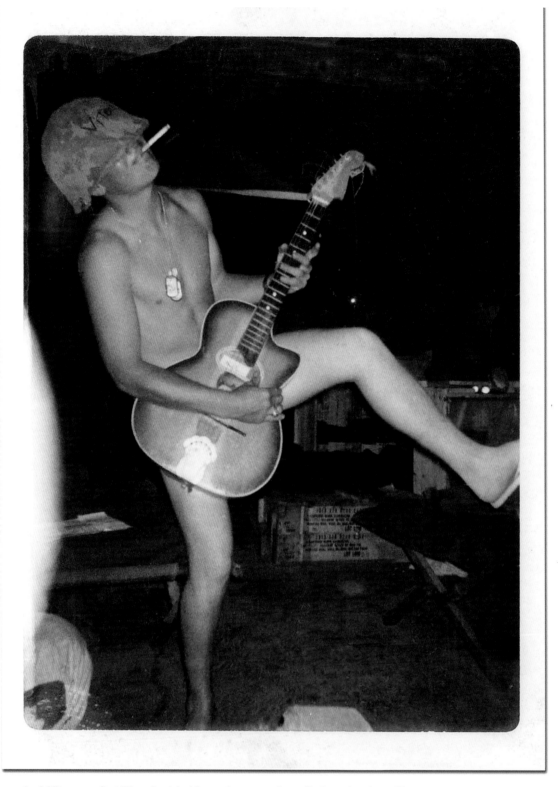

Jack Vitou, my first 'Nam buddy. My mother secretly mailed me bottles of booze, and this is the result, clearly demonstrating why it was forbidden.

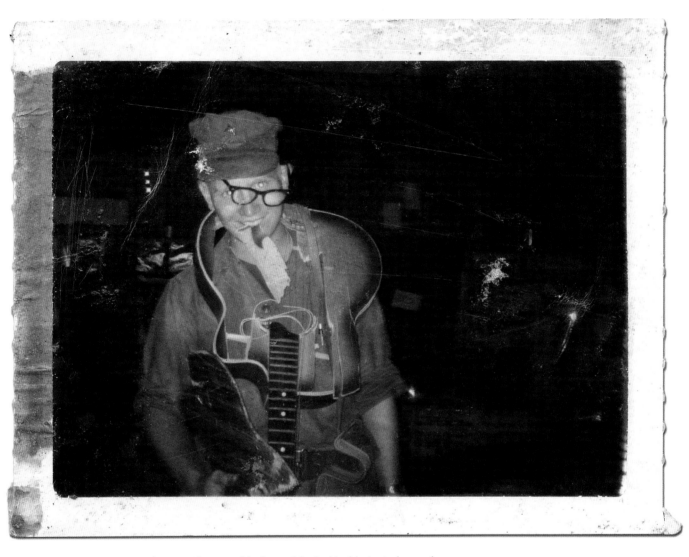

Apparently some Marines objected to his taste in music.

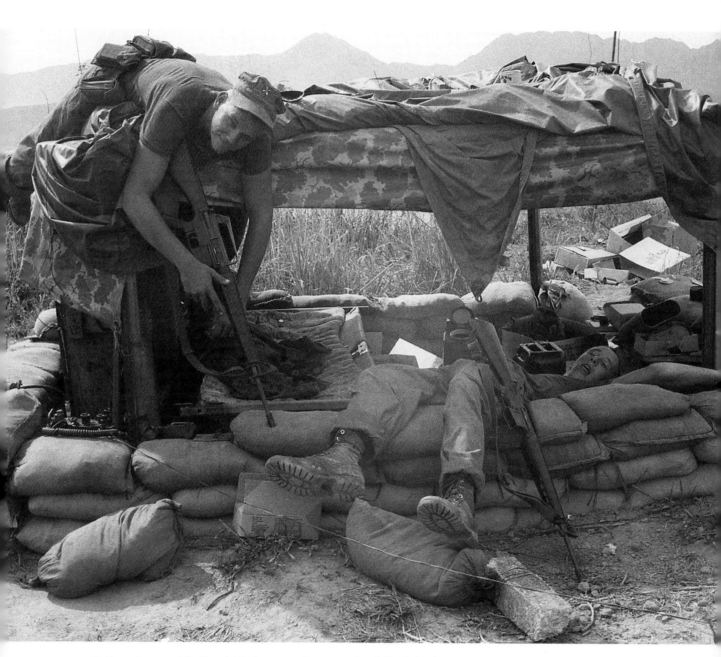

Gallows humor at its finest. Having staged our own battlefield death, my conspirators
can't help cracking up as I prepare to take the shot.

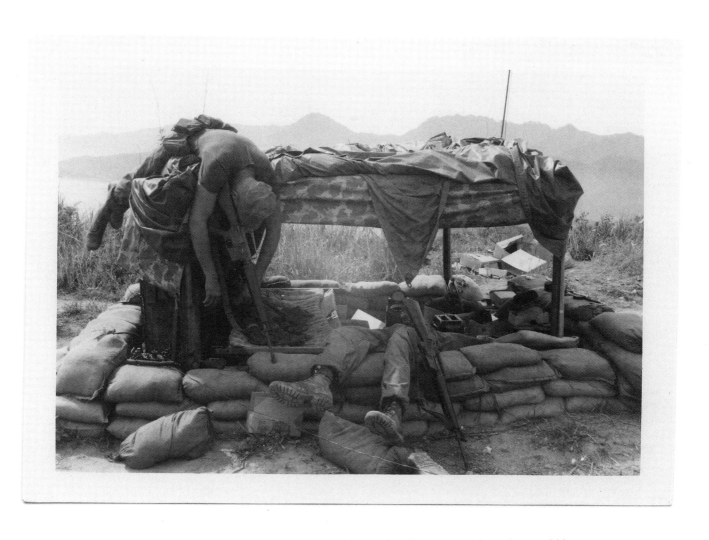

Poor taste, to say the least. I can only wonder what someone's mother would have thought if she had seen this picture while we were still over there.

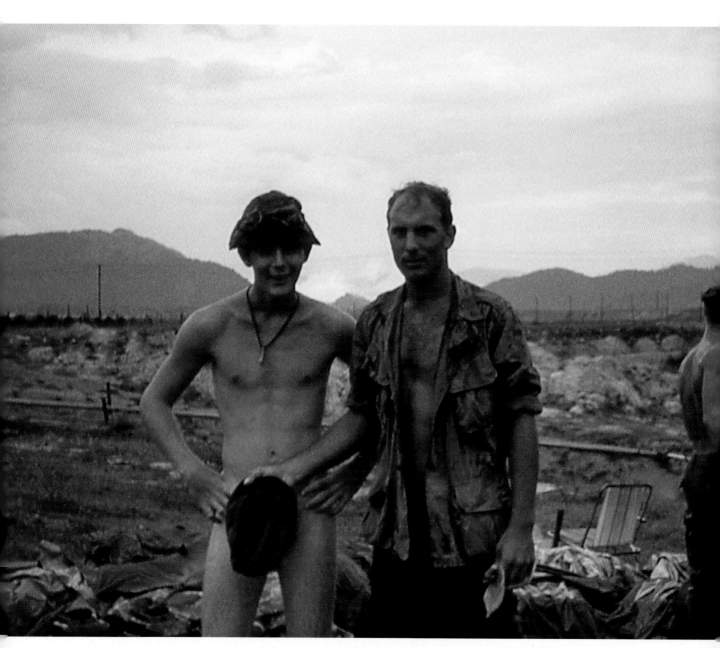

Sometimes lack of modesty is funny; sometimes feigning modesty is funnier.

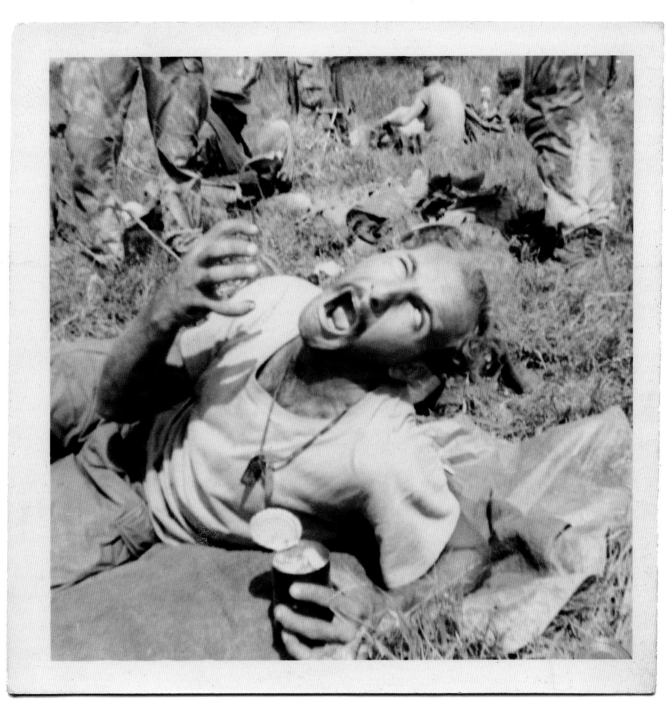

Doing my best Vincent Price impersonation. I was famous for it.

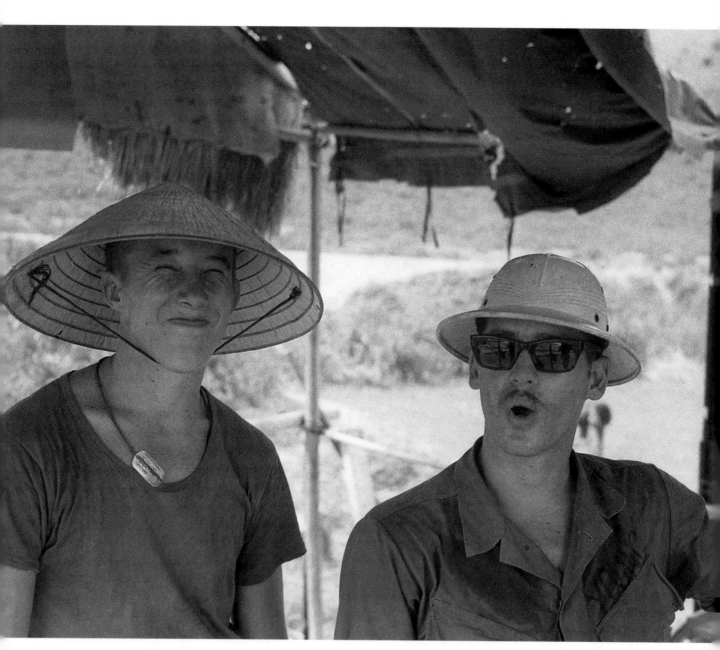

Wilson and Harris. Man, that opiated pot was strong.

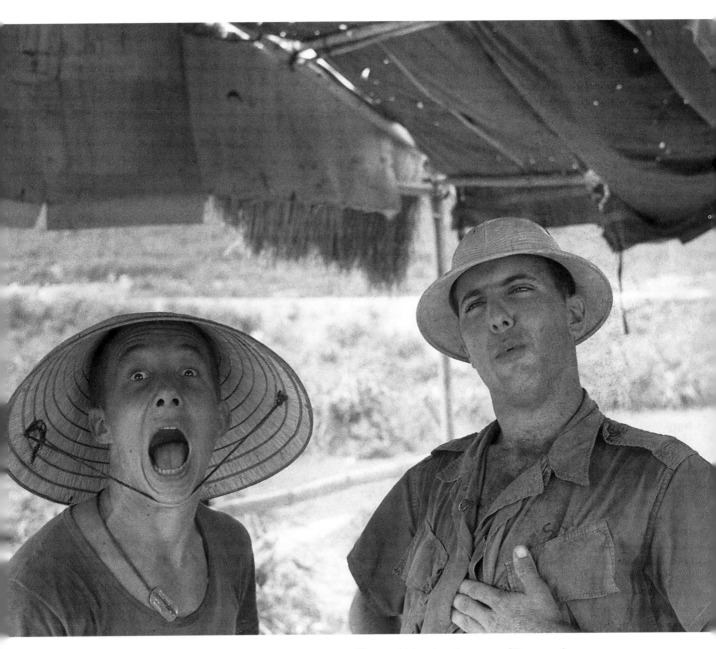

Harris and Waszkiewicz. My line was "Doctor Livingston, I presume?" over and over. Well, it seemed funny at the time.

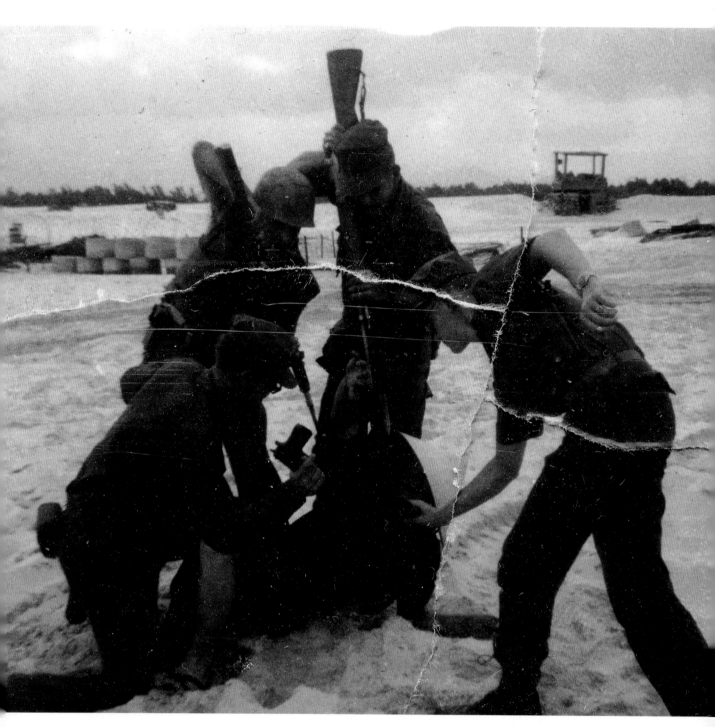

Over-the-top vaudevillians demonstrating how we were going to wipe out Communism and save the world.

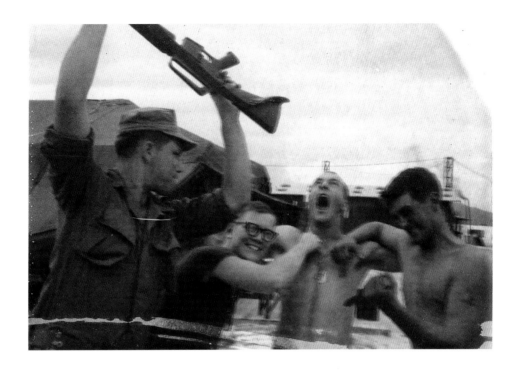

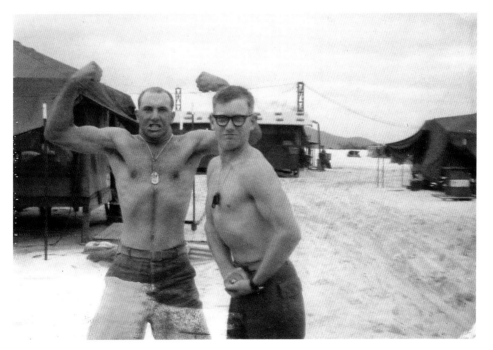

Hazing and posing: some things never change.

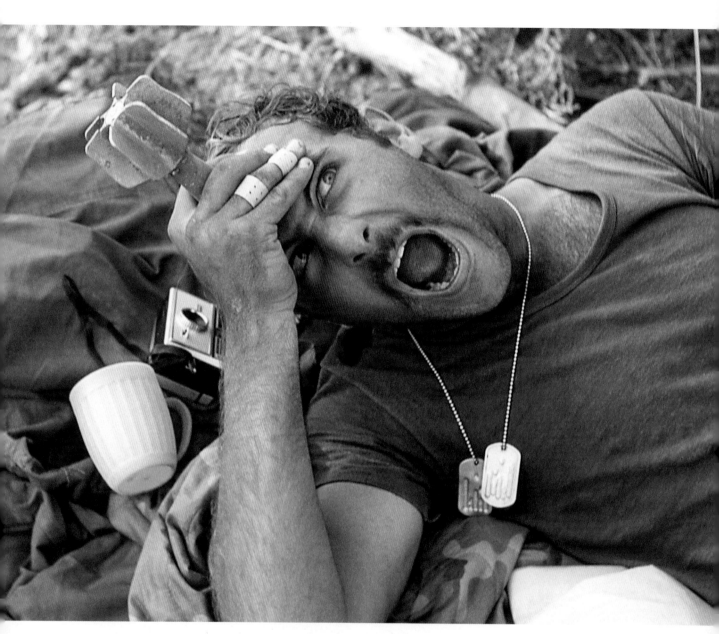

The phrase "Excedrin headache" was originally coined in Vietnam.

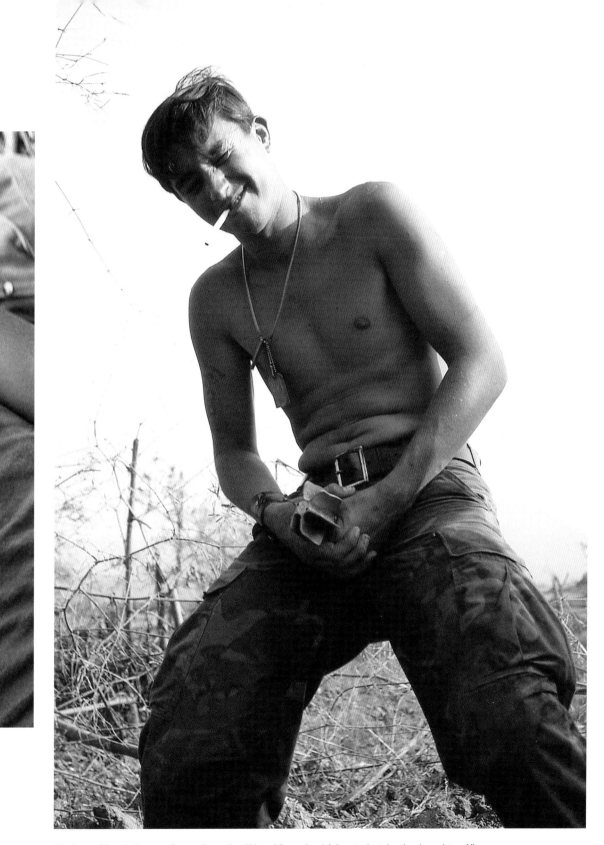

My best friend, Donny Serowik, yells, "Hey, Marc, look! I got shot in the head too!"

We could even find humor on the flight to Vietnam, jokingly looking forward to a crash landing because we had a better chance of survival.

#3

Sergeant Marshall and I chilling out while bullets buzz above. Donny took this picture of us seconds after I took the photo of him on the facing page.

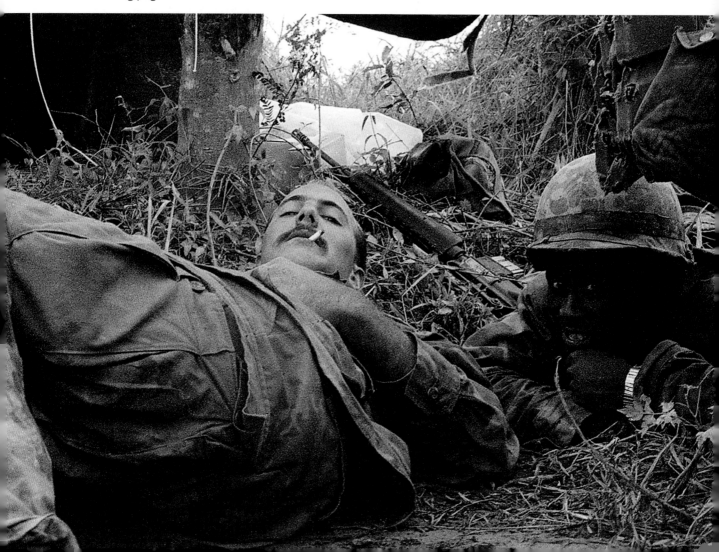

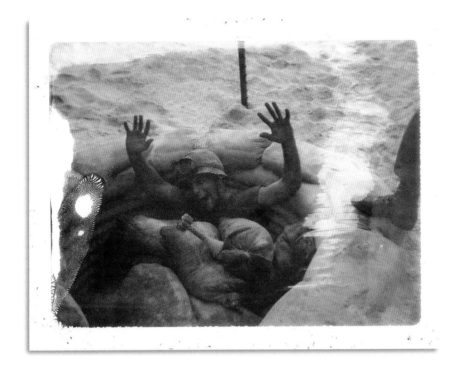

Self-deprecating humor broke both the boredom and the tension of being in a war without seeing any action, a situation that would change soon enough.

Donny Serowik brushing his teeth under fire. Those are my boots in the foreground.

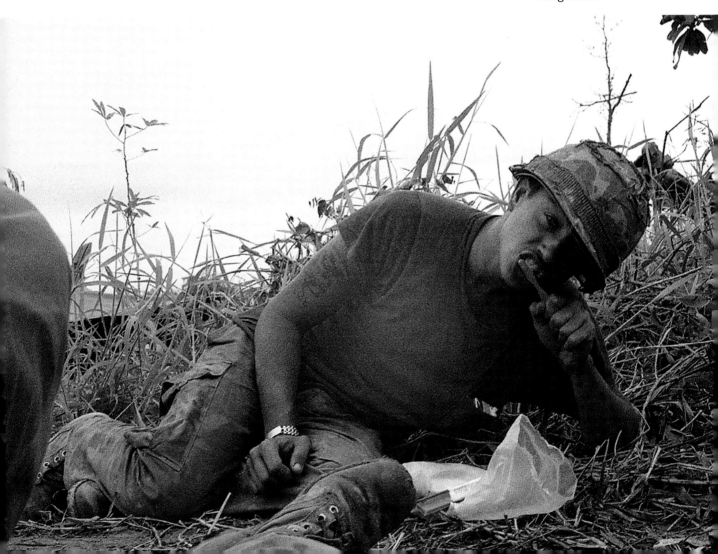

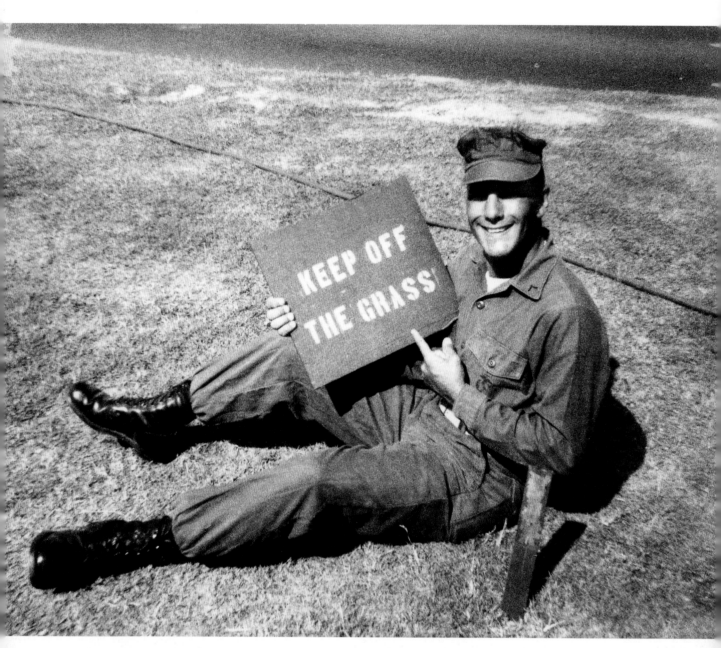

The original, the classic: self-explanatory

THE PEOPLE AND THEIR LAND

IN THE MIDST OF THE WAR, I WAS FASCINATED BY THE VIETNAMESE PEOPLE AND THEIR BEAUTIFUL COUNTRYSIDE

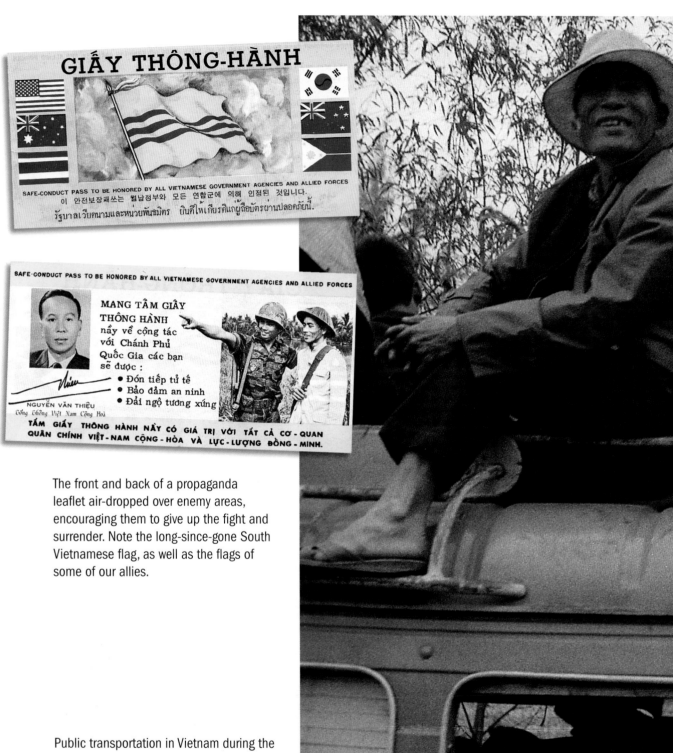

GIẤY THÔNG-HÀNH

SAFE-CONDUCT PASS TO BE HONORED BY ALL VIETNAMESE GOVERNMENT AGENCIES AND ALLIED FORCES
이 안전보장패쓰는 월남정부와 모든 연합군에 의해 인정된 것입니다.
รัฐบาลเวียตนามและหน่วยพันธมิตร ยินดีให้เกียรติแกผู้ถือบัตรผ่านปลอดภัยนี้.

SAFE-CONDUCT PASS TO BE HONORED BY ALL VIETNAMESE GOVERNMENT AGENCIES AND ALLIED FORCES

MANG TẤM GIẤY
THÔNG HÀNH
nẩy về cộng tác
với Chánh Phủ
Quốc Gia các bạn
sẽ được :
● Đón tiếp tử tế
● Bảo đảm an ninh
● Đãi ngộ tương xứng

NGUYỄN VĂN THIỆU
Tổng Thống Việt Nam Cộng Hoà
TẤM GIẤY THÔNG HÀNH NẦY CÓ GIÁ TRỊ VỚI TẤT CẢ CƠ - QUAN
QUÂN CHÍNH VIỆT - NAM CỘNG - HÒA VÀ LỰC - LƯỢNG ĐỒNG - MINH.

The front and back of a propaganda
leaflet air-dropped over enemy areas,
encouraging them to give up the fight and
surrender. Note the long-since-gone South
Vietnamese flag, as well as the flags of
some of our allies.

Public transportation in Vietnam during the
sixties. If you could find a spot, you could
ride for next to nothing.

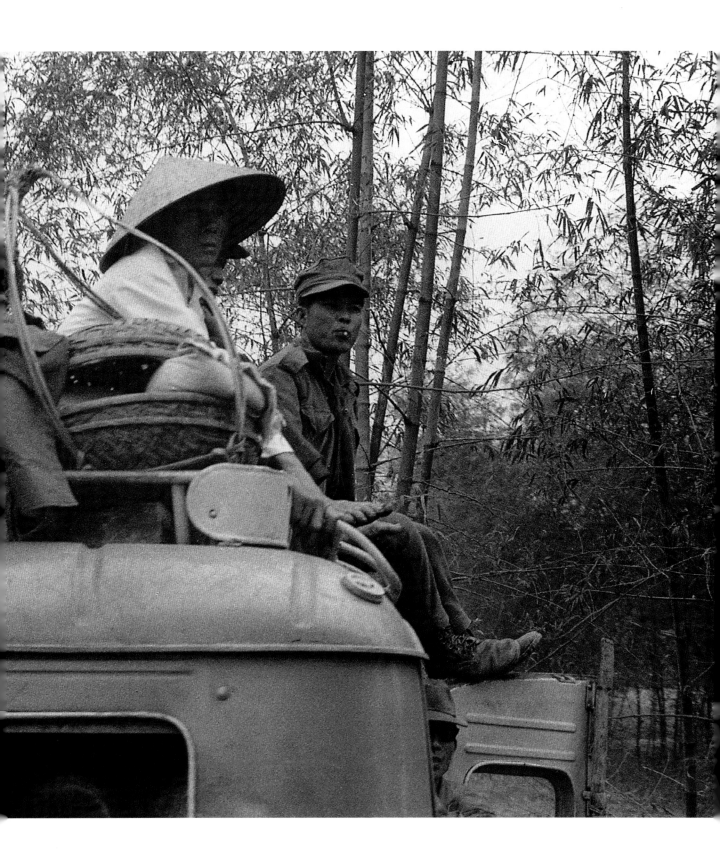

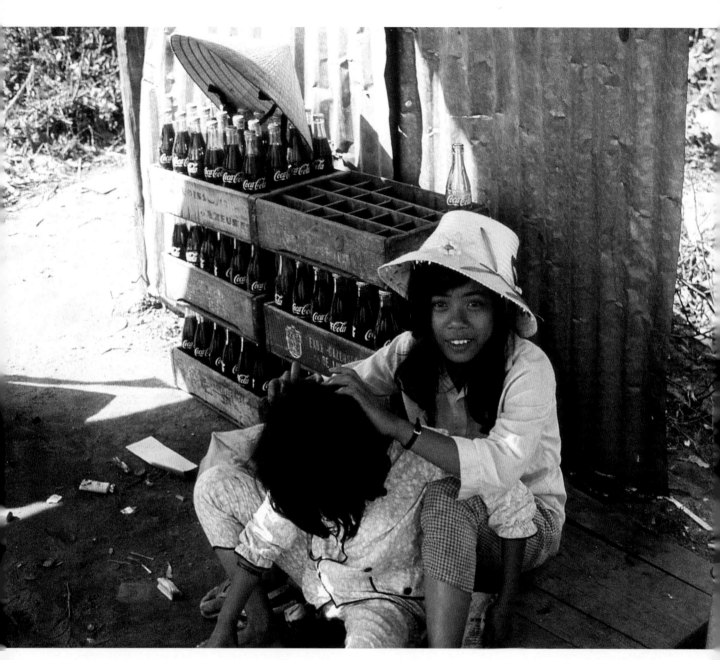

Ice-cold Coke for a buck, right out of the ice chest on the right.

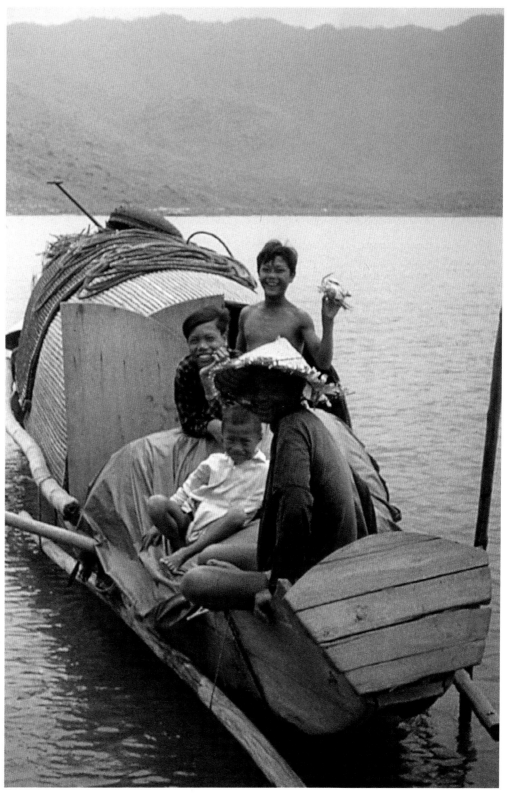

A local fisherman and his family. Kids love pets; in this case, it's a crab.

Vietnam was known as the breadbasket of the Orient. Plowing the rice paddies was a common sight that still evokes the memory of their smell.

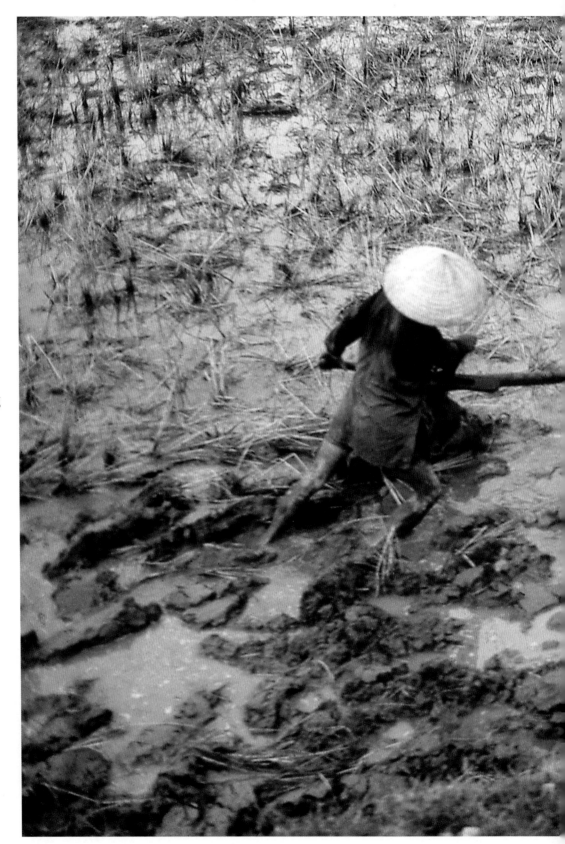

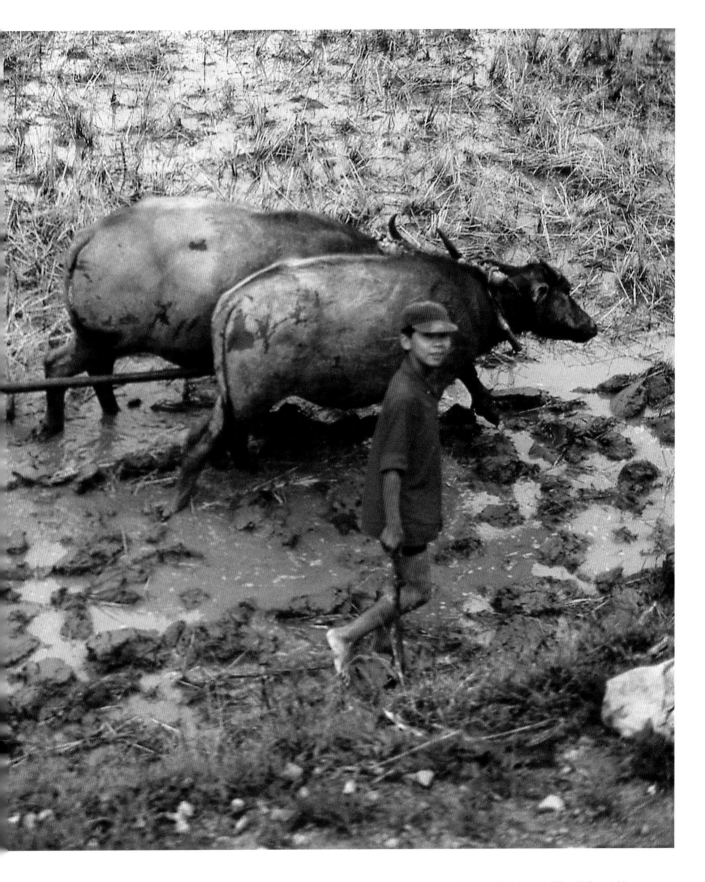

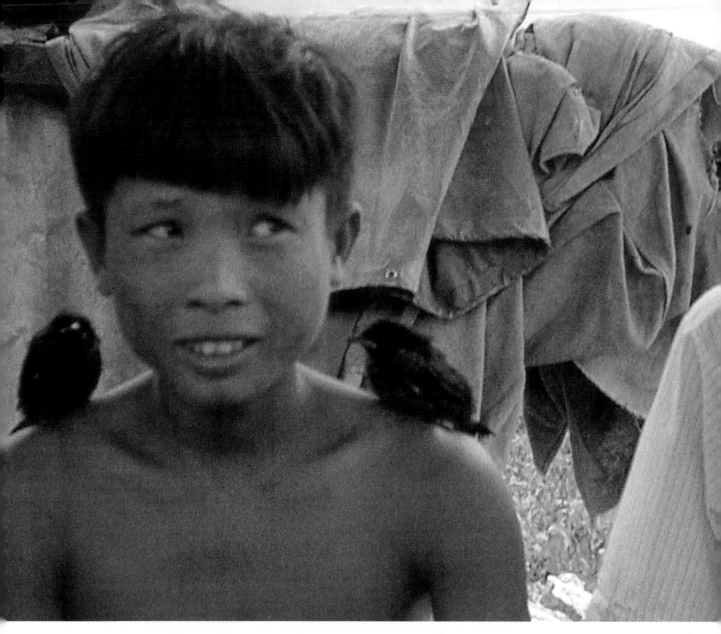

This kid was always hanging around the local Coke shop outside our base. The birds were absolutely bonded to him. He'd carry them atop his head, arms, and shoulders and go about his business. Obviously he garnered lots of attention. He even took them to school with him.

Facing page: First day of Operation Meade River. We were to stay put for a few days while locals were evacuated out of the coming fight zone. This kid came forth and told me, in pidgin English, where the enemy had been and where they headed off to. I thought that bold and brave and convinced Dave Brown, our company commander, to give him some reward. Dave chose a stack of C-ration cases to give him, and I enlisted some other Marines to help me take them to his house. He befriended me, never left my side for the three days I remained there, and even slept with me in my hammock (a common Vietnamese sign of honor and not as it would seem in our culture), talking endlessly about his desire to see America someday. His face was disfigured from a VC mortar attack. I often wonder how he is today.

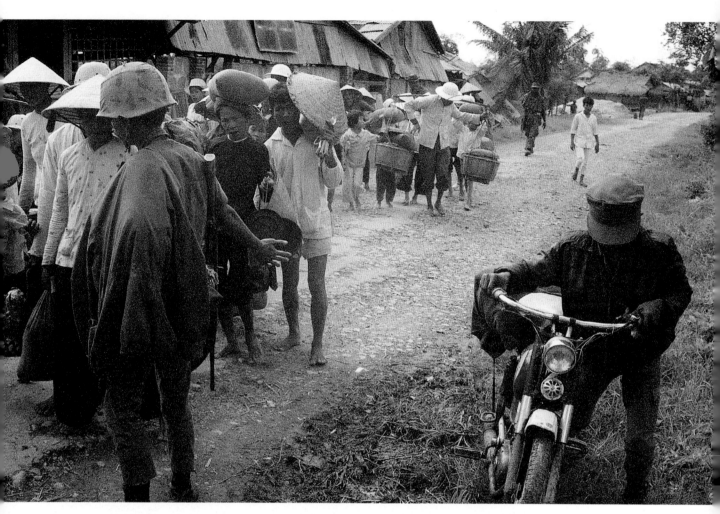

Operation Meade River kicks off. Once we had the area encircled and secured. ARVN troops came in to begin the sorting out of local civilians from enemy impostors temporarily wearing civilian clothing.

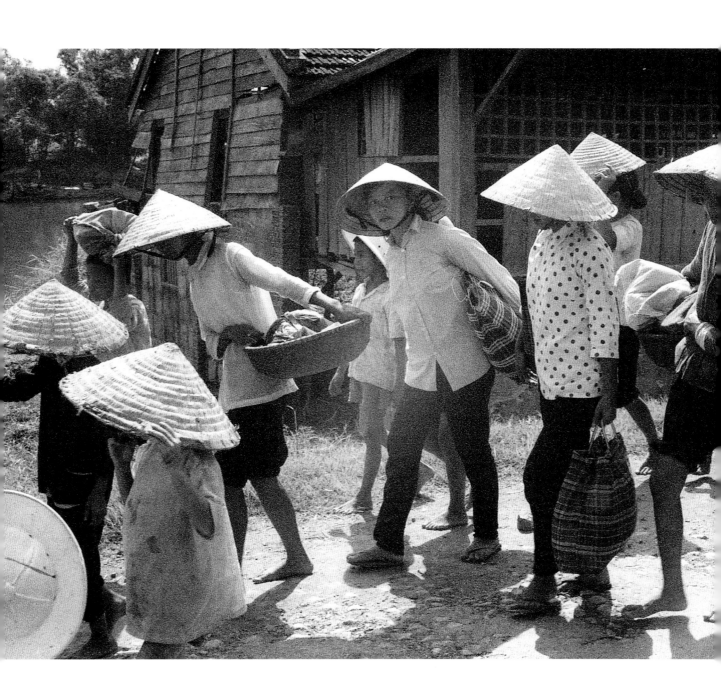

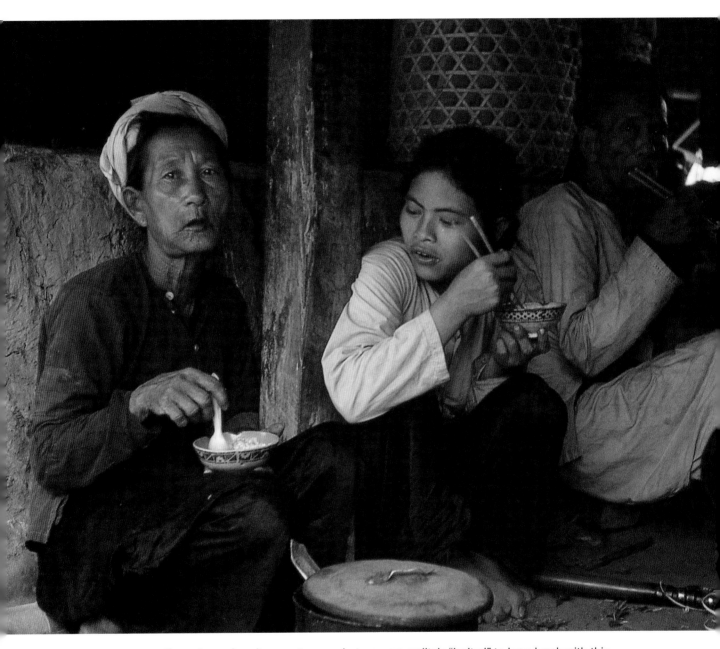

I'm not sure how it came to pass, but we were politely "invited" to have lunch with this family, somewhere deep in the jungle. Likely, they just wanted to be left alone and thought a little hospitality was a good investment. It was monsoon season, and we had been cold, wet, and hungry for days. It was an awkward but much-enjoyed break for us.

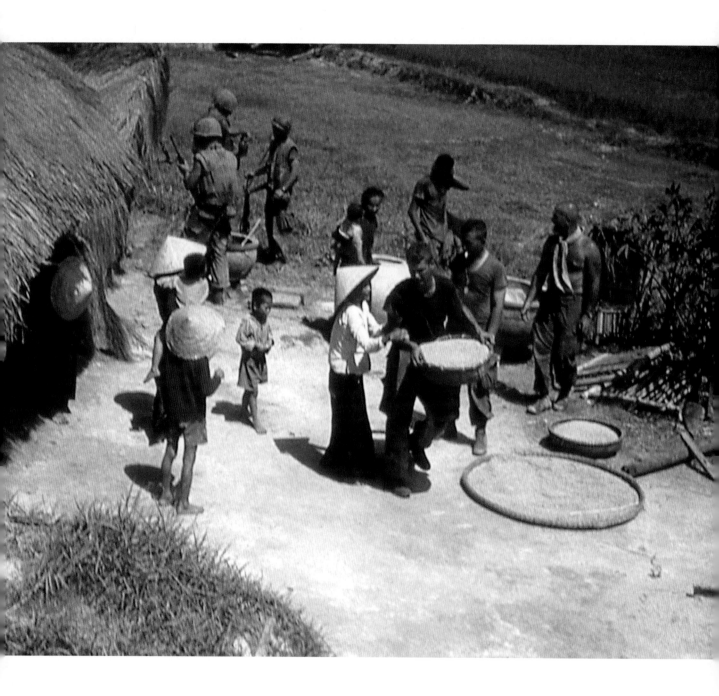

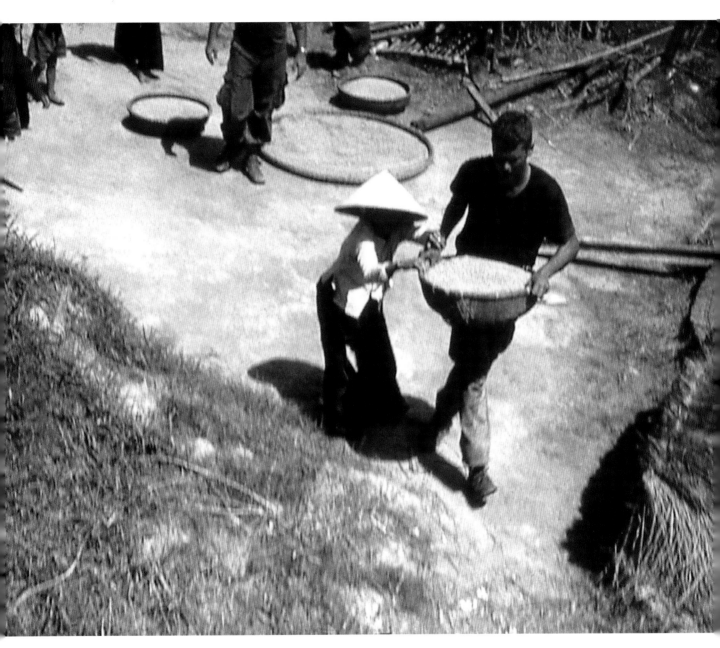

During rice harvest season, we were told to check the amount of rice each family was storing for taxes and necessity. However, the enemy troops in these areas were not locals and counted on the villagers to feed their men. Hence, we were ordered to confiscate their "excess" rice in an attempt to make it harder on the enemy to keep fighting. Those mama-sans did not comply easily.

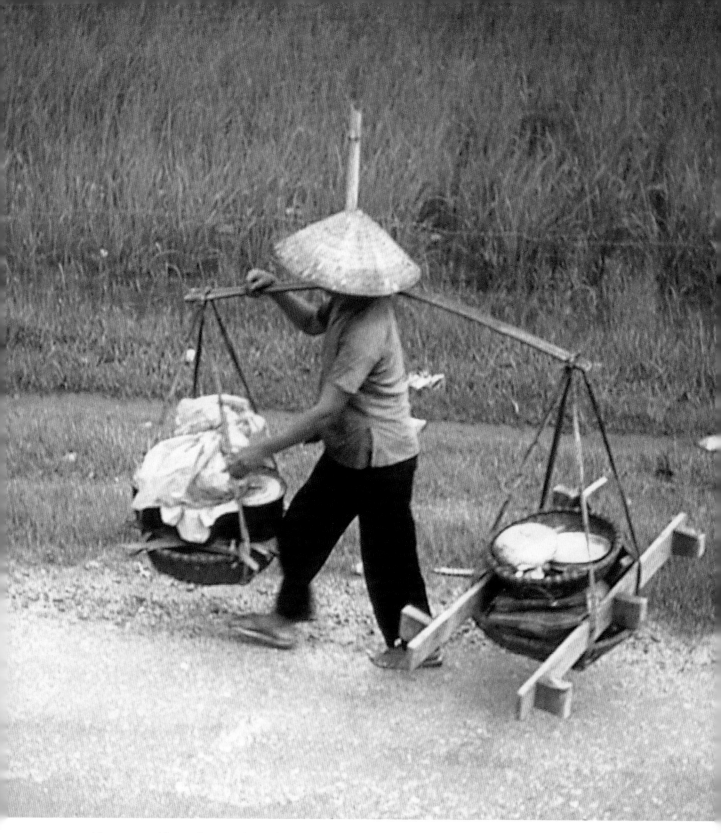

Mama-san with wooden carrying poles and baskets. I was amazed at the strength of some of the older women. I was twice their size, yet they could easily lift and walk with a load that I could not get off the ground!

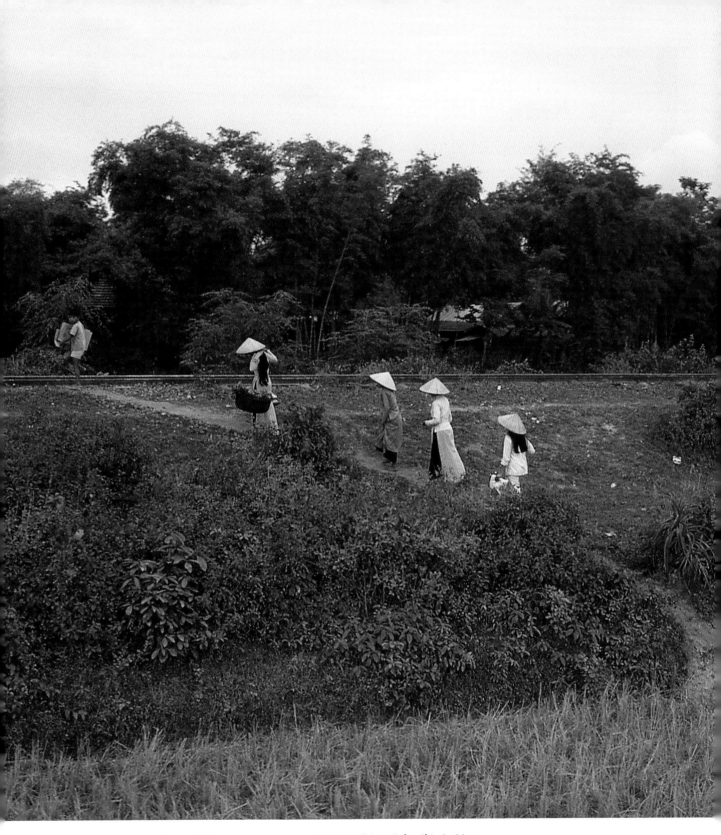

Local Vietnamese; some wear the traditional áo dài clothing.

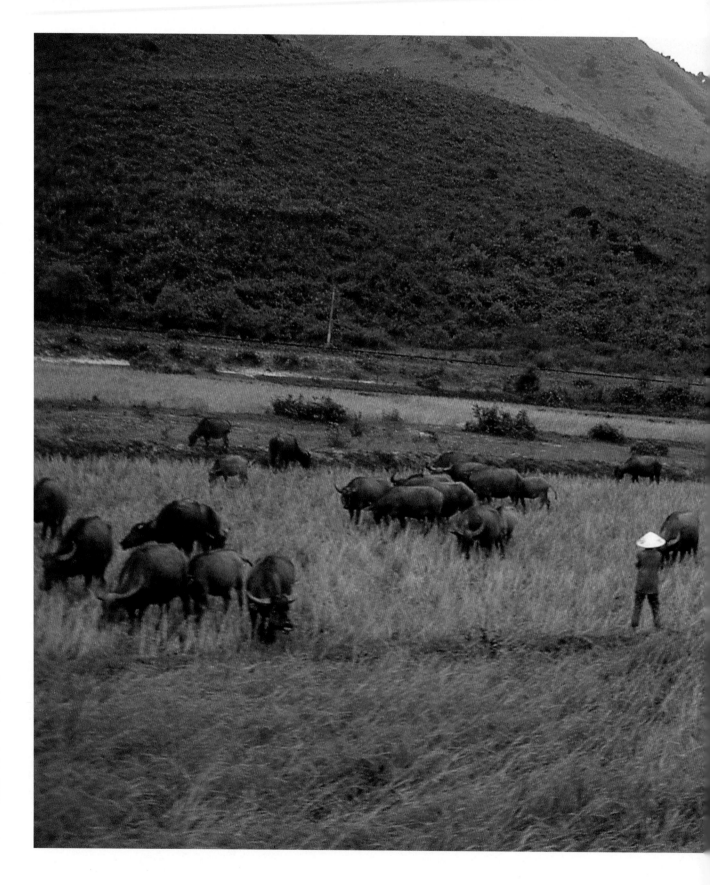

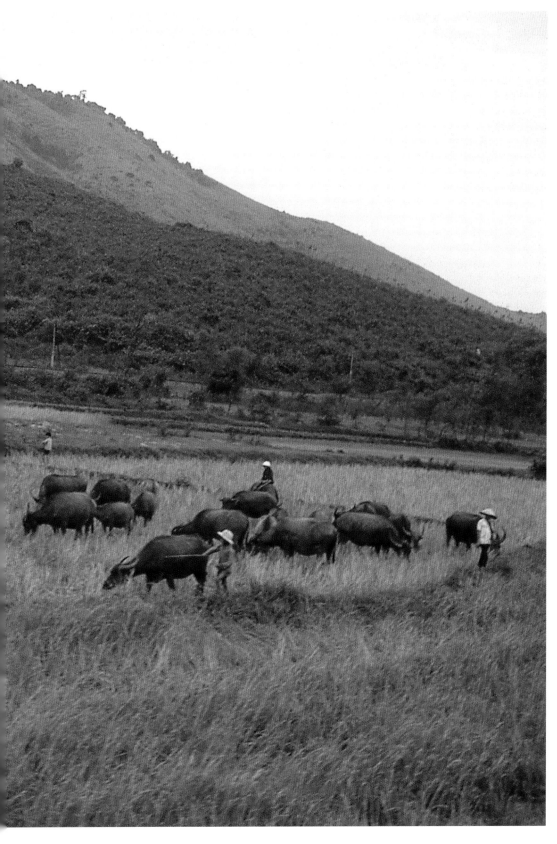

A grazing herd of what we commonly called water buffalo. I don't know if the object was to have them trim down the now-dry and harvested rice stalks, break up clods of earth to turn the soil, or fertilize for next season's crop planting. Perhaps all three.

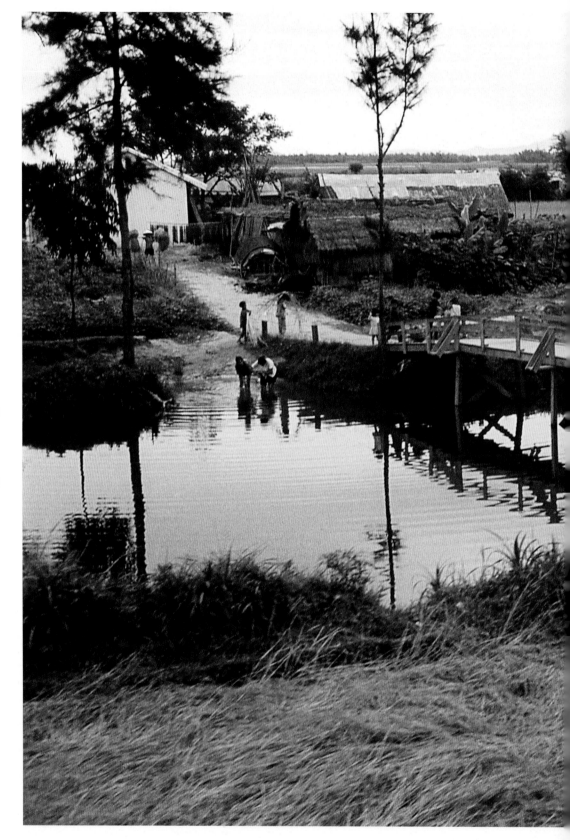

A pastoral scene along Vietnam's central coast. Lush gardens and immaculate grounds like these evoked daydreams about retiring to a place just like this after we won the war.

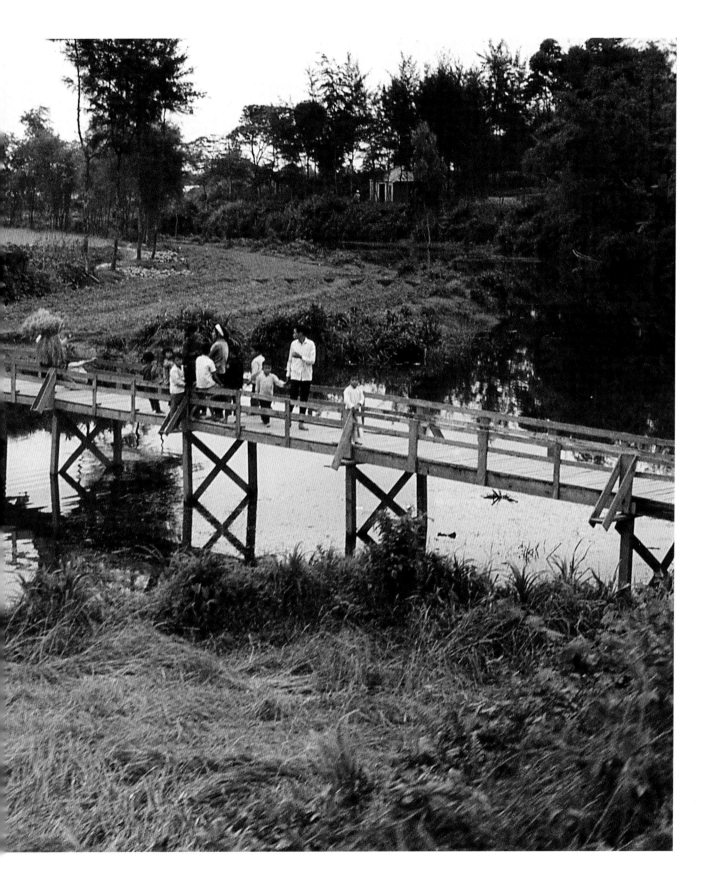

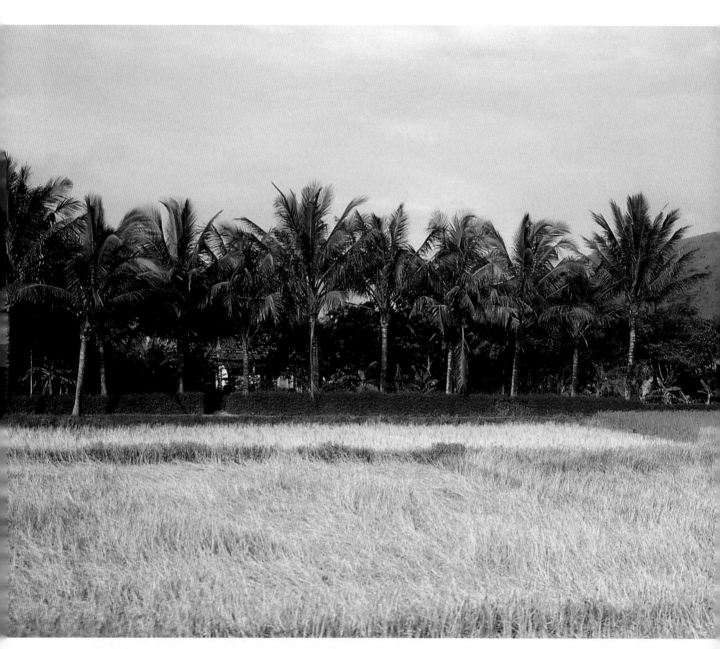

Nothing says Vietnam like palm trees and rice paddies.

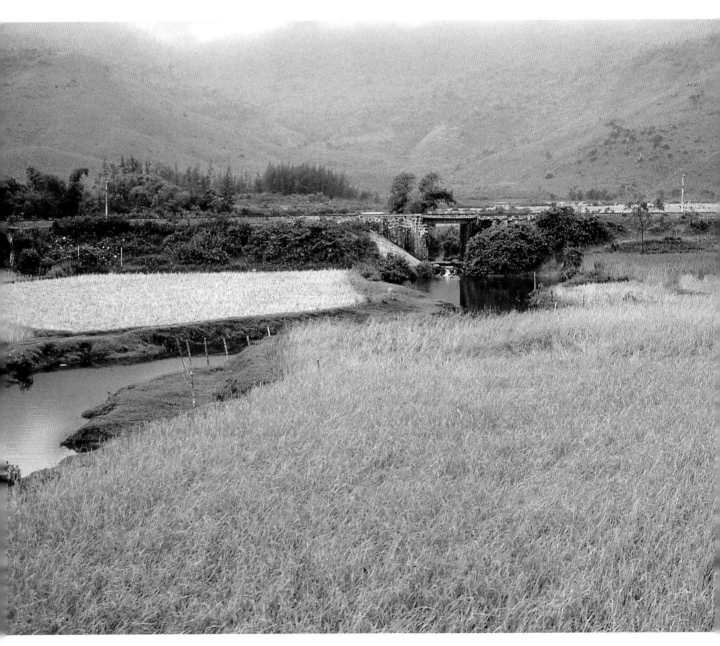

One of my favorite photographs of the countryside. I sometimes gaze at this picture and dream of being there.

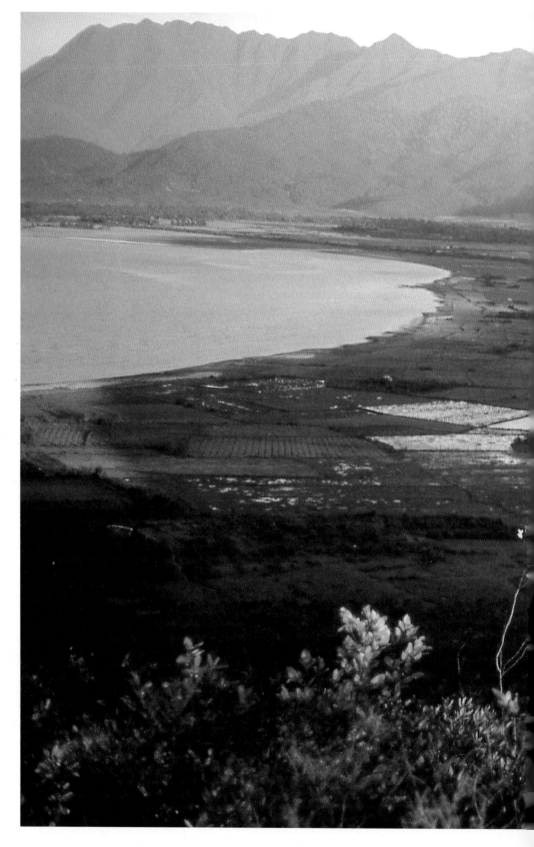

Highway 1 and the narrow-gauge railway, both connecting Saigon and Hanoi. They were built by the French decades earlier. We maintained the road but not the railway. This stretch is between Phu Bai and the Hai Van Pass, looking south.

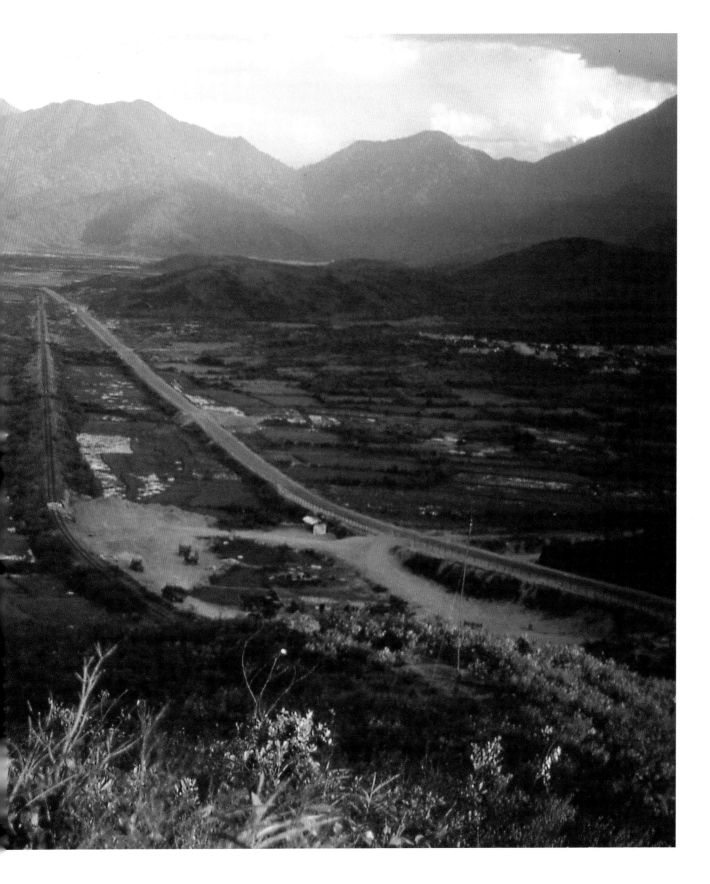

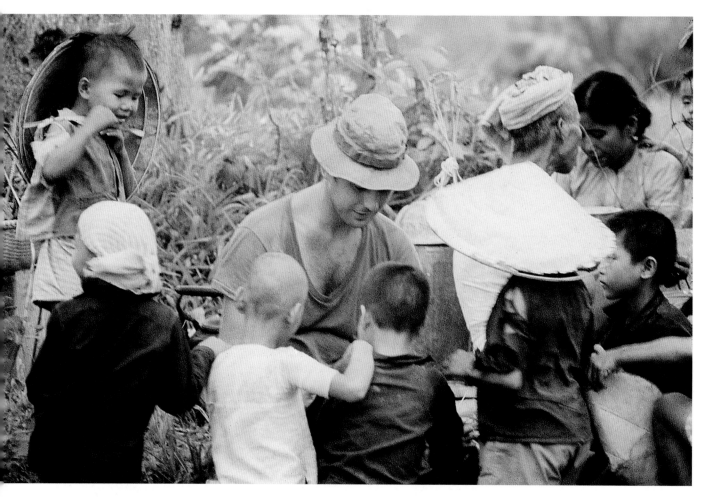

MEDCAP. An armed group, including a corpsman, would go into a local village to address medical, health, and hygiene issues. In this case, they are handing out toothbrushes and teaching kids how to care for their teeth.

Facing page: As in most Asian countries, smoking cigarettes begins early. Nothing opens the doors of friendship better than a simple gift.

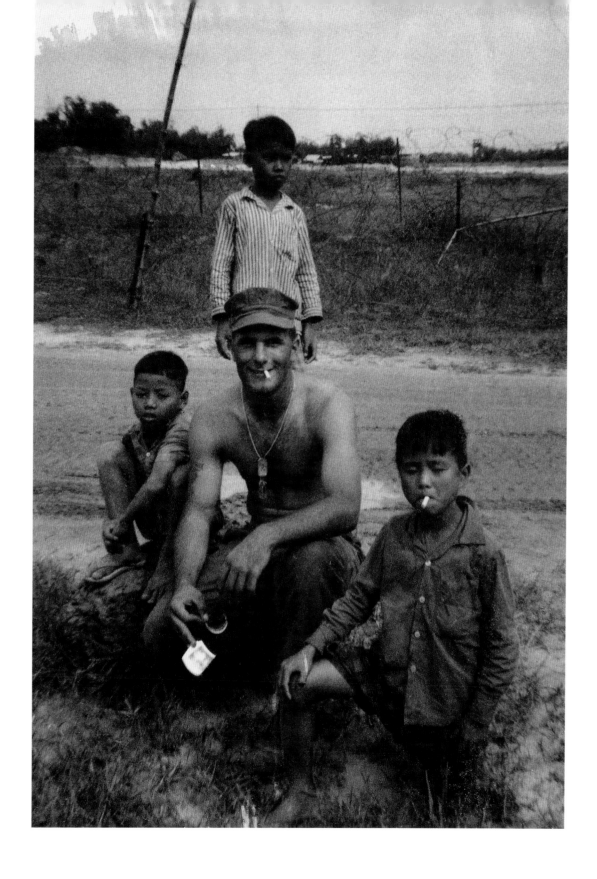

Placid calm masks the constant underlying tension of being in a war zone with mines, booby traps, and snipers. Travel was safe nowhere.

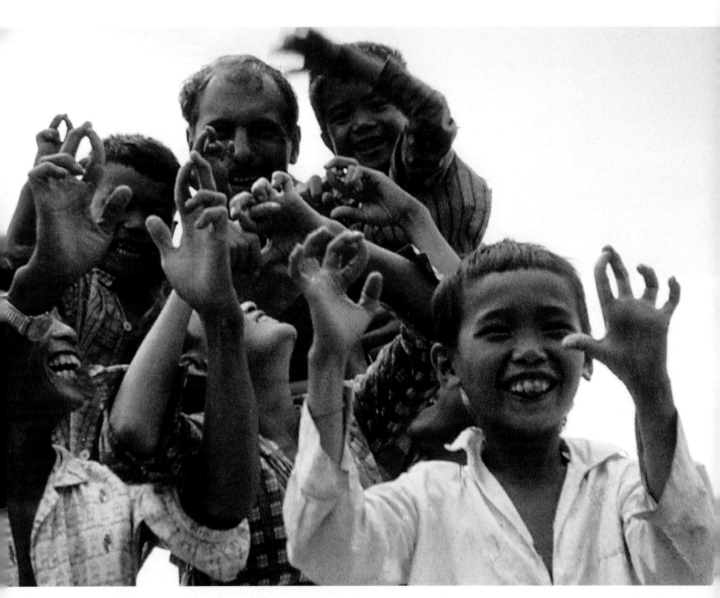

Obscene hand gestures are common the world over. In this case, I found the local idiom to be unusually humorous.

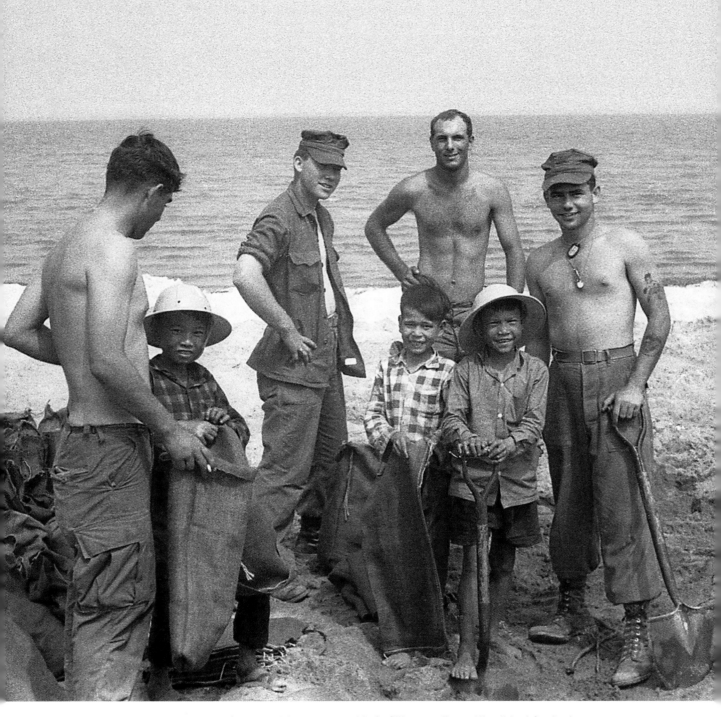

They just wanted to befriend us. We just wanted help filling sandbags. We all had fun in the process.

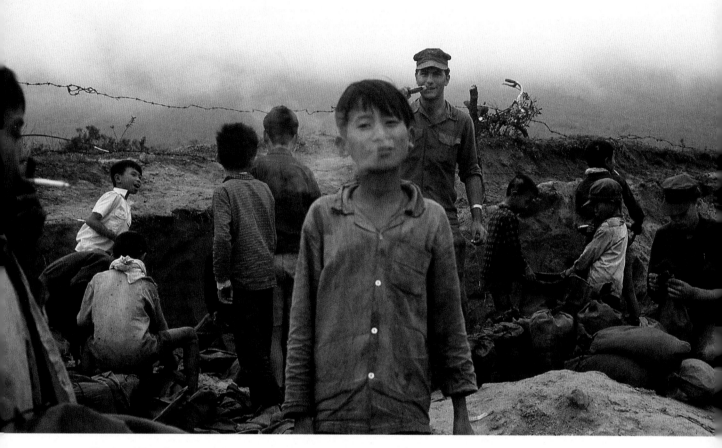

The local Tom Sawyer takes a break to smoke his reward for the sandbag work the younger kids are doing at his direction. I supervised and maintained discipline among my work party.

Facing page top: Whenever we could, we would take time and effort to help those suffering or in need.

Facing page bottom: Our corpsman, having cleaned a woman's amputation stump, applies a sterile dressing in hopes of preventing infection.

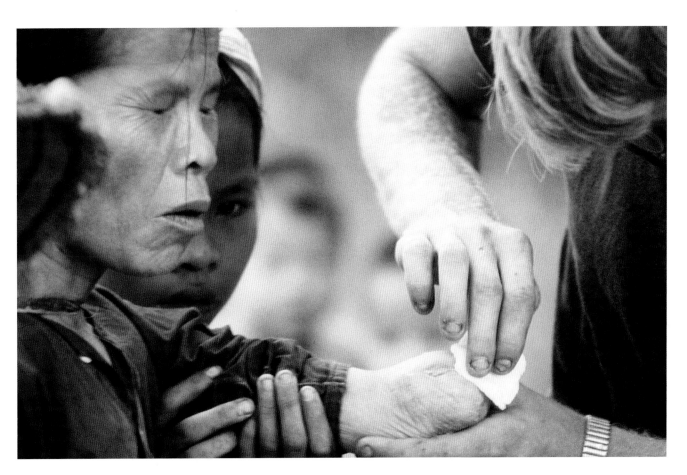

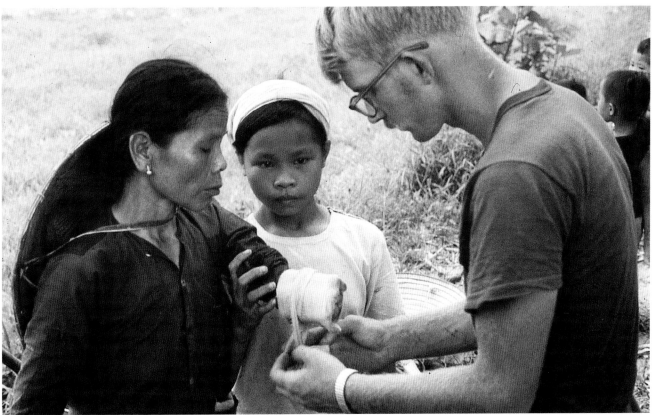

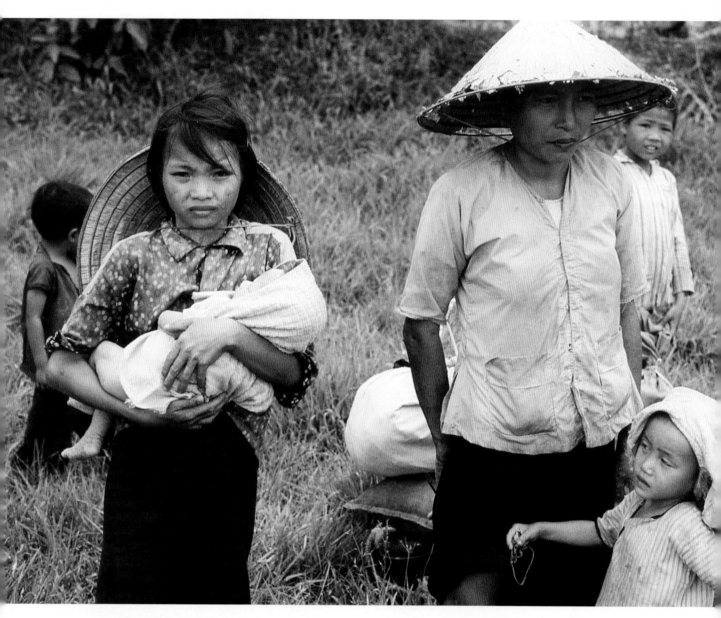

Refugees from a free-fire zone. Three generations waiting for relocation. Their religion ties them to the land of their ancestors. These people will no doubt soon return to their villages and rice paddies.

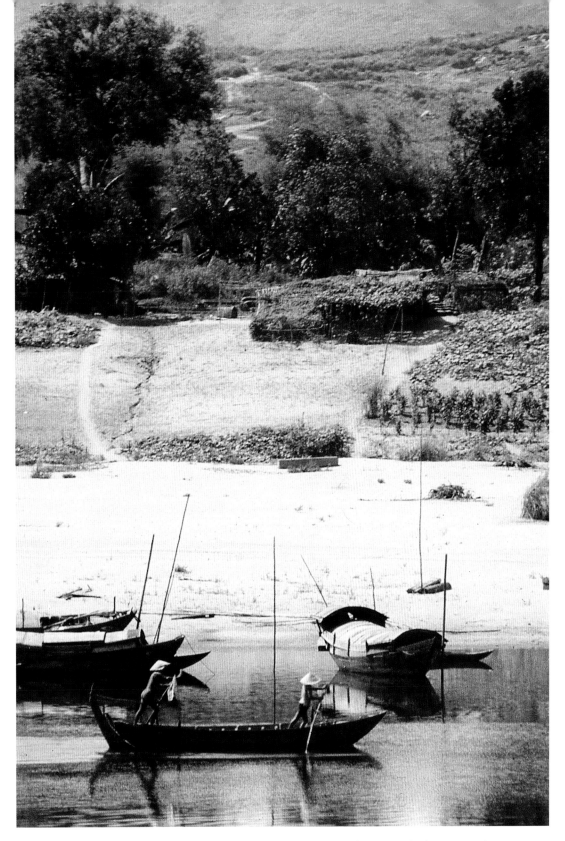

A trail from the interior of the country leads to this farmhouse and sampan dock at a popular river crossing.

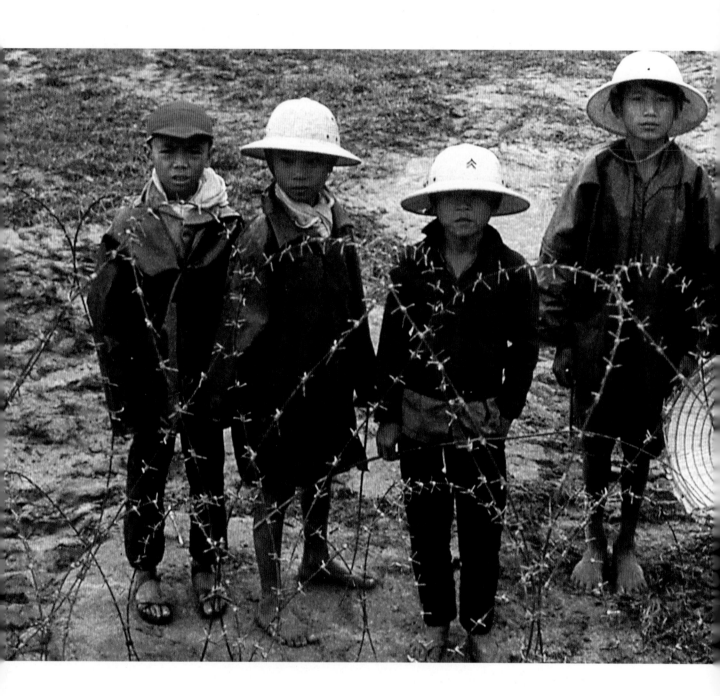

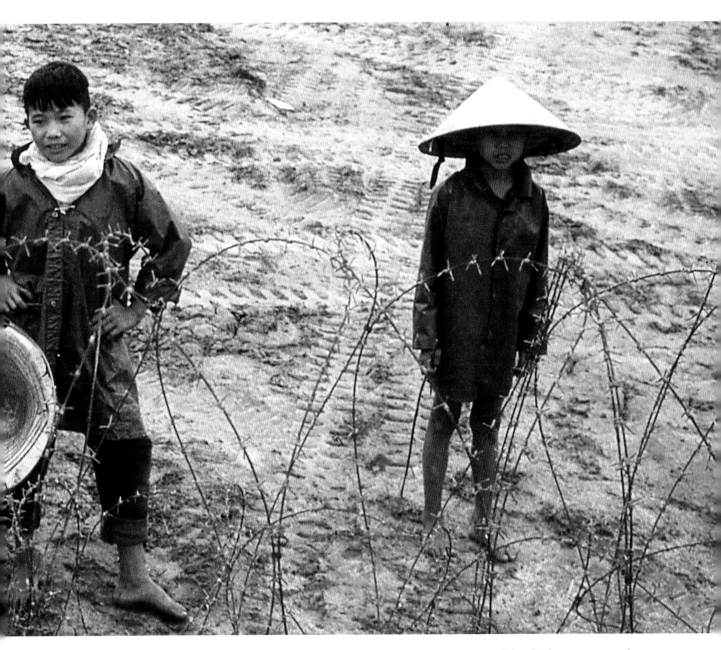

Not always as clearly illustrated as here, there was always a small barrier between us and the local people. You never knew whom you could really trust when you turned your back, no matter how friendly they might appear during the day.

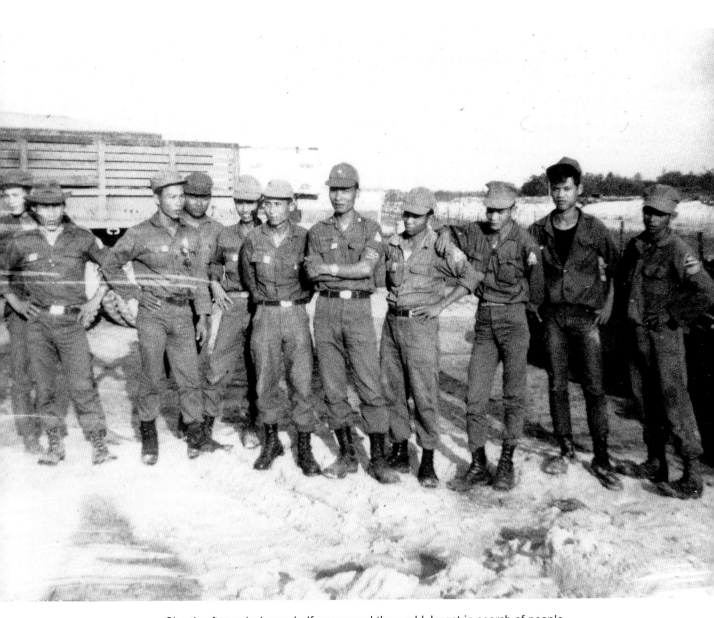

Shortly after arrival, now halfway around the world, I went in search of people
to meet and photograph. Here are a couple of my very first acquaintances.

A local policeman at a checkpoint in town. From my perspective, their main purpose seemed to be directing traffic when things got hectic.

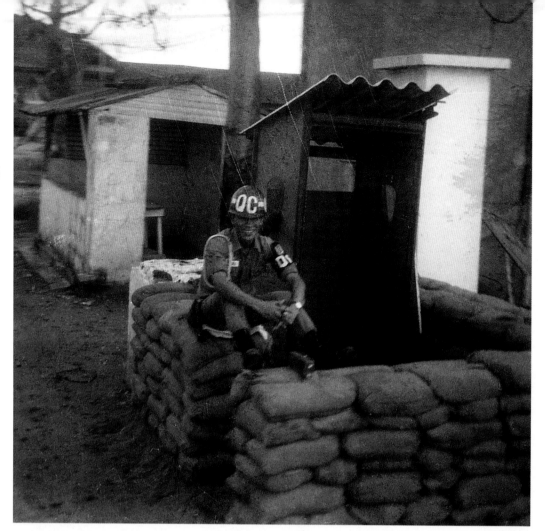

Lieutenant Lich was the first ARVN soldier I met.

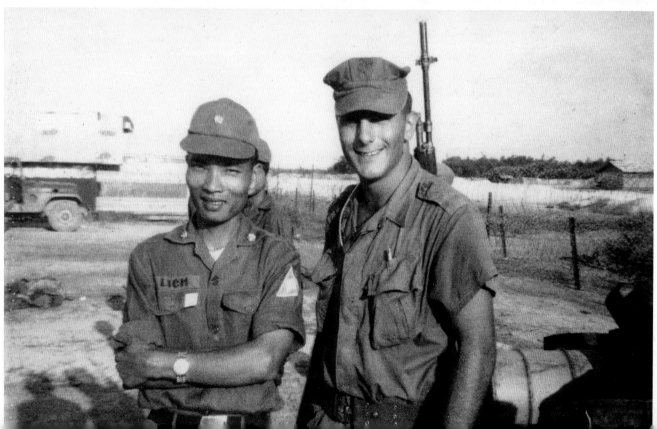

THE STARE

THEY WERE GONE SUCH A SHORT TIME BUT CAME BACK CHANGED. THEIR EYES SPOKE VOLUMES, HAUNTED BY DREAMS YOU CAN'T OUTRUN.

From photo-booth civilian to honorably discharged Marine in exactly three years, my face shows the accelerated aging caused by war's stress.

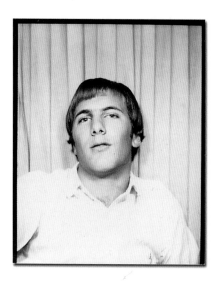 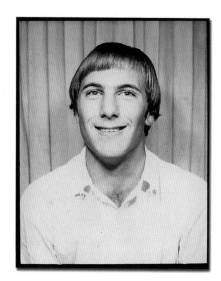 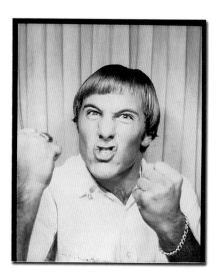

Photo-booth snapshots taken just before boot camp. Raised in a military family and a product of post–World War II American idealism, I gave up my college deferment and signed up to become a United States Marine.

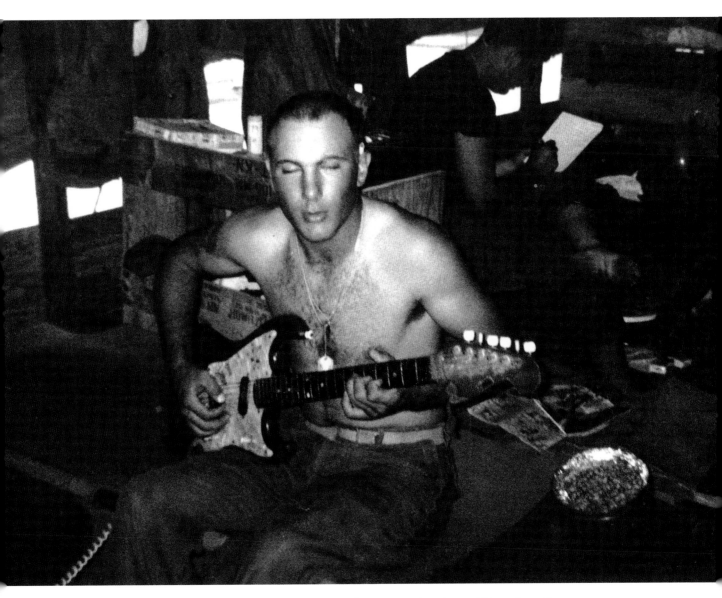

Looking back over my photographs, I am amazed at the rapid transformation from boy to man. This picture of me was taken shortly after my arrival in Vietnam, October 1967.

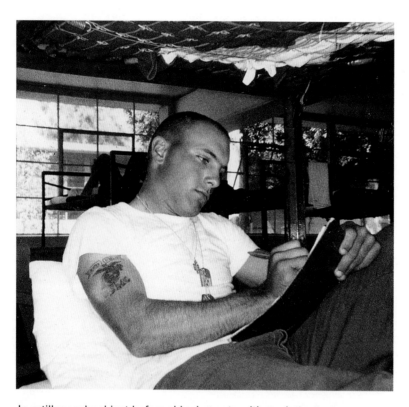

In artillery school just before shipping out, writing a letter to my girlfriend. Letters from home would come to have more weight and significance than I ever could have suspected. The girls who ended up writing some unfortunate soldier a dreaded "Dear John" letter never knew the damage done.

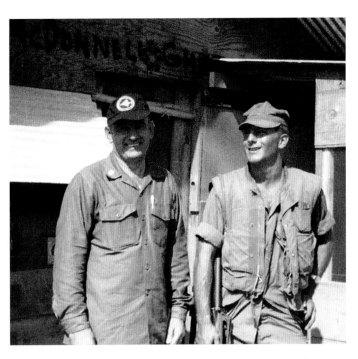

A surprise three-day visit by my father, who worked as a field rep for the company that made Phantom jets, included our mutual baptism by fire during an enemy mortar attack on his first night's visit. We shared a foxhole, shoulder to shoulder, awaiting a ground attack that never materialized.

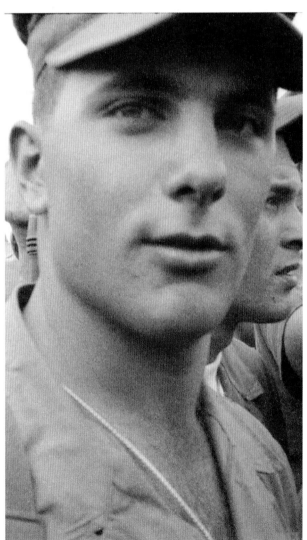

At the 1967 Bob Hope Christmas show in Da Nang

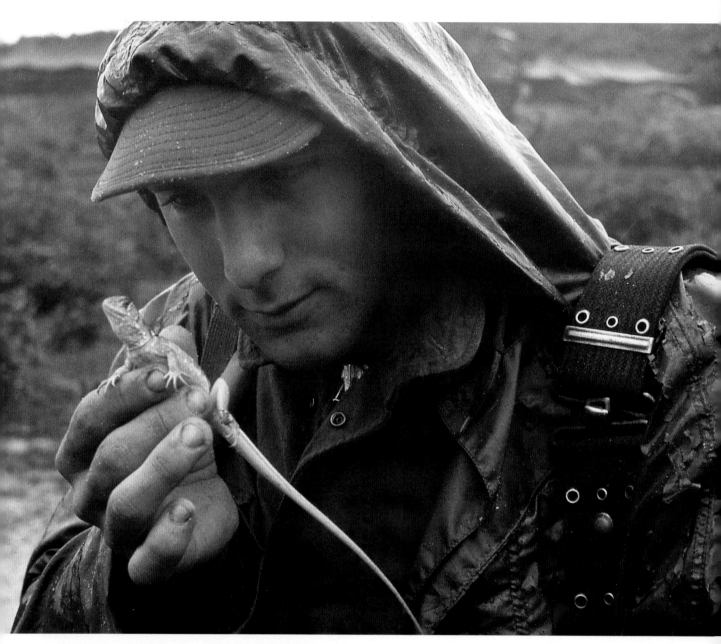

I was fascinated by just about everything.

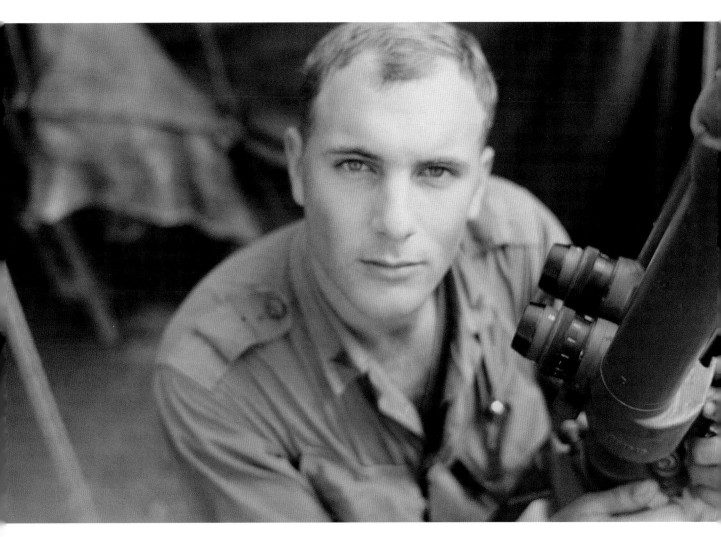

Watching the results of an artillery fire mission through a battery commander's (BC) scope. Shaped much like a periscope, it allows you to look over the top of your protective cover without having to expose yourself to enemy fire.

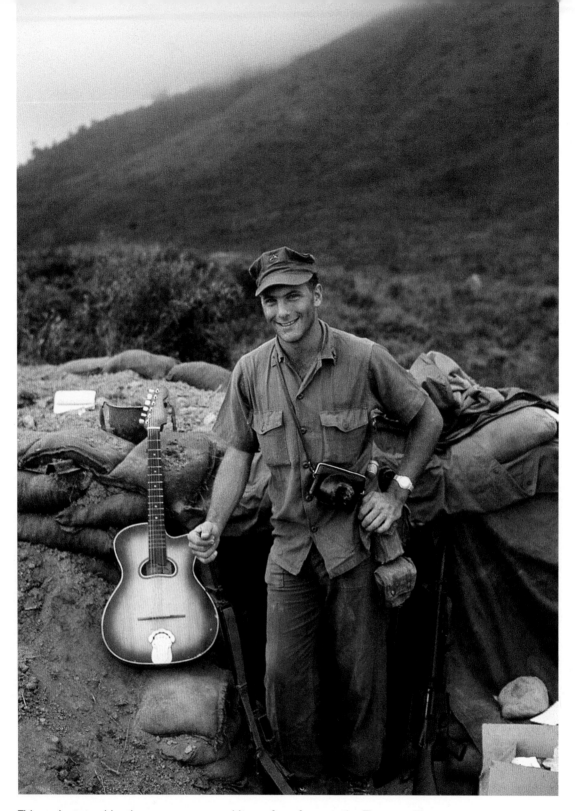

This underground bunker was my personal home for a few months. The amenities included a guitar, a camera, and a battery-powered record player with one album that played "Whiter Shade of Pale" incessantly.

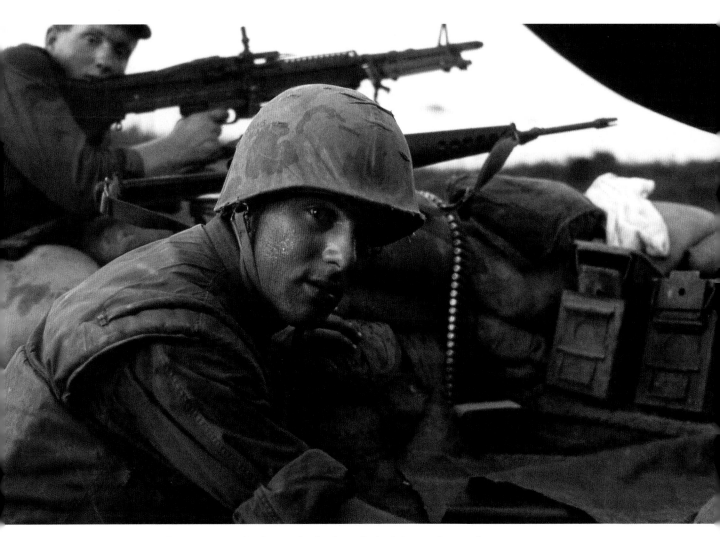

The intensity of being under fire just choked the youth out of us.

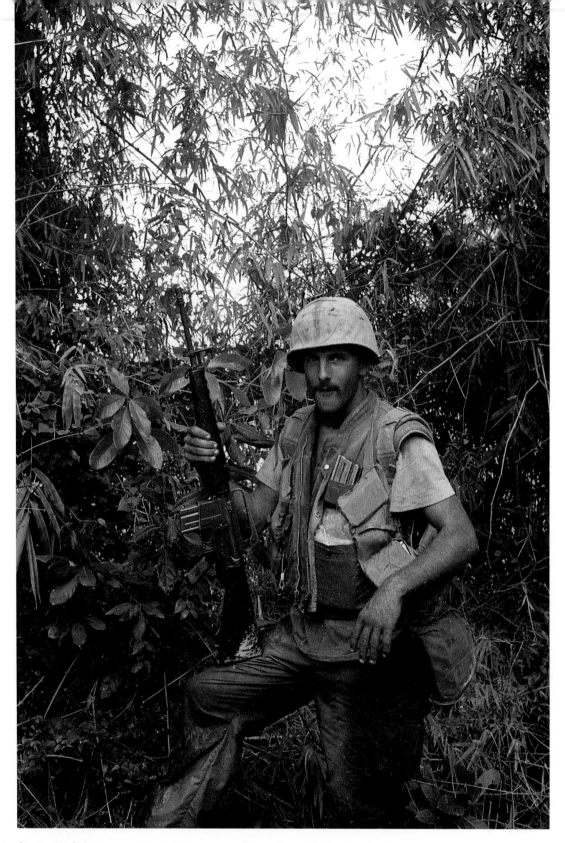

Out in the field as a corporal with my own artillery forward observer team

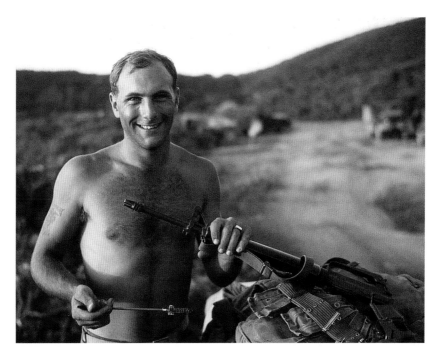

Keeping weapons and ammunition clean was imperative.

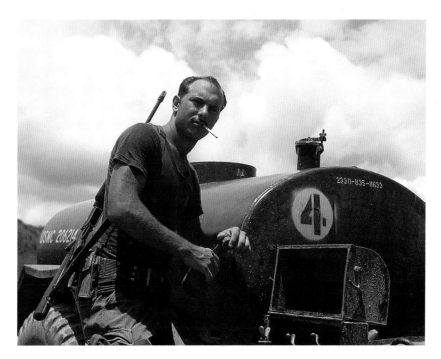

Filling my canteens at one of the many trailered water tanks, which we lovingly called "water buffalo"

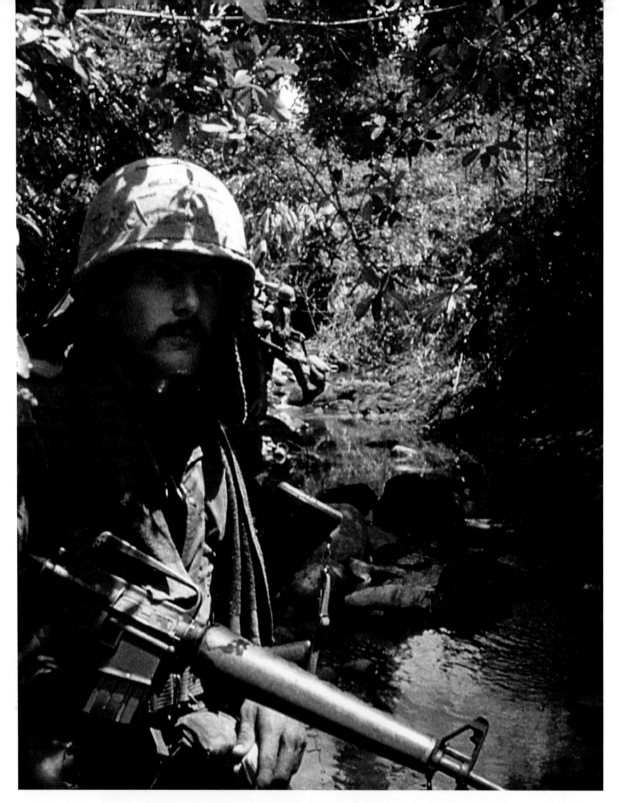

Deep in the mountain jungles, mingling with the sound of the running stream, we repeatedly heard whispered commands and the clicking off of rifle switches, but we never saw a soul. We were searching for an underground enemy hospital, and I'll always wonder how close we came to finding it.

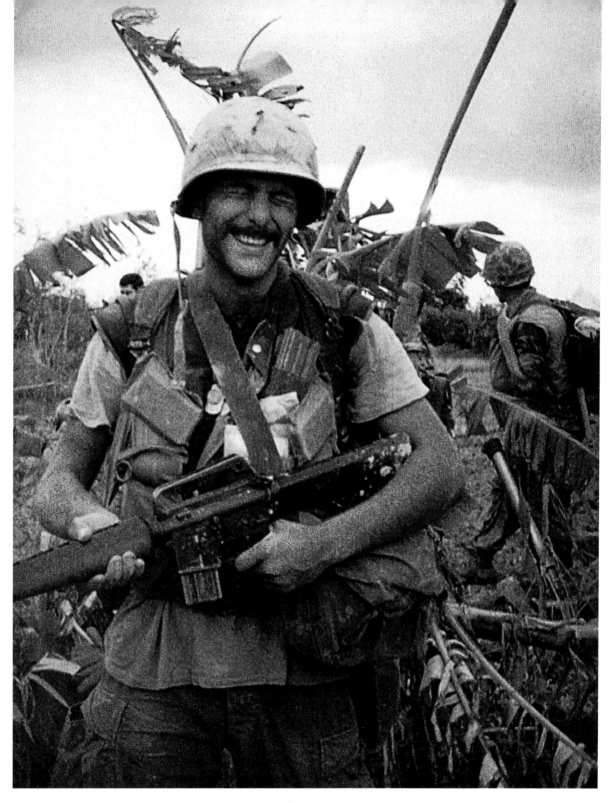

To this day, this picture reminds me not to take myself too seriously. The battle-scarred background, including the shredded foliage here, provides a grim counterpoint to my laughter.

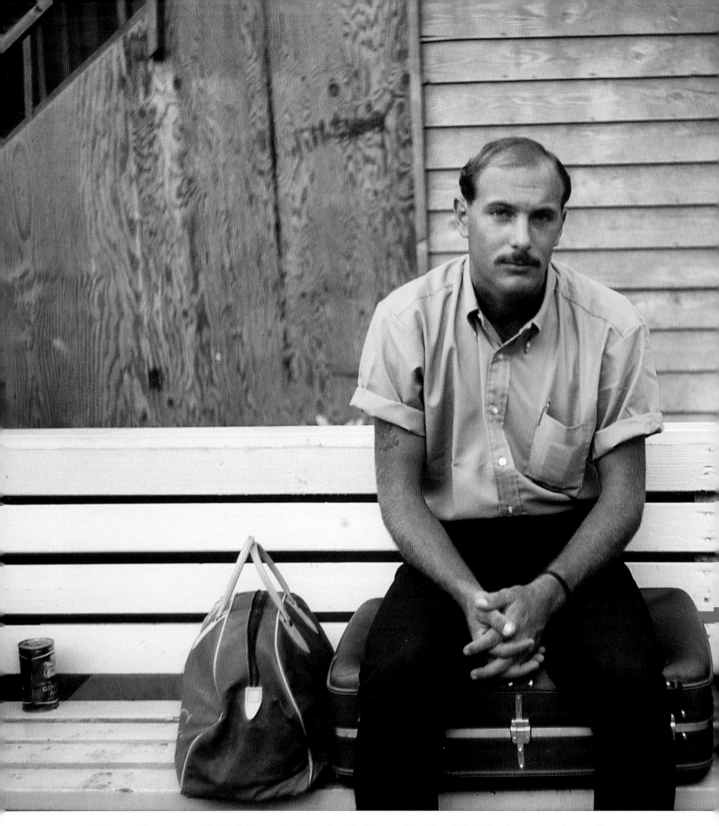

After nearly a year and a half in-country, I am headed home for a free thirty-day leave as a bonus for extending my tour an extra six months.

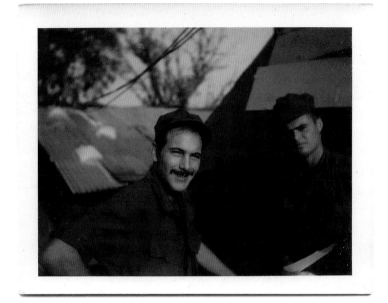

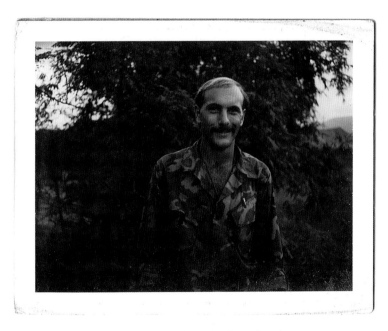

Snapshots while recuperating at 1st Med Battalion from a
jungle infection on my ankle. In addition to the horrific lancing,
I received six injections a day of antibiotics for eight days. Every
muscle group in my body was assaulted.

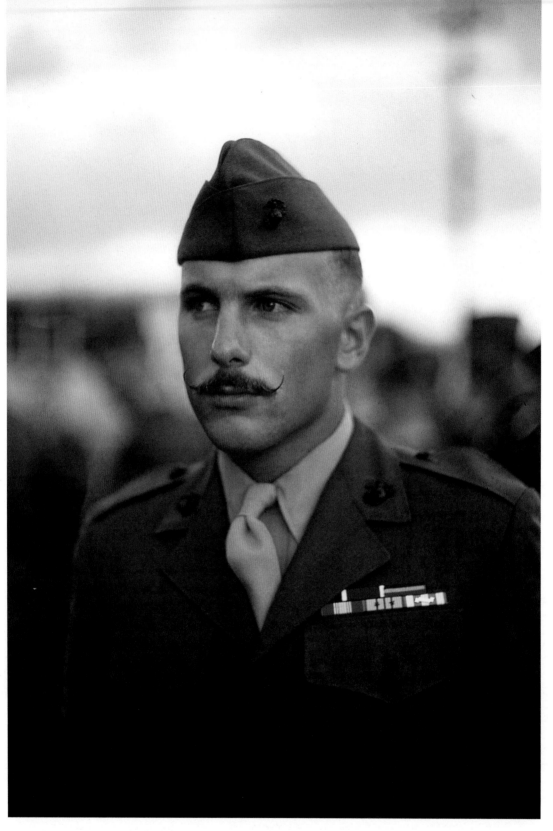

They made sure we looked sharp before letting us go home, but they couldn't change our countenance.

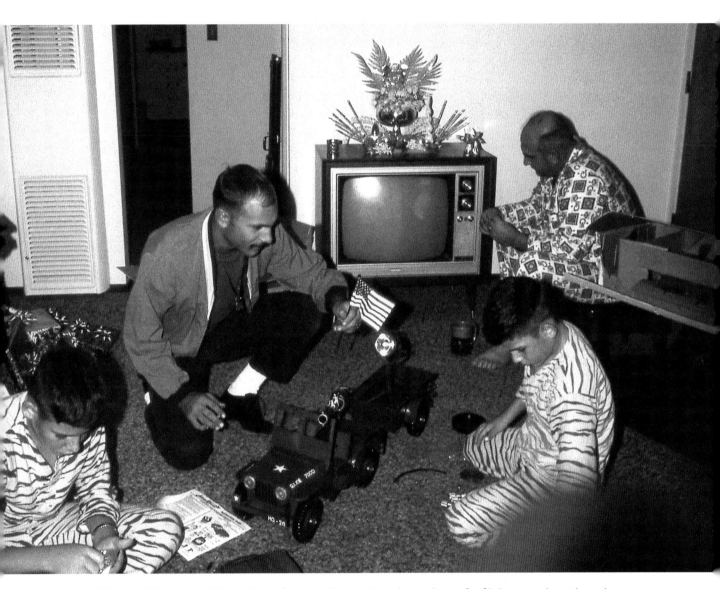

With my thirty days of bonus leave for extending my tour, I went home for Christmas, where the culture shock was more extreme than had been my arrival in Vietnam. Dad watches TV while I observe my two half brothers in their tiger-striped pajamas (so similar to the Korean jungle cammy). They play with their G.I. Joe combat sets. I can still smell the stench of death under my fingernails.

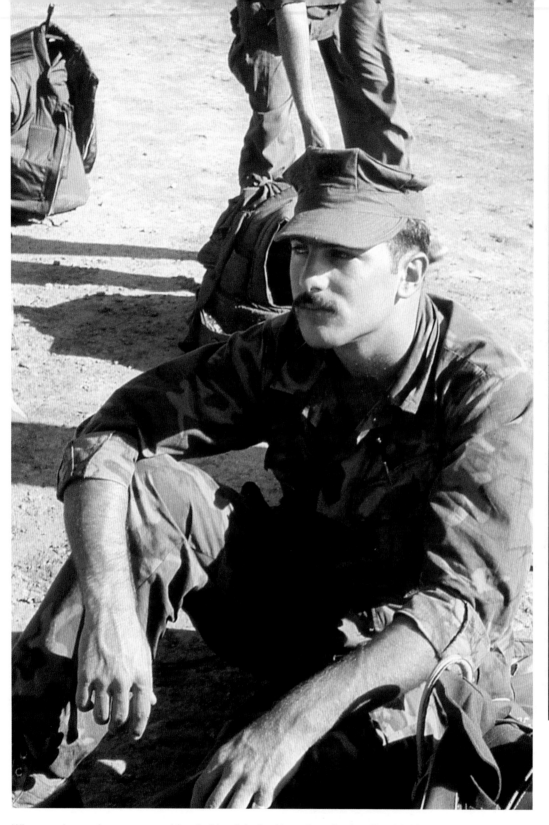

When my bonus leave was up, I landed back in Da Nang. I sat in the dirt, thinking about how comfortable I was here in 'Nam and how uncomfortable I had felt being back home in America.

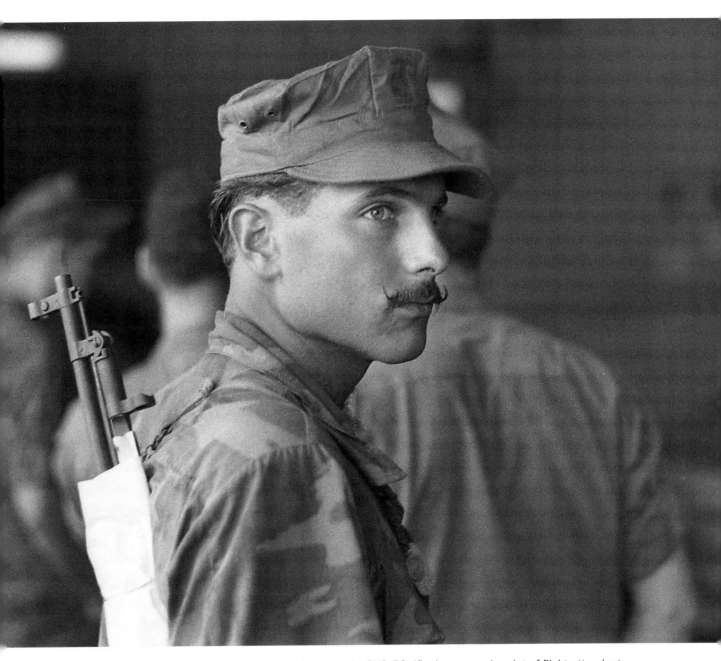

Hand-carrying a registered war trophy SKS-56 rifle. It sure made a lot of flight attendants uneasy, but I had papers to allow me passage with it.

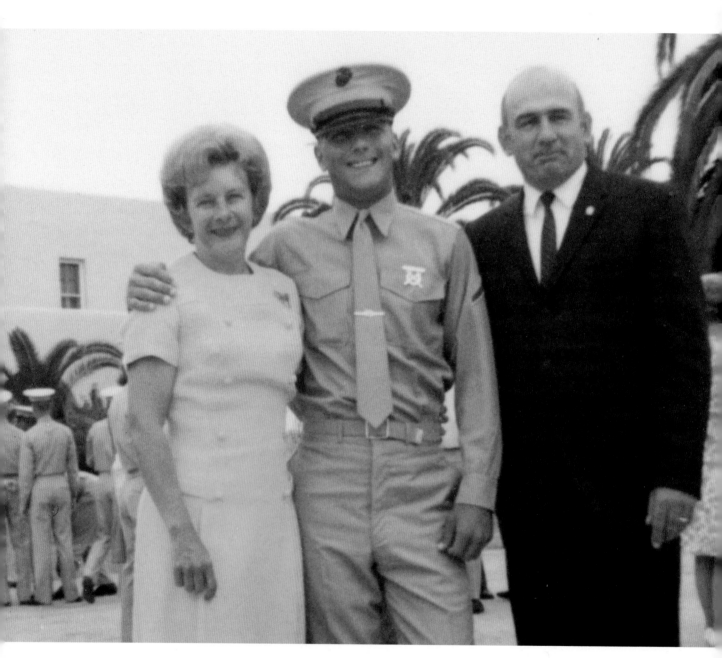

Less than three years separate this photograph and the next.

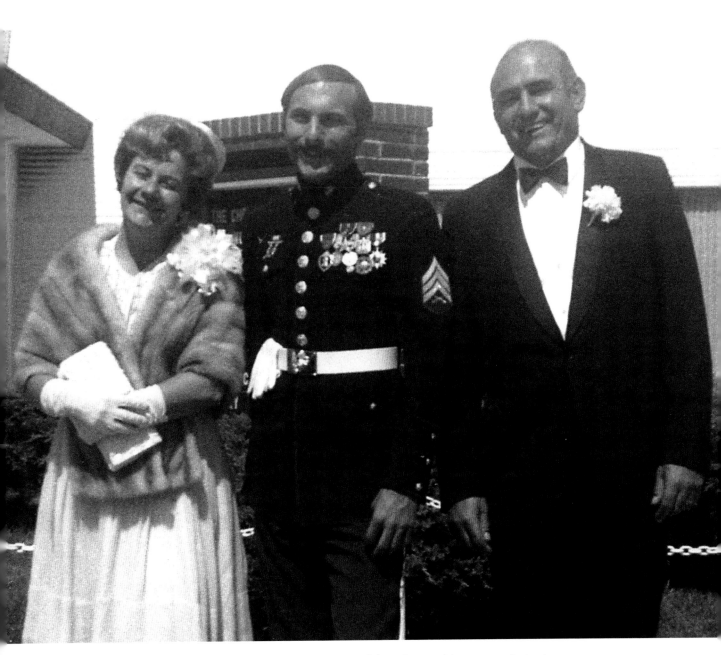

My sleeve, my chest, and my face record a passage of time that would seem much greater.

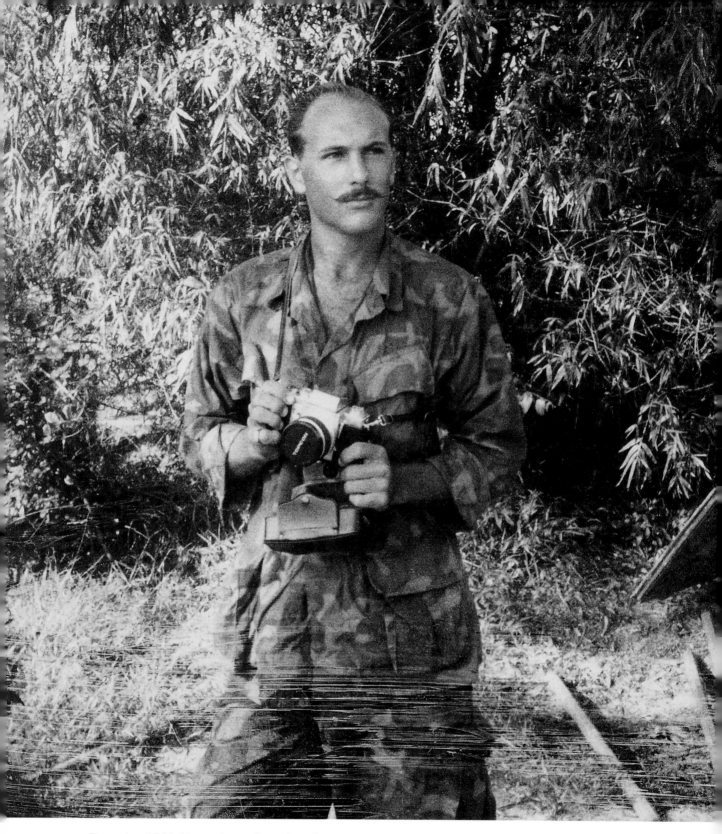

December 1968. I treated myself to a brand-new expensive camera, a Topcon Super D. I refer to this photograph as my "Ernie Pyle look."

THE LONG ROAD HOME

HOME IS WHERE THE HEART IS. BUT HOW DO YOU FIND HOME WHEN YOUR HEART IS SO BADLY SCARRED IT NO LONGER SERVES AS A COMPASS?

Searching, at times frantically, for heart and home, I left behind a trail of destruction and pain. After nearly two decades, I was diagnosed with posttraumatic stress disorder. Over the next twenty-plus years, I eagerly embraced all available treatments.

A few years ago I began to suspect I would never completely heal. My therapists said, "Give yourself more time. You're making great strides in your recovery."

Now, approaching the age of seventy, I have come to grips with the fact that the Marine Corps spoke the truth with their slogan. The change is forever.

When I am asked what I would do differently if I could go back in time, I say, "I would take more pictures and write more letters home."

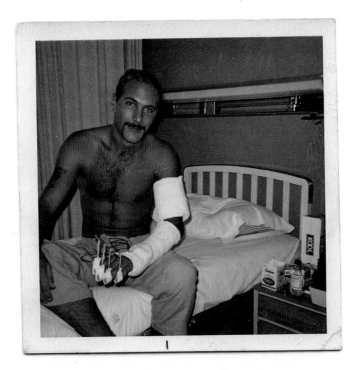

Leading two counterattacks against a nighttime suicide attack by a platoon of sappers, I was finally wounded by an AK-47 and left for dead on the battlefield. I spent six months in various naval hospitals (here, I'm at Long Beach Naval Hospital), twice refusing orders to sign a release for amputation at the shoulder. Today I have full use of that arm.

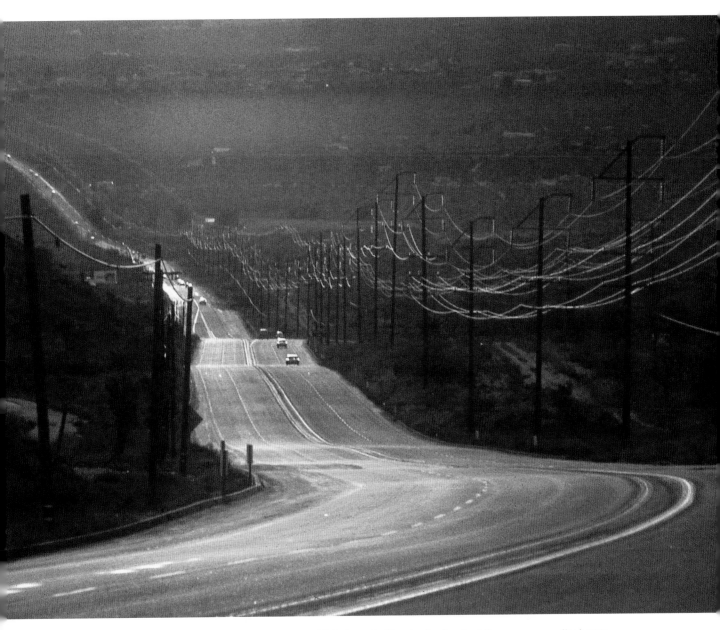

Leaving Marine Corps Base 29 Palms, California, for the last time upon my discharge from active duty. I paused to take my first photograph as a civilian of this stretch of road leading home.

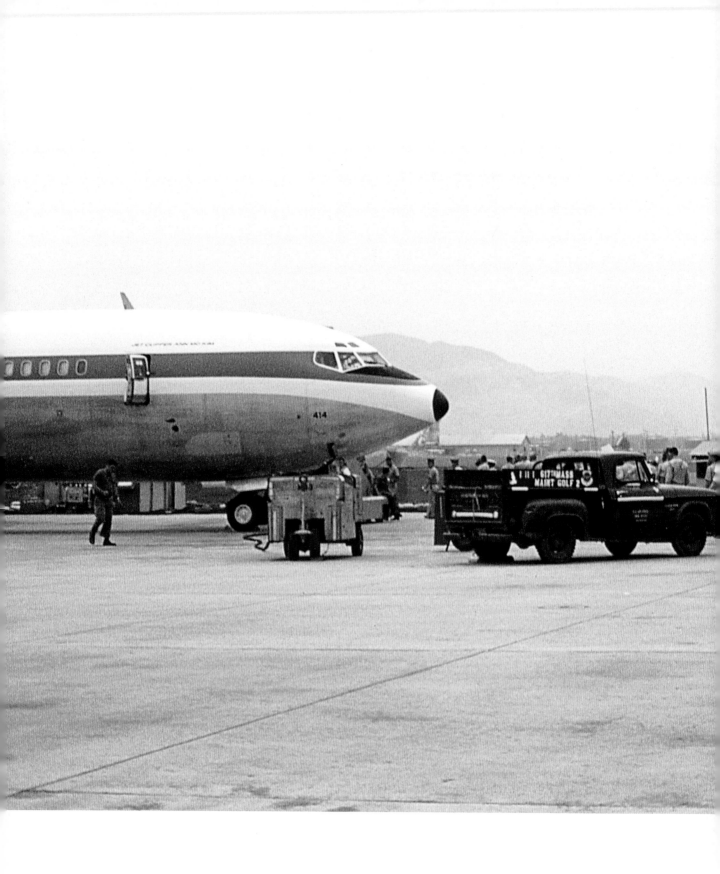

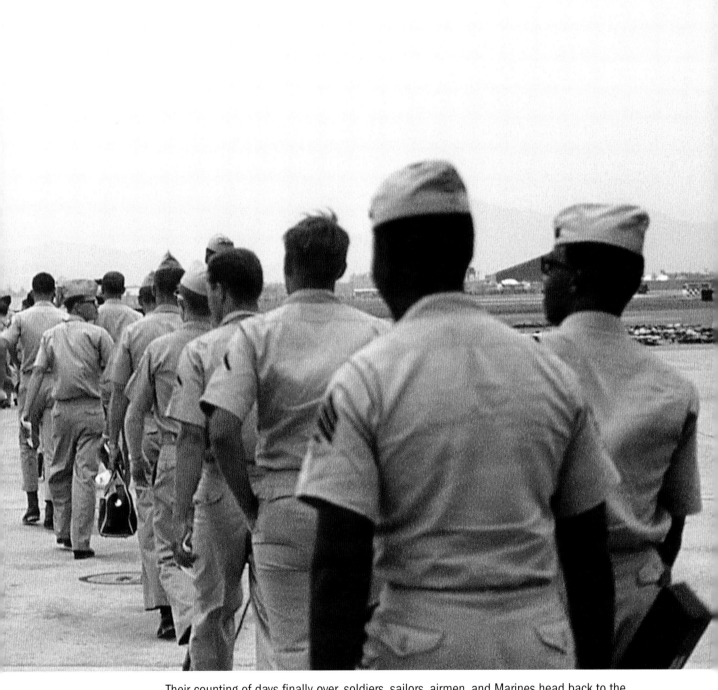

Their counting of days finally over, soldiers, sailors, airmen, and Marines head back to the world on a Pan-Am "freedom bird."

THE CAMERAS

POLAROID SWINGER

This was the "party camera" of my era. You could take pics and have instant gratification. You had to evenly smear a special gel brush (which accompanied each pack of film) as a photo "fixer"—which explains why there are smears and long brushstrokes on some pictures. After all, it was a party favorite, and we were not always fully in control of our abilities when taking pictures! Upon graduation from boot camp, I became enamored with photojournalism. My earliest shots over there were in this format.

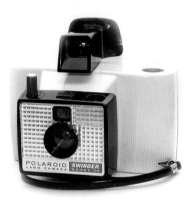

INSTAMATIC

This was the most common camera among my friends. Many vets had one around for snapshots to send home. Occasionally I borrowed one from friends to grab a few shots otherwise not obtainable (when I was out of film, for instance). Additionally, a couple shots in this book were taken by people other than me, demonstrating the commonness of this camera and film format. PHOTO COURTESY OF NICHOLAS HALWA

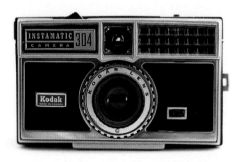

MINOLTA 16

I don't remember where, when, or how I came to possess one of these, but it certainly was handy. I quickly figured out that I could firmly wedge one in my breast flak jacket pocket in conjunction with a spare M-16 magazine, and the combination seemed almost reasonable to me. I could do my Marine "antics and acrobatics" without dislodging it, while maintaining its ready availability—a true plus in a war zone.

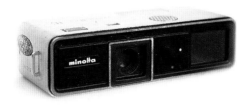

YASHICA LYNX

Very early in my 'Nam time, I won thirty-five dollars in a poker game. The debtor had no money, so he gave me this camera in lieu of cash. I never again played poker, and I never again quit seriously taking photographs while in Vietnam. Film was hard to come by, and I preferred Kodak Kodachrome 25. However, I often had to settle for what was on hand, including black-and-white Tri-X and Pan-X, as well as color print film. There were a few times I had to use other film, but I forget the names. The body of my photographic work for my historical record, as well as what was used in this book, is from this camera.

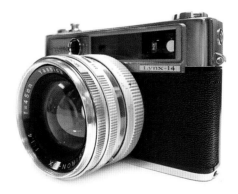

TOPCON SUPER D

This is the camera that someone at the Da Nang PX convinced me was "the camera to have." I bought it en route home on a thirty-day leave, but I took a couple rolls of film before leaving 'Nam. Many shots taken back home were recorded on this camera as well. It's a dandy, and I still have it today. It has accompanied me on many a photographic journey.

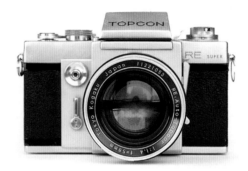

POLAROID 350

I bought this camera at the same time as my Topcon, while traveling home on leave for my six-month extension around Christmas 1968. It was fun and provided higher quality instant-gratification prints, making me a party favorite. It was also discreet, so it went with me to Bangkok. That's all I have to say about that. . . .

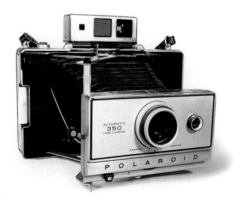

SEEKING

IN THE EARLY 1990S, OPERATION WE REMEMBER (IN WASHINGTON STATE) BEGAN PROVIDING ALL-EXPENSES-PAID TRIPS TO THE WALL TO DISABLED VIETNAM VETERANS. I WAS HIRED TO PHOTOGRAPH AND VIDEOTAPE THREE OF THESE HEALING PILGRIMAGES.

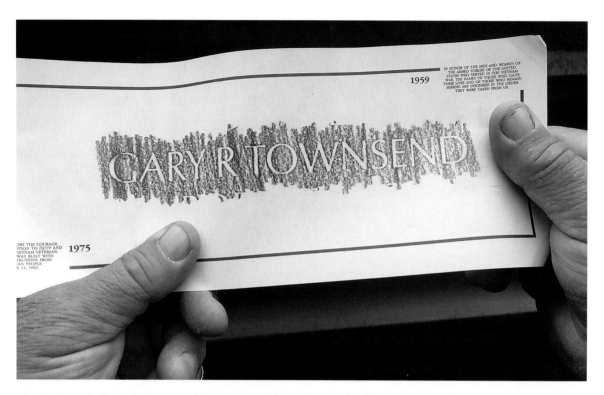

Most vets, and others, have a special someone they are in search of . . . to say good-bye to. In my case it was Gary Ray Townsend, who died in my arms on the battlefield.

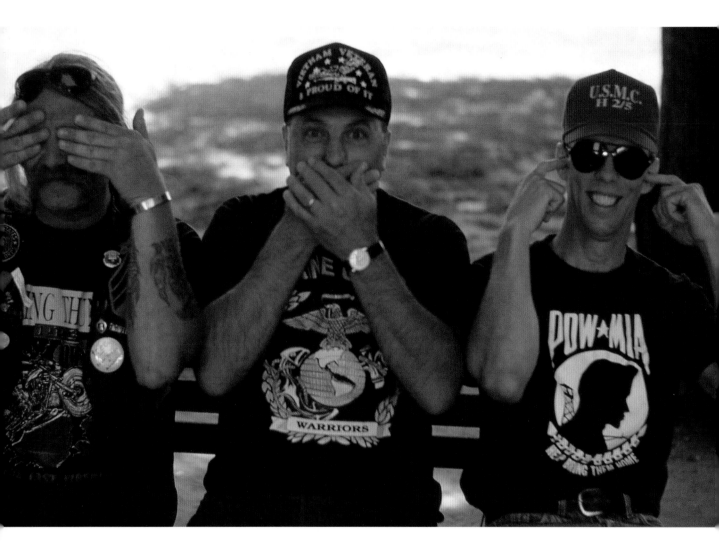

We three recite, with delight, the nirvana-peace mantra of the three monkeys. But we know that we will not heal while continuing to hide and deny our true selves, as the platitude suggests.

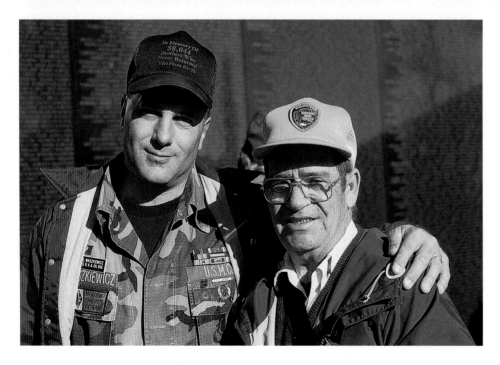

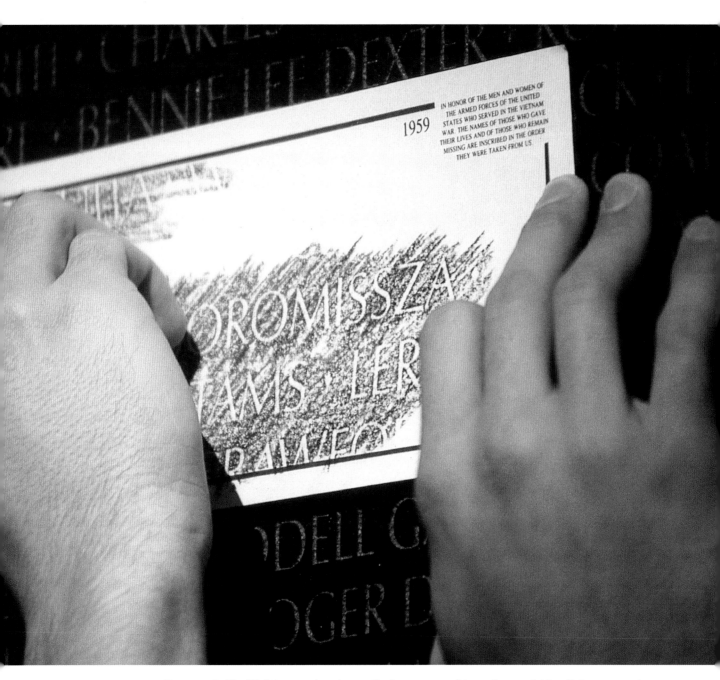

Some go to The Wall to search out a particular name and to make an etching. Yellow-capped volunteers help visitors find these special names; they also provide ladders.

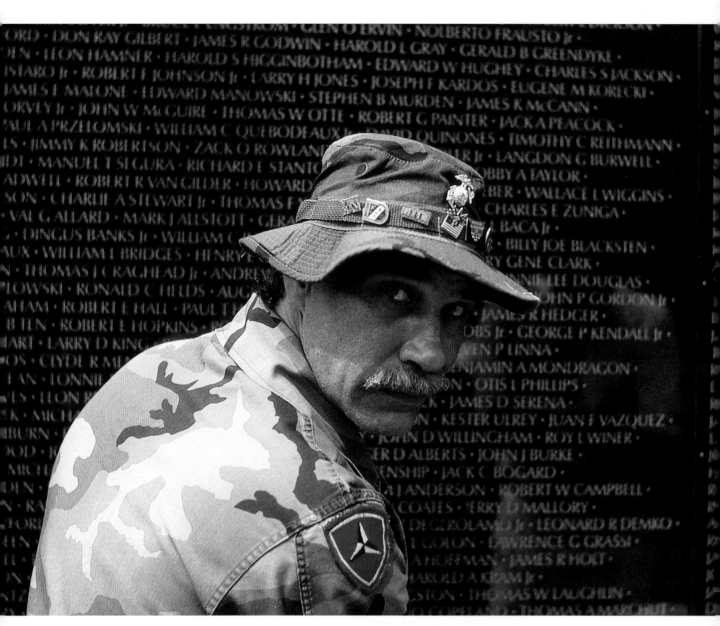

My friend Corporal Mike Crouch, who, in his third helicopter shootdown, was thrown clear of the burning wreckage while his comrades remained trapped inside. Here he pays homage to those who still scream for help in his nightmares.

Facing page: We went there to find old friends, to spend one last time with them, and to seek some sort of resolution to it all. Sometimes, however, we found ourselves instead.

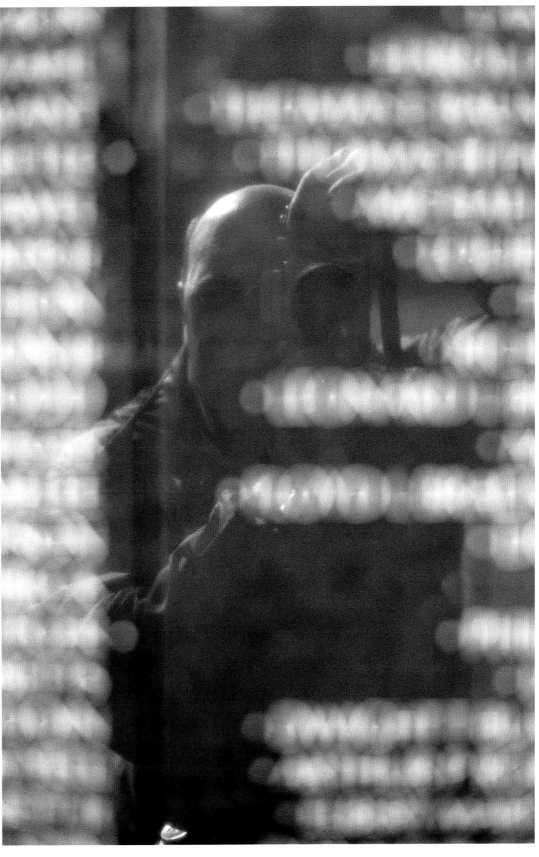

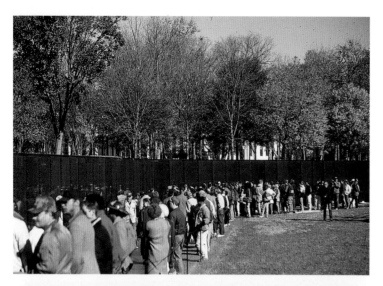

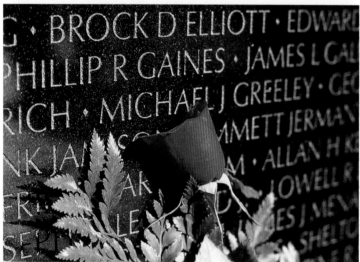

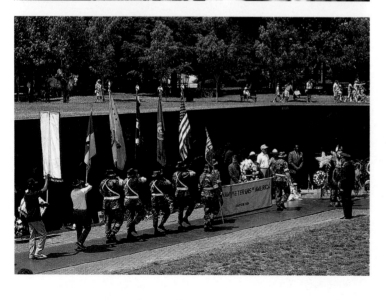

The Wall towers over its attendees. Yet it is personal enough for an individual eulogy. Here I lead my VVA Color Guard, presenting colors before General Colin Powell.

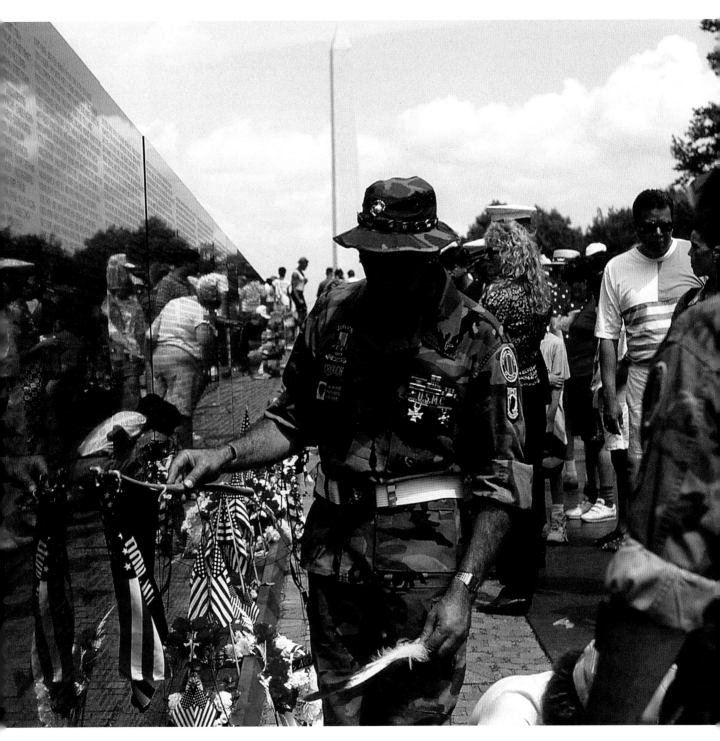

Corporal Crouch searches for more lost brothers.

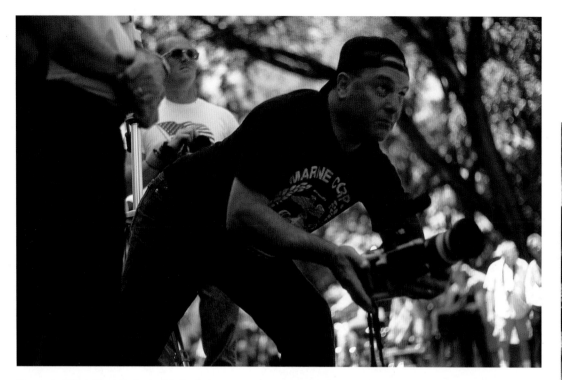

Memorial Day. Dissatisfied with "sideline shots," I planted myself in the middle of Pennsylvania Avenue to capture the immensity and grandeur of Operation Rolling Thunder from ground level, head-on.

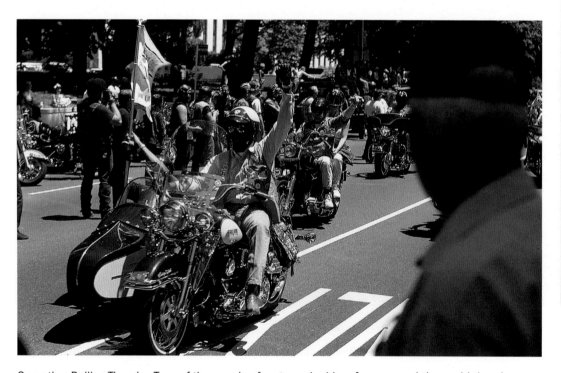

Operation Rolling Thunder. Tens of thousands of motorcycle riders from around the world thunder down Pennsylvania Avenue. Their focus is POW/MIA, keeping lit the candle for those left behind in Southeast Asia.

A surrogate prisoner in an eerily authentic bamboo tiger cage reminds us of the POW's plight.

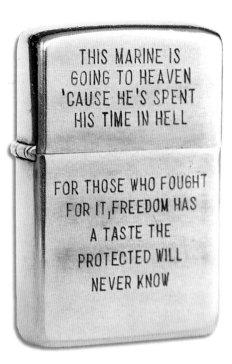

THIS MARINE IS
GOING TO HEAVEN
'CAUSE HE'S SPENT
HIS TIME IN HELL

FOR THOSE WHO FOUGHT
FOR IT, FREEDOM HAS
A TASTE THE
PROTECTED WILL
NEVER KNOW

The back side of my Zippo,
which I still carry.

Savoring the taste of freedom!

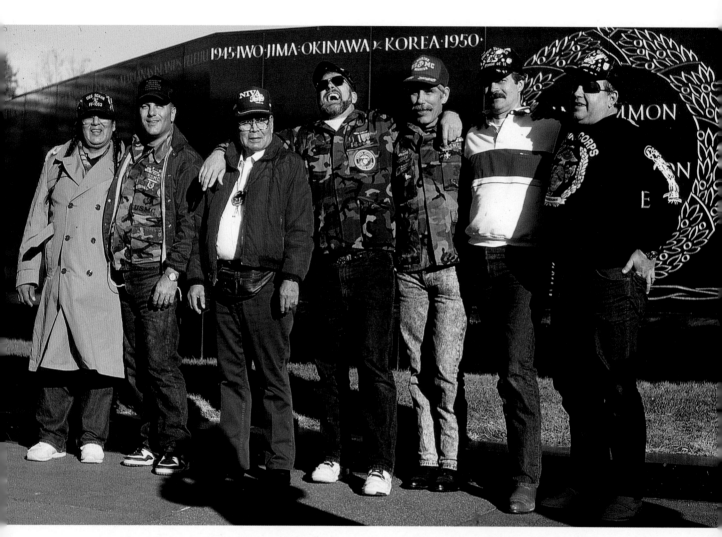

The Marine Memorial. Just across the Potomac River from The Wall, behind Arlington Cemetery, is a must-visit icon for every US Marine. Here all the Marine veterans from our group pose while the vets from other services sing their version of the Marine Hymn: "M-I-C-K-E-Y Mouse."

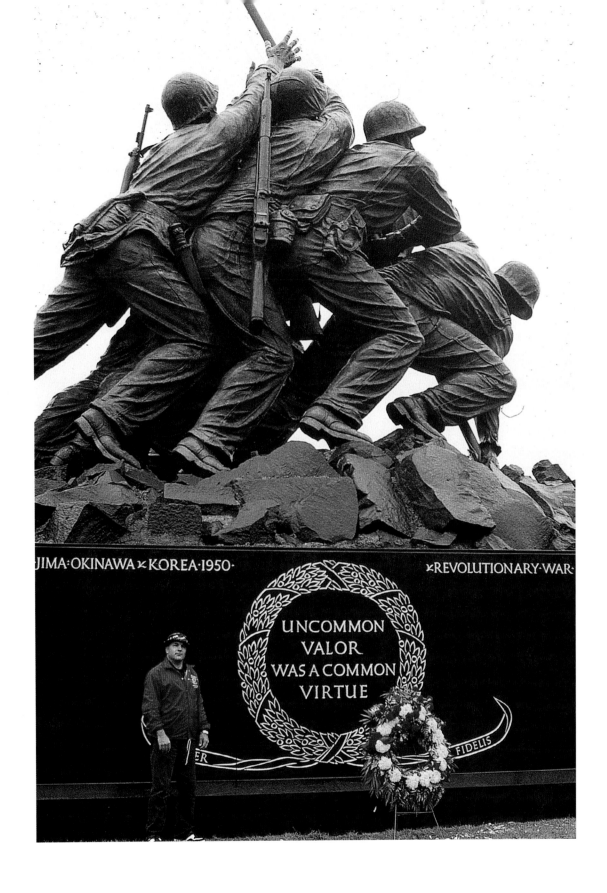

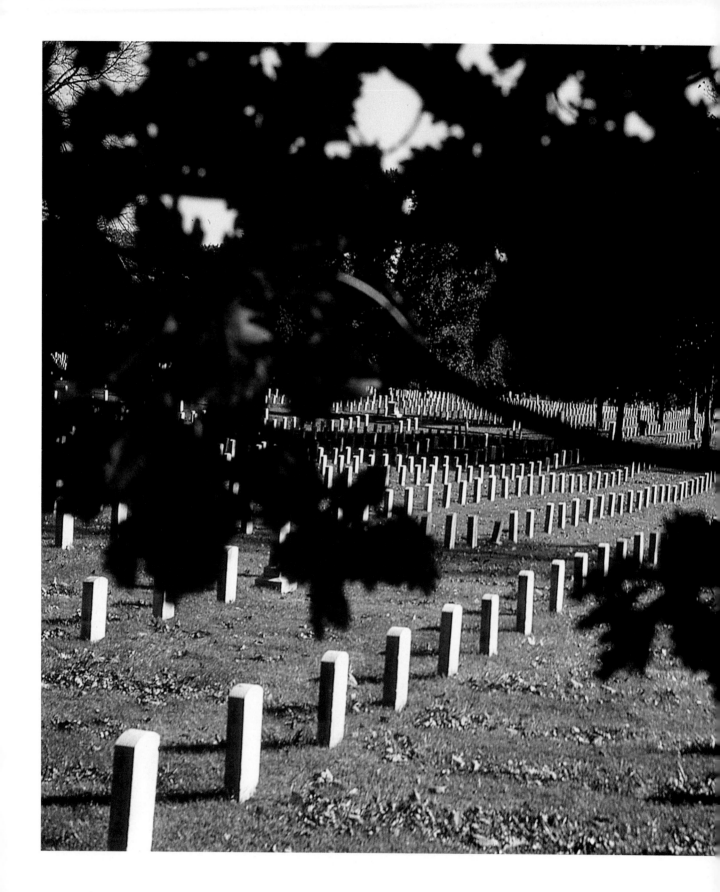

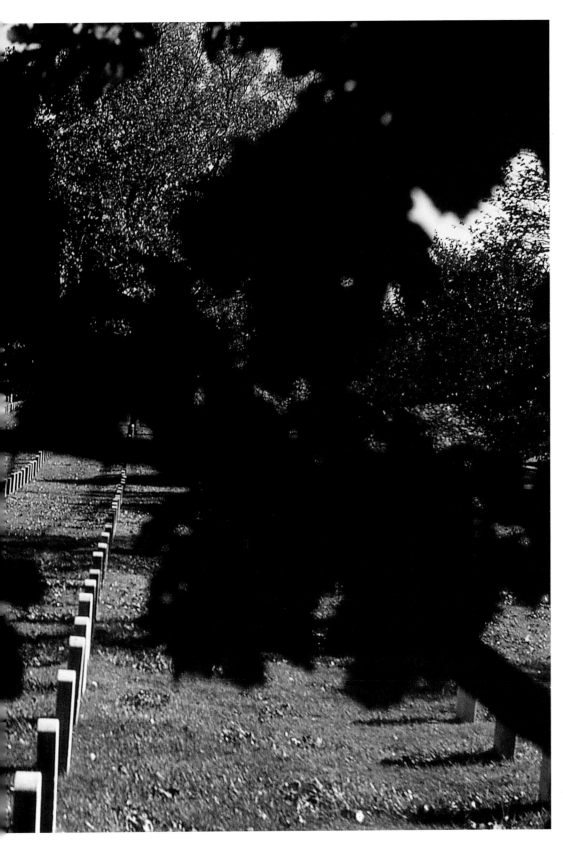

Arlington National Cemetery. Its silence speaks more profoundly than any words I can write.

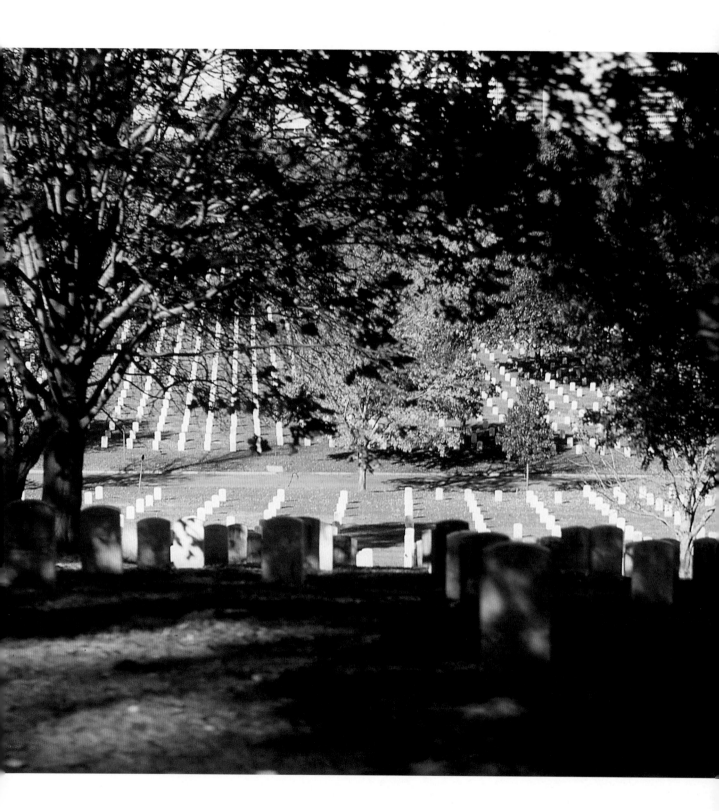

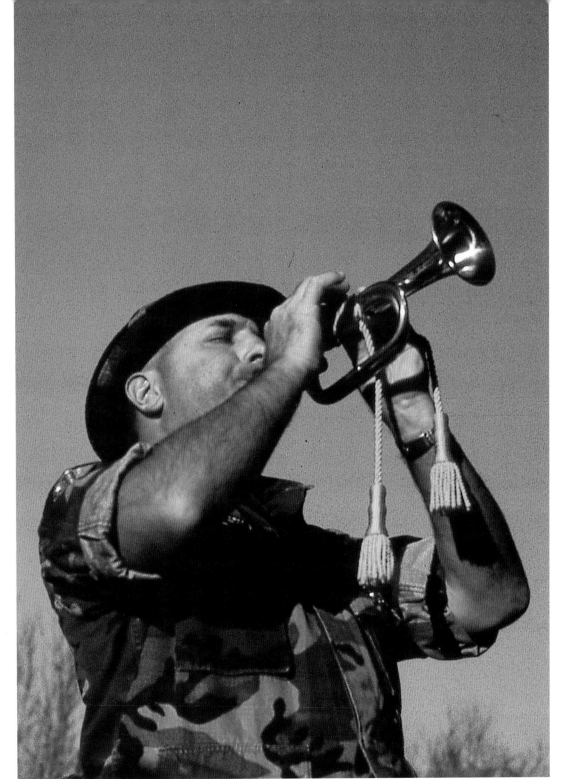

Carrying my bugle, I was often called upon by my fellow vets to play "Taps"—an honorable assignment I can no longer accept as the emotions elicited by the melody are too hard to handle.

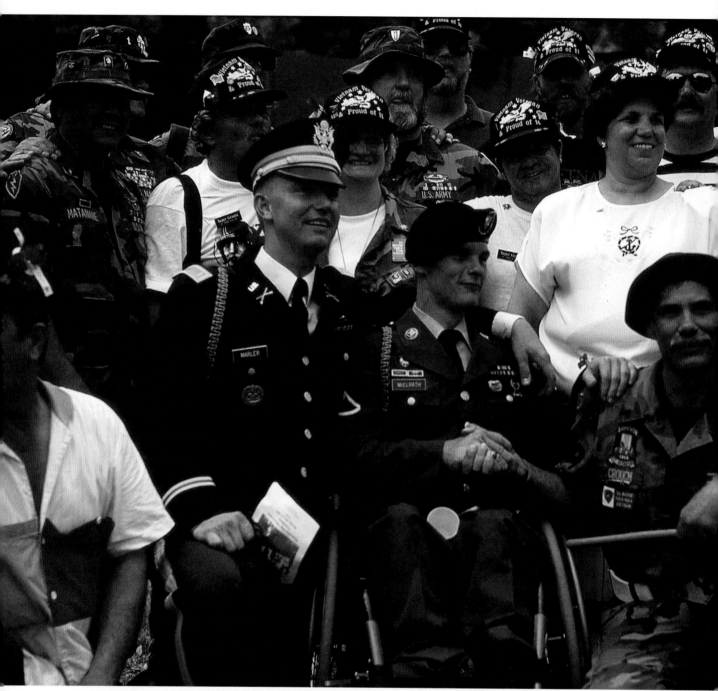

Our group has many memories and stories to bring back home. Hopefully, peace and healing are among them. . . .

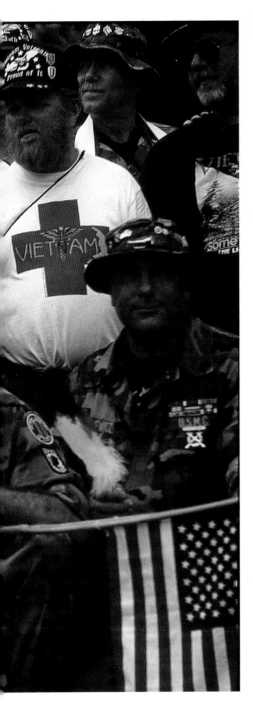

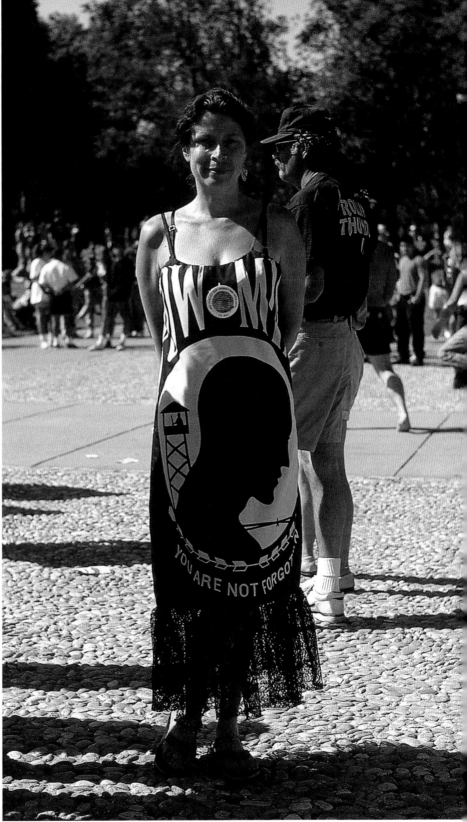

One woman's way of bringing focus to a difficult national issue

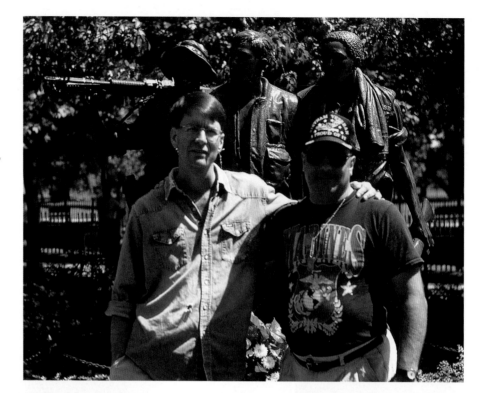

My songwriting partner, Lea Jones, joins me during his first visit to The Wall in 1993. The experience hit him like he was a veteran himself.

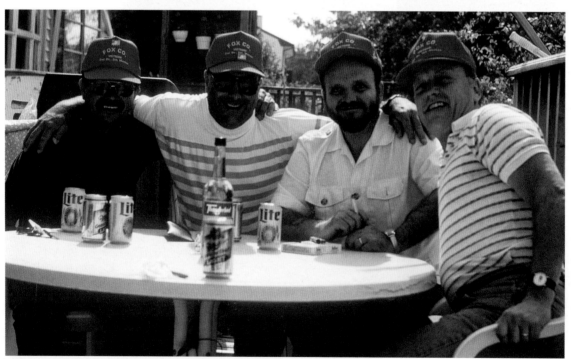

Renewed camaraderie twenty-five years later. Left to right: Sergeant Donny Serowik, platoon sergeant, my best friend, and veteran suicide statistic; me; Lance Corporal Dennis Caddigan, machine gunner blinded by booby-trap shrapnel, now a retired PTSD counselor; and Lieutenant Colonel Dave Brown, our company commander, successful Marine officer and businessman, and executive director of the Museum of the Marine.

During the early 1990s, awareness of PTSD's effects on Vietnam vets came into full flower. Veterans Administration Dr. Ray Scurfield founded an experimental treatment program. The members of one graduating class challenged one another to revisit the locations of their wartime traumas. Stevan M. Smith of Echo Productions documented their return trip to 'Nam, creating *Two Decades and a Wake Up* for PBS. I wrote and produced the music score, which garnered me a regional Emmy.

On Steve's next PBS Vietnam documentary, *Kontum Diary*, I hired myself out as field audio man and score composer/producer.

When not working on *Kontum Diary*, I went searching for my past in local villages and towns. Steve compensated me for my work on his project by videotaping my personal "return to Vietnam." These photos were taken on the fly during that epic three-week, oft-harried production shoot.

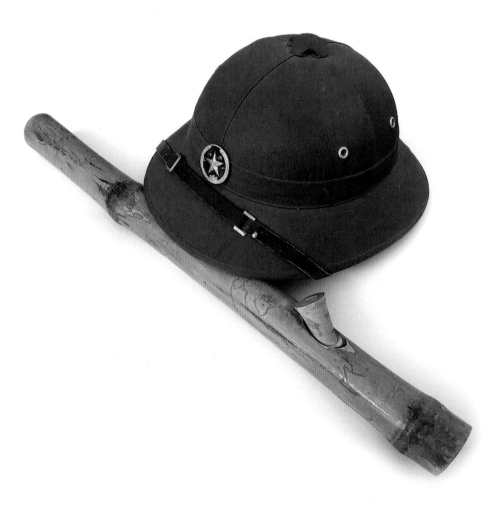

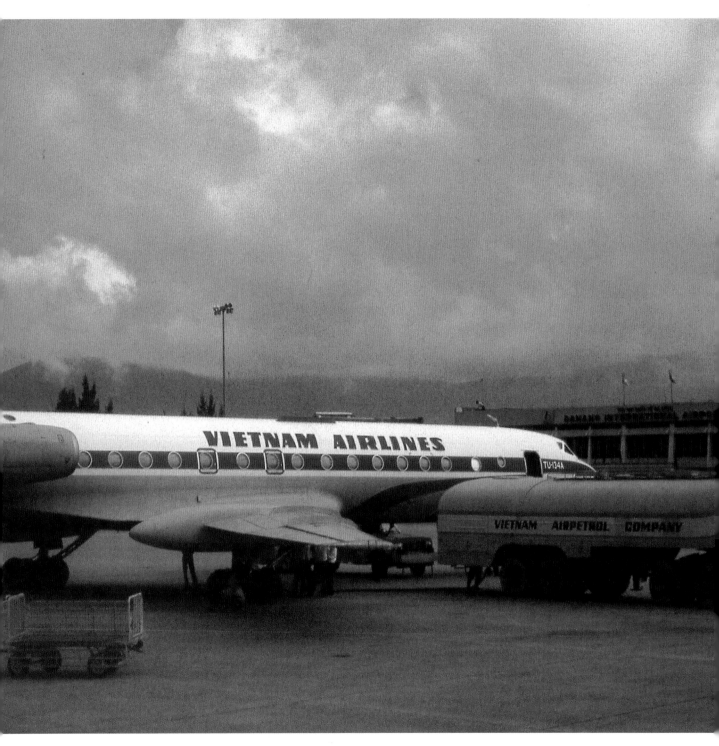

Flying on one of Vietnam Airlines' flights was a surreal experience. The airplanes were worn-out Russian hand-me-downs, and to my eye, maintenance and safety precautions were just a tad below nonexistent.

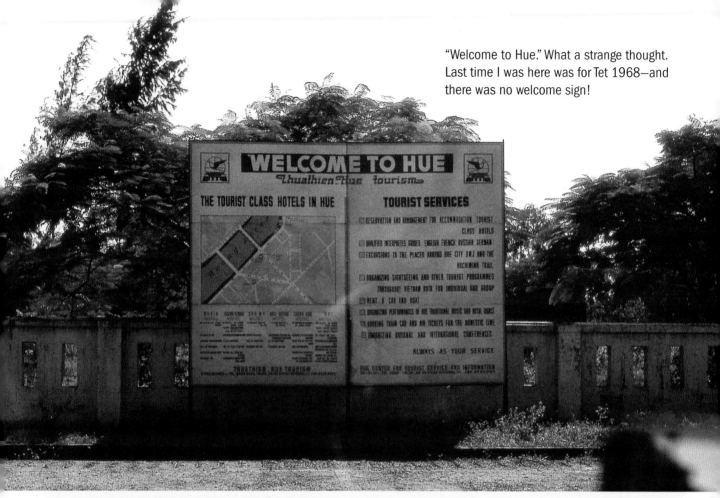

"Welcome to Hue." What a strange thought. Last time I was here was for Tet 1968—and there was no welcome sign!

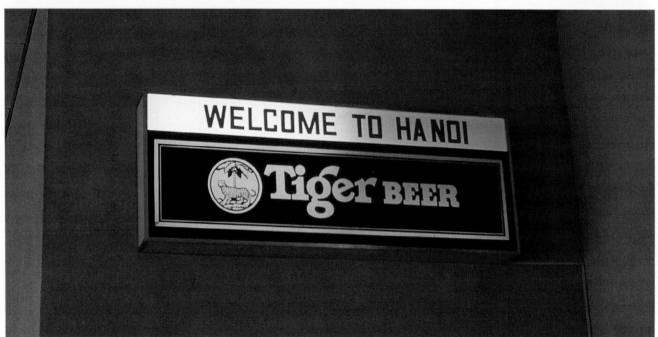

The first sign I saw upon entering customs and baggage check indicated that Tiger Beer had indeed survived the war.

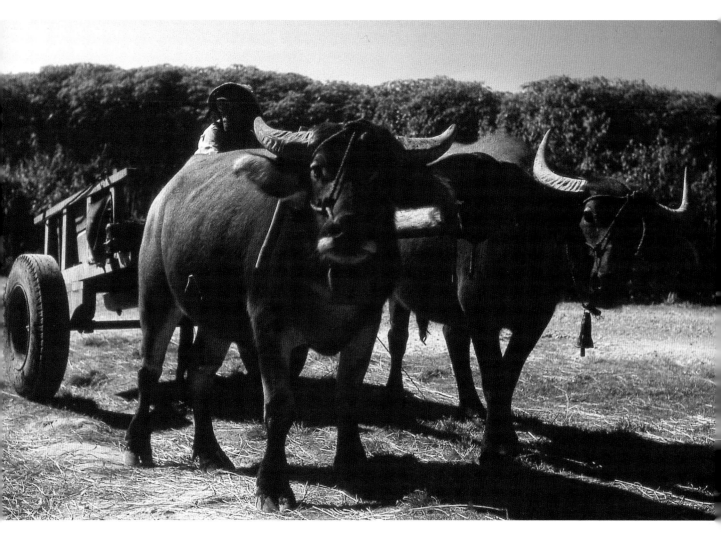

In the countryside, work today is unchanged. Water buffalo still harbor ill-will for our odor. These two are about to charge, forcing me to jump aside as their driver forcibly redirects them down the road.

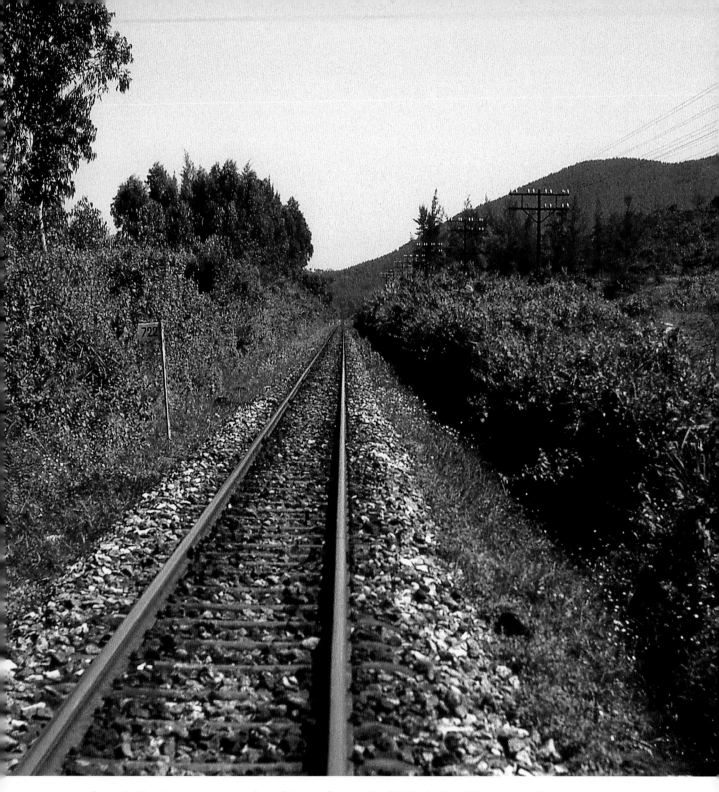

Remarkably, the trains now run from China to Saigon (Ho Chi Minh City). What a beautiful, pastoral countryside ride that would be. I'd love to go back and take that ride.

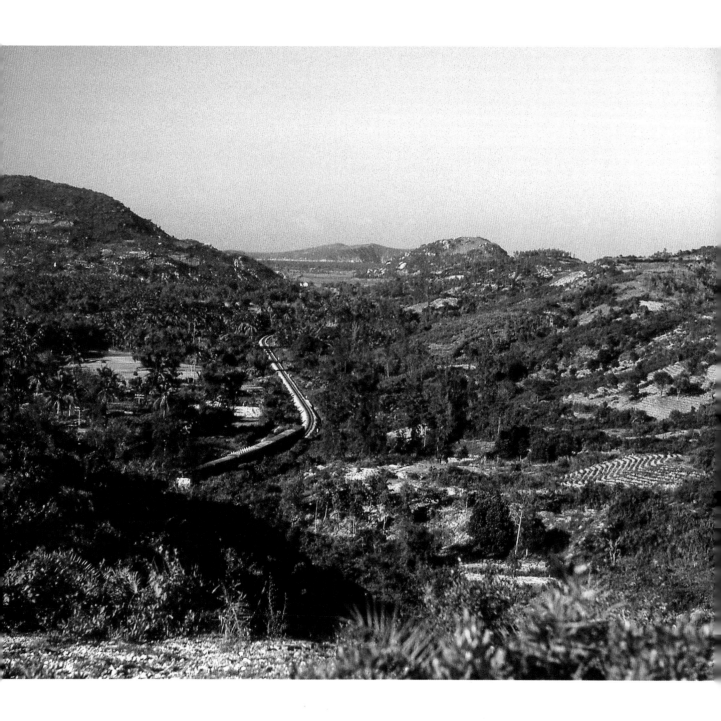

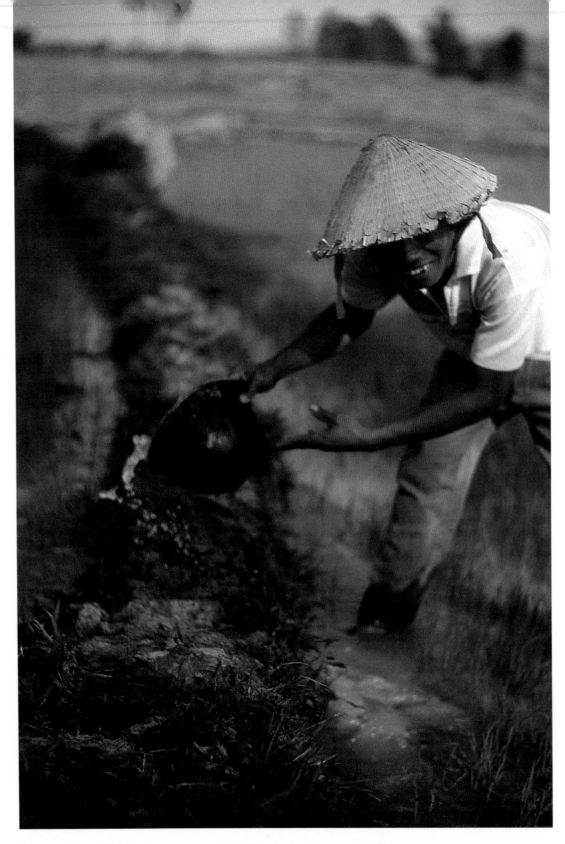

Farmer using a US helmet war remnant to bail water between paddy dikes.

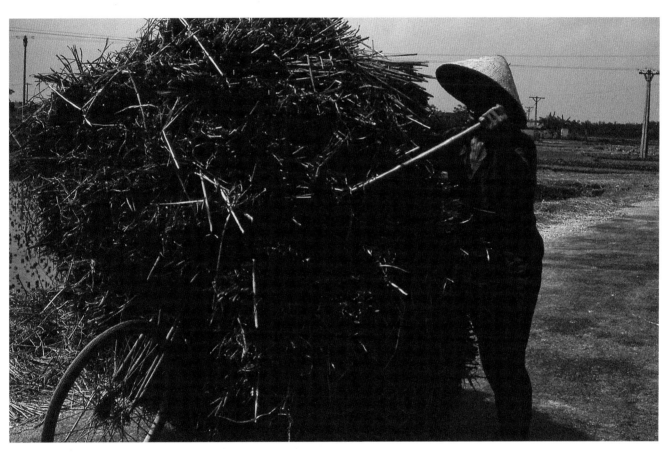

They still use the specially altered bicycles for hauling oversize loads, just as they did down the Ho Chi Minh Trail during the war. Note the handlebar extension for balance and steering.

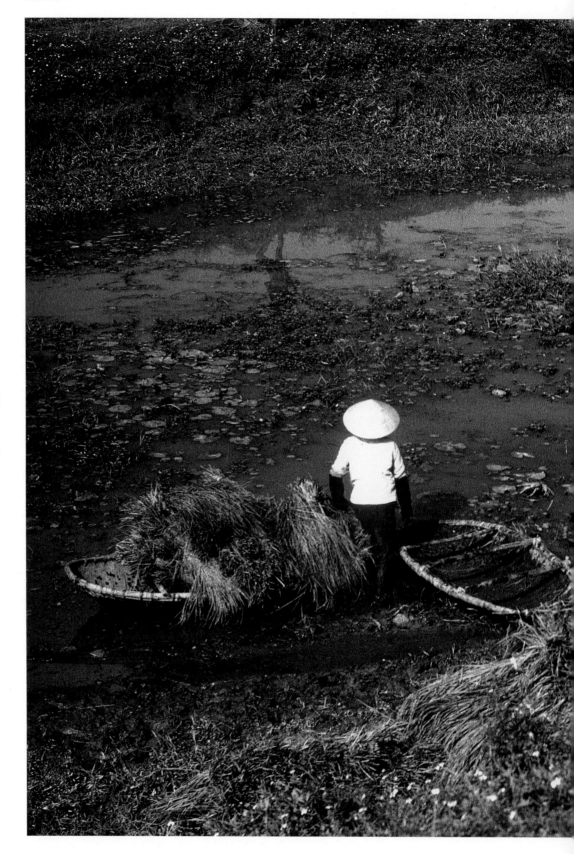

Wicker shallow-water craft are used to cross streams and marshes while keeping the rice dry and clean.

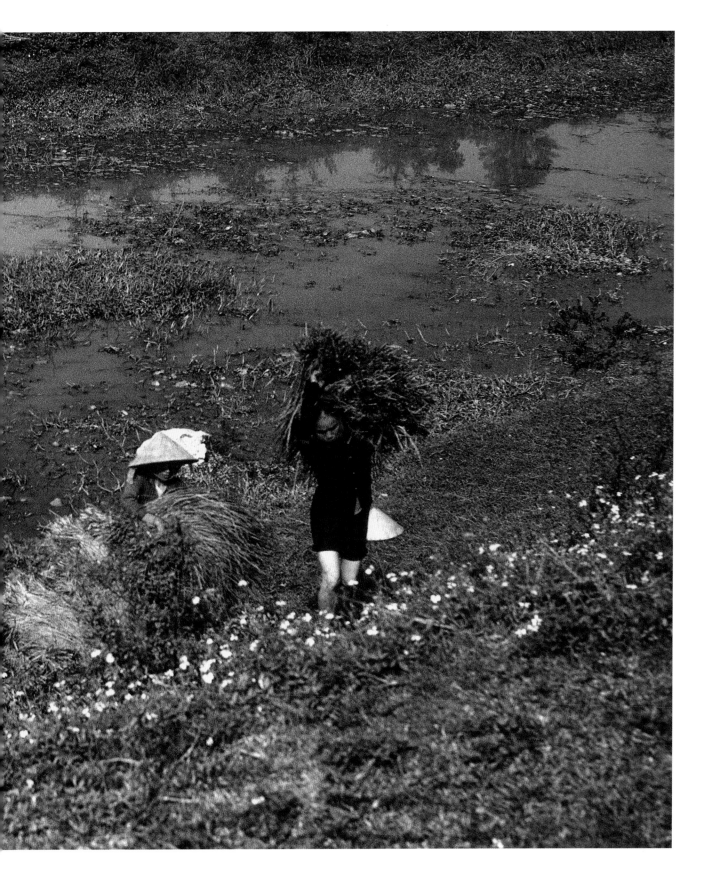

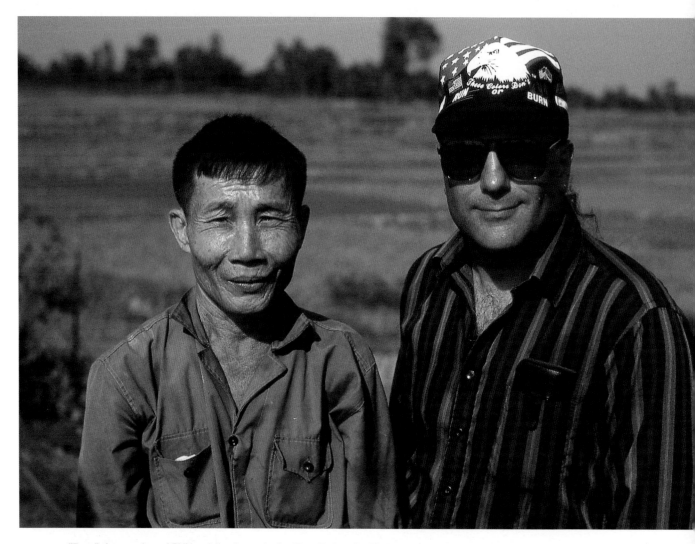

"Tom," the armless ARVN soldier I met in An Hoa. Today the Vietnamese people love Americans. New friends are everywhere.

Facing page: Mr. Nguyen Van Nghia, a North Vietnamese soldier who fought the French, the Japanese, and the Americans and who was a centerpiece of the PBS documentary *Kontum Diary*.

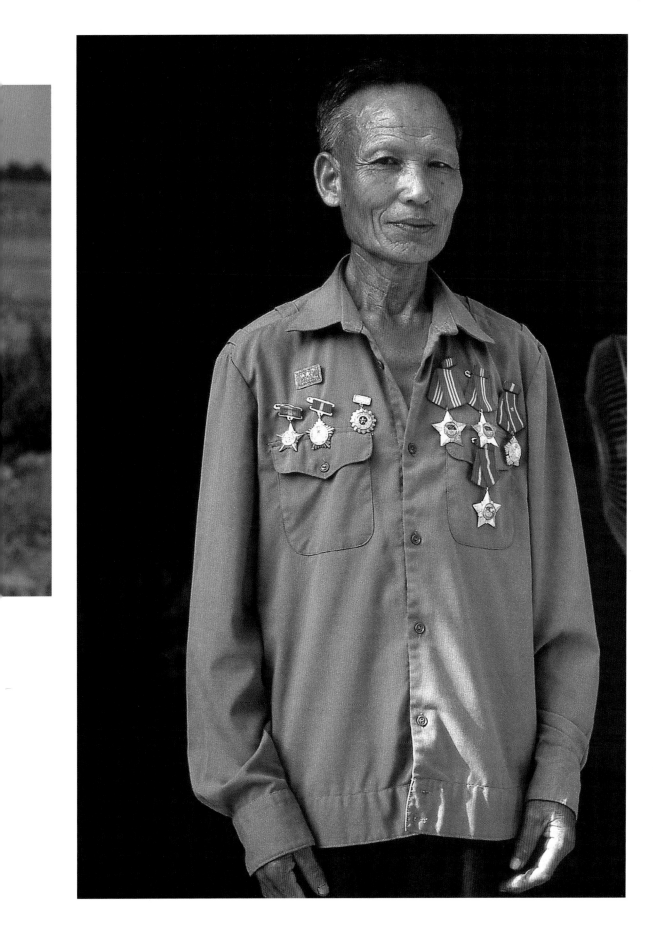

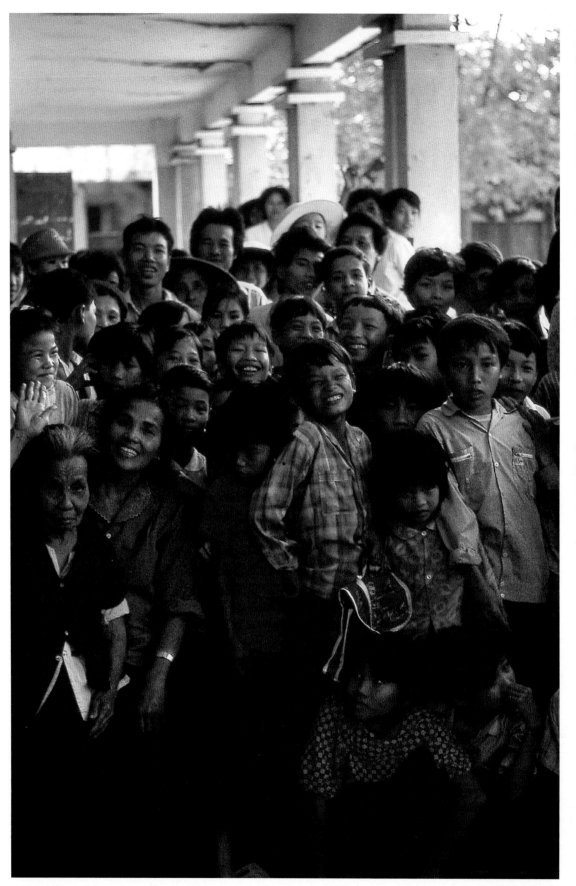

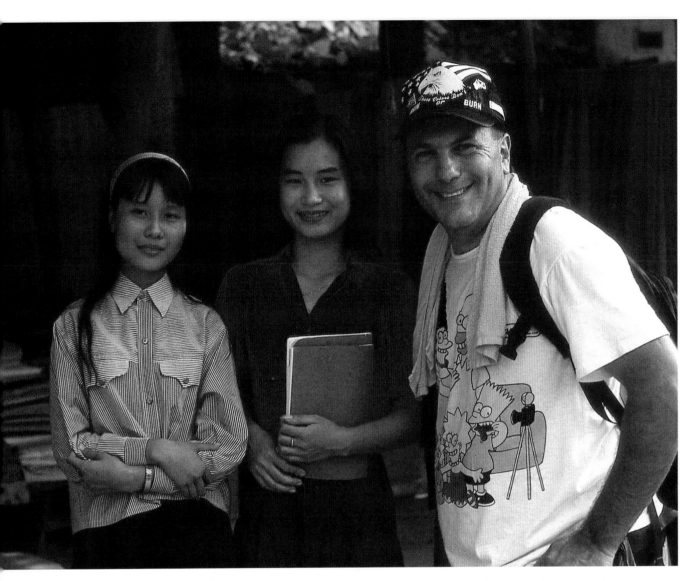

The young lady in the red blouse won my heart with her smile and graceful kindness during the couple days I spent in Thài Binh.

Facing page: Everywhere we went, the children in particular were eager to meet the Americans. Here a grade-school class is barely held in check by their frail head mistress (lower left) with a single raised arm.

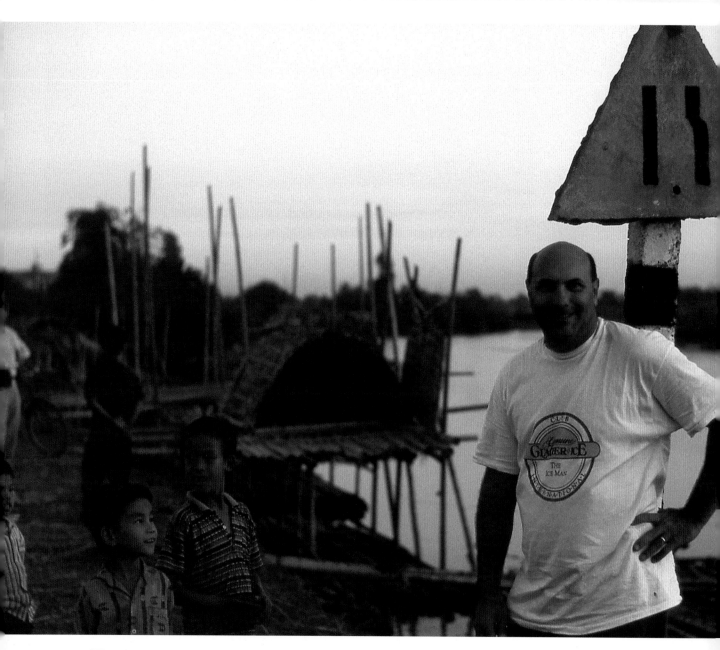

Miles down the road, we stopped for everyone to take a roadside piss. I was enamored with the hand-painted road signs and the local lifestyle. Note the sleeping accommodations for a family of river-fishing people.

Facing page: Local kids everywhere tried to sell us "US dog tags." In almost every case, these are handmade knock-offs, which they hope to sell us for a buck or two in the black-market cottage industry some of them live off. We didn't fall for it: They spelled John "Jonh."

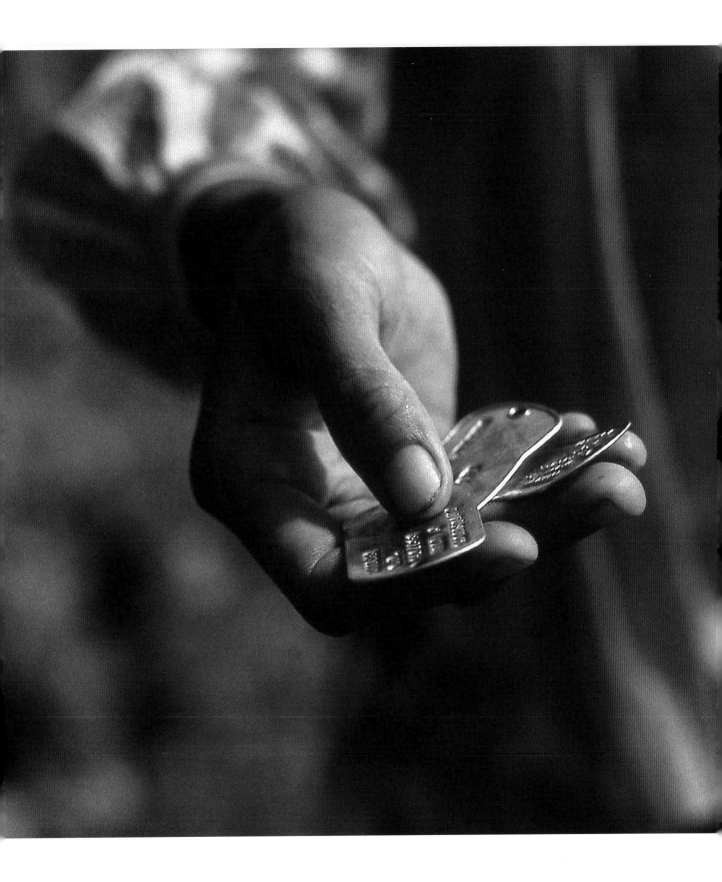

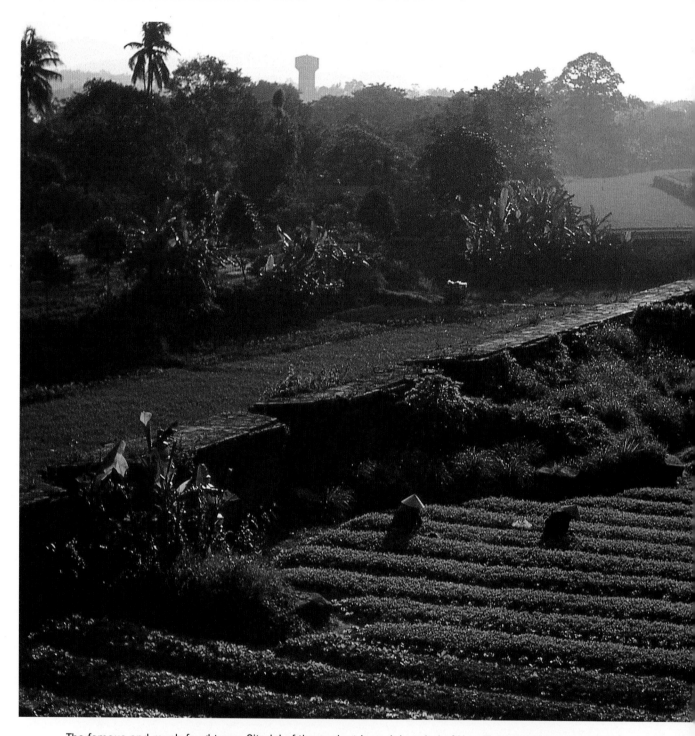

The famous and much-fought-over Citadel of the ancient imperial capital of Hue. Today its terraces provide acreage for locals to grow produce for consumption, and the once-contested flagpole now rests flagless. It, at least, has found peace (hòa bình).

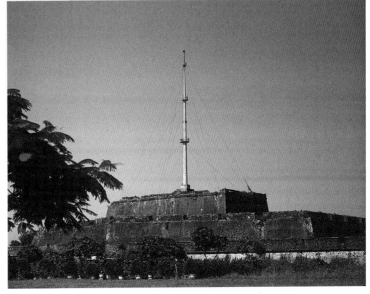

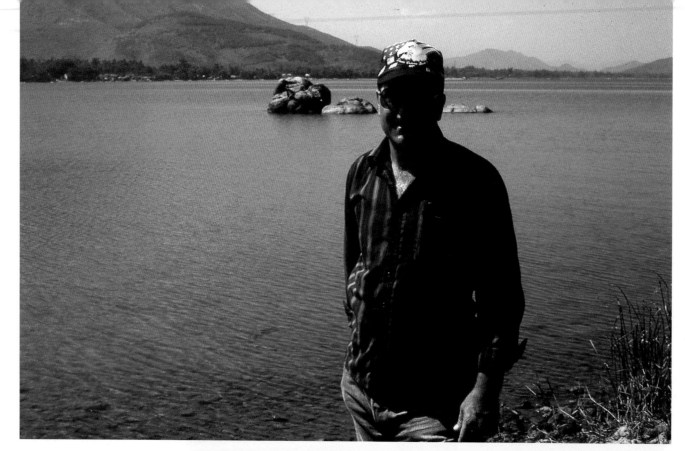

Like many other parts of the country left unaffected by the war, these are the rocks in Cau Doi Bay, where we once pretended to fish (see photo, page 104). I smoked a token joint to them on this return trip. Hòa bình indeed.

The Valley of the Tombs of the Kings, where the ancient rulers of Vietnam lie in perpetual slumber. At moments like this, and much to my surprise, I felt at peace, more like a tourist or student than a return veteran of war.

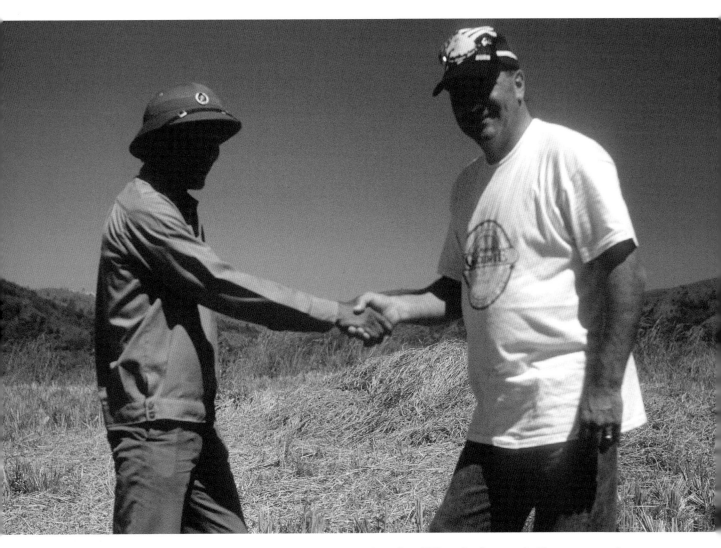

While filming near Kontum, we were assigned an NVA major for security. Tigers commonly attack local workers in this area. He and I struck up a friendship: hòa bình.

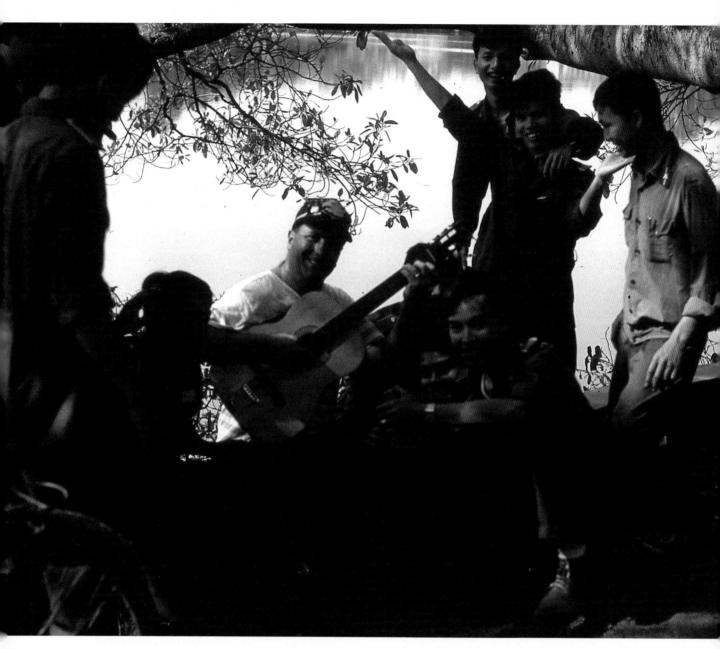

By the Lake of the Restored Sword in downtown Hanoi. I joined in, playing their guitar and bringing smiles to NVA soldiers, just as I had years before with my fellow Marines.

AFTERWORD

As a boy, I was fascinated by firsthand accounts of war. Shortly after arriving in Vietnam, I realized I was in the middle of history being made. Without training or experience, I began documenting daily life around me. Armed with various cameras, an occasional guitar, and my letter-writing pad, I recorded what I was certain folks back home would be eager to learn. I was excited to get back to the world so I could share my photographs and my stories, but when I finally made it home, very few people were interested; it was clear the subject made them uneasy. Life moved on, and Vietnam was soon history.

The purpose of this project is to provide insight into the Vietnam experience. I hope my photographs offer my fellow vets a means for self-expression; for civilians, I hope the photos provide openings for conversation with veteran relatives and friends. I hope to promote understanding and healing for all involved so that my brothers and sisters may find the peace of being genuinely "welcomed home." Veteran suicide is not the answer; *sharing* is the answer!

There are many I want to thank who have brought me to where I am today: completing my life's work in this book and its companion projects, including a written memoir and an album of songs. I suppose a chronological approach is as good as any.

Thank you, Googie, my maternal grandmother, who taught me about war. Her four French-born brothers fought in World War I—three for France, one for Germany. She especially taught me about the humanity that can survive, even in

war: "They'd blow a whistle and both sides would come out of their trenches and swap French coffee for German chocolate until the whistle blew again, resuming the fighting."

Then there are my parents. My overbearing mother picked all my school classes, making sure I took the hardest English, history, social studies, and—thank you, Mom!—typing classes. My stepfather gave me his name, teaching me "team commitment." As a grade schooler, an eighteen-month stint on the Japanese island of Okinawa (only a decade after the horrendous all-out fighting there) cemented my future as a US Marine.

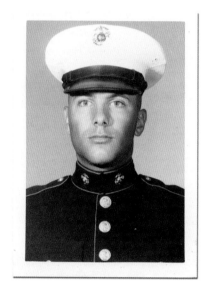

It was the early sixties. My awesome, doe-eyed first girlfriend, Elayna, encouraged me to step up and serve my country. Darrel Smith was in my first rock band with me. His father and older brother both served in the US Army. Danny, his older brother, was killed in action in Vietnam in 1966, which brought the death specter of reality to our childhood concept of cowboys and Indians, motivating Darrel to join the Army to avenge his brother. My other rock bandmate, Tom, joined me in enlisting on the buddy plan in 1967. My boot camp DIs certainly motivated me toward where I am today; I will always remember Gunny D'vorak.

Every Marine I met or served with taught me something, but one stands out above all the others—my first company commander, Dave Brown (Lieutenant Colonel, Ret., USMC), who took me under his wing. Years later, he wrote our stories in his book *Battlelines*, encouraging me to write my memoir. Two other Marines deserve special mention here. Sergeant John Hehr repeatedly risked his life to save what everybody thought was my dead body, only to find me alive but paralyzed and surrounded by enemy. Sergeant Donny Serowik, a platoon sergeant with my first infantry company, taught me how to stay alive and how to have childish fun in the process. Both are dead today.

In the last twenty-five years, there have been more veterans and counselors who have helped me than space allows me to name. In particular, Steve Old Coyote, a local Native American medicine man and spiritual leader, who apprenticed me in the traditional warrior healing practices of "the old ways." Perhaps most important was "Corky" Sullivan, PhD, clinical psychologist and US Army Airborne Vietnam vet, who diagnosed my PTSD and helped me begin to address a new range of growing challenges.

There are my three children, Taylor, Austin, and Ariel, who have softened some of the rough edges I gained from the war. Their mother, Sharon, supports my work to this day, despite our being divorced for well over a decade now.

In more recent years, with age and health issues slowing me down, Lea Jones, my songwriting and recording partner, stepped in to help move this historical piece of art and healing to the finish line. He's truly my partner. I very likely could not and would not have finished this, my life's work, without him.

Marc C. Waszkiewicz
Sergeant, USMC (Ret.)
Vietnam, 1967-1968-1969

* * *

Antiwar sentiment ran high in Southern California during my high school years, and while I didn't believe all veterans were "baby killers," my feelings about Vietnam vets were no doubt colored by my disgust for the war. Generally, I felt best ignoring the whole topic and everyone associated with it. This was a fairly common response among civilians. Vietnam vets who didn't reintegrate smoothly (and quietly) on returning to the world were burrs under the saddle of our national consciousness. Even some older veterans expressed their disapproval of this new batch of "whiny troublemakers."

In 1991 Marc asked me to help him create the soundtrack to "what would soon be a PBS documentary film" based on his amazing collection of photos from three combat tours in Vietnam. I was not interested in studying and writing songs about the war from Marc's perspective, but I thought the project might move my music career forward. Marc seemed to have his ducks in a row. So I went for it.

We spent close to a year talking about Marc's life before, during, and after the war. We spent another six months writing and recording the music. By the time we were finished, I was a raw nerve. I spent a lot of time crying. **What I learned during the process of recording the soundtrack had everything to do with dispelling the stereotypes about Vietnam veterans that I'd harbored subconsciously for decades.** I learned about PTSD firsthand. I walked in Marc's boots and was changed. The soundtrack album is excellent, and it went almost nowhere. The film concept fizzled as our respective lives got in the way.

Now Marc and I have dug in once again and are set to push his project to completion. *1,000-Yard Stare* is but one piece of a multipart multimedia experience. I am honored to be involved in its publication.

Many of my progressive-leaning acquaintances follow my creative doings but steer clear when it comes to this project. Word is that even today, "the whole Vietnam gestalt is just too hard to deal with." I believe this book can go a long way toward healing that rift, when courageous, compassionate souls—veterans and

civilians alike—given the opportunity either to remember or learn for the first time what it was like to serve in 'Nam, bite the bullet and spend time with Marc's images.

Lace up your boots and prepare to be changed. We're going in hot.

Lea Jones

* * *

What to leave in? What to leave out? Poring through the archive of boxes. Scanning previously neglected images. The challenge of restoring, repairing, and even colorizing. How can we present these images to understand this story as I have learned to understand? Images wrestling to be included grew from 80, to 100, to more than 200. Now, poised to go to print with a publisher, we add another 100 to the mix. How do you present or possibly condense these images of war?

Before starting on this book, I only knew the war in Vietnam for its influence on 1960s America: draft-card burning, antiwar protests, sit-ins and walk-outs, and distaste for returning veterans. I did not know veterans from this era; and if I did, I didn't know what or how to ask. Throughout these months of working with Marc, looking at his photographs and listening to his anecdotes, they have become a part of my psyche.

What started as an ad on Craigslist for scanning negatives became afternoons rich with stories, laughter, and tears as we worked through boxes of slides. I love stories, and Marc is a gifted storyteller. I would sit at the computer scanning images while Marc would stand over the light table commenting about this or that, remembering moments and retelling events. We would discuss and select images, both for the events' significance to Marc and their content and meaning to me, a pair of eyes separate from the experience.

Having little understanding of the veteran experience beyond the physicality of war in film and media, I lacked insight into the deep internal conflicts of fear, pride, boredom, heritage, friendship, and loneliness. This project furthered my understanding of my peers who serve today, that everyone has his or her own motivations, experience, and recovery process.

I am thrilled to bring care and restoration to these images and to share them with you. In this book we bring you the view of one person, but the opportunity to relate and share what is often untold and kept silent. We hope to open the dialogue of understanding the Vietnam War and those affected by this conflict, even to those with little veteran experience, and to provide a place to begin.

This book does not speak for all veterans, but through it we hope to help veterans find their voice and begin to share.

Crista Dougherty

ABOUT THE AUTHORS

MARC C. WASZKIEWICZ

After the war—despite generous offers for continuing employment from the Marine Corps—Marc returned to civilian life and his first love, music. His master's degree from the Dick Grove School of Music led to short-term successes in Hollywood and to a regional Emmy for documentary film scoring. Marriage and hopes of raising a healthy family spurred a move to the Pacific Northwest, where the nagging effects of three combat tours took hold of him and wouldn't let go. Marc's commitment to completing his life's work, Vietnam: An Inner View (of which this book is one part), remained the constant, sustaining thread, and his target is now in range. He dreams of owning a Harley.

vietnaminnerview.com

LEA JONES

Lea has long enjoyed recording and performing original music, producing graphic art, writing essays and screenplays, editing video, making photographs, and dreaming up creative marketing schemes. His ultimate roll of the dice came back in 1992, when he agreed to help write and record the soundtrack to Marc's documentary film. In 2010 his skill set came into play when he committed to helping bring Vietnam: An Inner View to fruition. It's been a rocky road to travel, and a deeply rewarding one, not least because of the unanticipated friendships forged with Marc's brothers in arms (and others) along the way. Lea rhymes with "flea." It's a Southern thing.

reverbnation.com/LeaJones2

CRISTA DOUGHERTY

An artist and designer residing in Poulsbo, Washington, Crista received her BFA in photography and printmaking and enjoys a spectrum of creative pursuits: illustration, graphic and object design, photography, photo restoration, and handcrafts. With an interest in storytelling and image sequencing, she first worked as the photography editor for *Planet Magazine* in Bellingham, Washington. *1000 Yard Stare* is her first photobook production, and she would love to continue working with people in actualizing their ideas.

cristadougherty.com

The four-part multimedia experience.

1000 YARD STARE
The Photobook

TRIPWIRE!
The Film

WELCOME TO THE JUNGLE
The Memoir

WARSPEAK
The Soundtrack

For author signings and multimedia presentations, please contact us at
www.vietnaminnerview.com